Nikon® D300 Digital Field Guide

Nikon[®] D300 Digital Field Guide

J. Dennis Thomas

Nikon® D300 Digital Field Guide

Published by Wiley Publishing, Inc. 10475 Crosspoint Blvd. Indianapolis, IN 46256 www.wiley.com

Copyright © 2008 by Wiley Publishing, Inc., Indianapolis, Indiana

Published simultaneously in Canada

ISBN: 978-0-470-26092-0

Manufactured in the United States of America

 $10\ 9\ 8\ 7\ 6\ 5\ 4\ 3\ 2\ 1$

No part of this publication may be reproduced, stored in a retrieval system or transmitted in any form or by any means, electronic, mechanical, photocopying, recording, scanning or otherwise, except as permitted under Sections 107 or 108 of the 1976 United States Copyright Act, without either the prior written permission of the Publisher, or authorization through payment of the appropriate per-copy fee to the Copyright Clearance Center, 222 Rosewood Drive, Danvers, MA 01923, (978) 750-8400, fax (978) 750-4744. Requests to the Publisher for permission should be addressed to the Legal Department, Wiley Publishing, Inc., 10475 Crosspoint Blvd., Indianapolis, IN 46256, (317) 572-3447, fax (317) 572-4355, or online at http://www.wiley.com/go/permissions.

LIMIT OF LIABILITY/DISCLAIMER OF WARRANTY: THE PUBLISHER AND THE AUTHOR MAKE NO REPRESENTATIONS OR WARRANTIES WITH RESPECT TO THE ACCURACY OR COMPLETENESS OF THE CONTENTS OF THIS WORK AND SPECIFICALLY DISCLAIM ALL WARRANTIES, INCLUDING WITHOUT LIMITATION WARRANTIES OF FITNESS FOR A PARTICULAR PURPOSE. NO WARRANTY MAY BE CREATED OR EXTENDED BY SALES OR PROMOTIONAL MATERIALS. THE ADVICE AND STRATEGIES CONTAINED HEREIN MAY NOT BE SUITABLE FOR EVERY SITUATION. THIS WORK IS SOLD WITH THE UNDERSTANDING THAT THE PUBLISHER IS NOT ENGAGED IN RENDERING LEGAL, ACCOUNTING, OR OTHER PROFESSIONAL SERVICES. IF PROFESSIONAL ASSISTANCE IS REQUIRED, THE SERVICES OF A COMPETENT PROFESSIONAL PERSON SHOULD BE SOUGHT. NEITHER THE PUBLISHER NOR THE AUTHOR SHALL BE LIABLE FOR DAMAGES ARISING HERE-FROM. THE FACT THAT AN ORGANIZATION OR WEB SITE IS REFERRED TO IN THIS WORK AS A CITATION AND/OR A POTENTIAL SOURCE OF FURTHER INFORMATION DOES NOT MEAN THAT THE AUTHOR OR THE PUBLISHER ENDORSES THE INFORMATION THE ORGANIZATION OF WEB SITE MAY PROVIDE OR RECOMMENDATIONS IT MAY MAKE. FURTHER, READERS SHOULD BE AWARE THAT INTERNET WEB SITES LISTED IN THIS WORK MAY HAVE CHANGED OR DISAP-PEARED BETWEEN WHEN THIS WORK WAS WRITTEN AND WHEN IT IS READ.

For general information on our other products and services or to obtain technical support, please contact our Customer Care Department within the U.S. at (800) 762-2974, outside the U.S. at (317) 572-3993 or fax (317) 572-4002.

Wiley also publishes its books in a variety of electronic formats. Some content that appears in print may not be available in electronic books.

Library of Congress Control Number: 2008924510

Trademarks: Wiley and the Wiley Publishing logo are trademarks or registered trademarks of John Wiley and Sons, Inc. and/or its affiliates. Nikon is a registered trademark of Nikon, Inc. All other trademarks are the property of their respective owners. Wiley Publishing, Inc. is not associated with any product or vendor mentioned in this book.

About the Author

J. Dennis Thomas has been interested in photography since his early teens when he found some of his father's old photography equipment and photographs of the Vietnam War. Fortunately, he was able to take photography classes with an amazing teacher that started him on a path of learning that has never stopped.

His first paying photography gig was in 1990 when he was asked to do promotional shots for a band being promoted by Warner Bros. Records. Although he has pursued many different career paths through the years, including a few years of being a musician, his love of photography and the printed image has never waned.

With the advent of digital photography, although he was resistant to give up film, Dennis realized there was yet more to learn in the realm of photography. It was just like starting all over. Photography was fresh and exciting again. Realizing that the world of digital photography was complex and new, Dennis decided to pursue a degree in photography in order to learn the complex techniques of digital imaging with the utmost proficiency.

Eventually Dennis decided to turn his life-long passion into a full-time job. He currently owns his own company, Dead Sailor Productions, a photography and graphic design business. He does freelance work for companies including Red Bull Energy Drink, Obsolete Industries, Secret Hideout Studios, and Digital Race Photography. He continues to photograph bands, including LA Guns, the US Bombs, Skid Row, Quiet Riot, Echo & the Bunnymen, Dick Dale, Link Wray, Willie Nelson, Bo Diddley, and the Rolling Stones. He has been published in several regional publications and continues to show his work in various galleries throughout the country.

He is also the author of the Nikon Creative Lighting System Digital Field Guide, the Nikon COOLPIX Digital Field Guide, and the Canon Speedlite System Digital Field Guide.

Credits

Acquisitions Editor Courtney Allen

Senior Project Editor Cricket Krengel

Technical Editor Chris Bucher

Copy Editor Kim Heusel

Editorial Manager Robyn B. Siesky

Vice President & Group Executive Publisher Richard Swadley

Vice President & Publisher Barry Pruett

Business Manager Amy Knies

Senior Marketing Manager Sandy Smith **Project Coordinator** Erin Smith

Graphics and Production Specialists Alissa D. Ellet Jennifer Mayberry

Quality Control Technician Melanie Hoffman

Proofreading Evelyn W. Still

Indexing Sherry Massey

Special Help Sarah Cisco Jama Carter

For Henrietta, the best dog ever...

Acknowledgments

hanks to Robert at Precision Camera & Video in Austin for getting me the first D300 in Austin. Thanks to my copy editor Kim Heusel and technical editor Chris Bucher. An extra special thanks to Cricket, Courtney, and Laura at Wiley. I know I'm not always the easiest guy to work with, but you still put up with me.

Contents

Introduction

About the D300 Upgrades from the D200 xvii xviii

xvii

Quick Tour 1

Selecting a Shooting Mode	
Choosing an ISO	3
Setting a Release Mode	
Setting a Metering Mode	6
Choosing a Focus Mode	7
AF Area Modes	9
Playback	10
Downloading	11

Part I: Using the Nikon D300 13

Chapter 1: Exploring the Nikon D300 15

Key Components of the D300	15
Top of the camera	16
Back of the camera	18
Front of the camera	21
Right front	21
Left front	22
Sides and bottom of camera	23
Right side	23
Left side	25
Bottom	25
Viewfinder Display	26
LCD Control Panel	28

Chapter 2: Nikon D300 Essentials 33

Exposure Modes	34
Programmed Auto	34
Aperture Priority	35
Shutter Priority	35
Manual	35
Metering Modes	36
Matrix	36
Center-weighted	37
Spot	38
Exposure Compensation	38
Histograms	39
Bracketing	4
Autofocus Modes	45
Continuous	4
Single	45
Manual	45
AF Area Modes	46
Single area AF	46
Dynamic area AF	40
9 points	46
21 points	46
51 points	46
51 points (3D tracking)	47
Automatic area AF	47
ISO Sensitivity	47
Auto ISO	48
Noise reduction	49
Long exposure NR	49
High ISO NR	5(
White Balance	50
What is Kelvin?	50
White balance settings	5
Picture Controls	54
Original Picture Controls	54
Custom Picture Controls	55
Image Size and Compression	59
LiveView	60

Chapter 3: Setting up the Nikon D300 63

Playback Menu	63
Delete	64
Playback folder	64
Hide image	65
Display mode	65
Image review	65
After delete	65
Rotate tall	66
Slide show	66
Print set (DPOF)	66
Shooting Menu	67
Shooting menu bank	68
Reset shooting menu	68
Active folder	68

File naming	68
Image quality	68
Image size	69
JPEG compression	69
(NEF) RAW recording	70
White balance	70
Set Picture Control	70
Manage Picture Control	71
Color space	72
Active D-Lighting	72
Long exp. NR	72
High ISO NR	73
ISO sensitivity settings	73
Live view	73
Multiple exposure	73
Interval timer shooting	74
ustom Settings Menu	74
Custom setting bank	75
Reset custom settings	75
CSM a - Autofocus a1 – AF-C priority	75
a1 – AF-C priority	
selection	75
a2 – AF-S priority selection	
selection	76
a3 – Dynamic AF area	76
a4 – Focus tracking	70
with lock-on	76
a5 – AF activation	76
a6 – AF point illumination	76
a7 – Focus point wrap- around	76
a8 – AF point selection	76
a9 – Built-in AF-assist	10
illuminator	77
a10 – AF-ON for MB-D10	77
CSM b – Metering/exposure	77
b1 – ISO sensitivity	
step value	78
b2 – EV steps for	
exposure cntrl	78

b3 – Exp comp/	
fine tune	78
b4 – Easy exposure compensation	
compensation	78
b5 – Center-weighted	
area	78
b6 – Fine tune optimal	
exposure	78
CSM c – Timers / AE lock c1 – Shutter-release	79
c1 – Shutter-release	70
button AE-L	79
c2 – Auto meter-off delay	79
c3 – Self-timer delay	79
c4 – Monitor off delay	79
CSM d – Shooting / display	79
d1 – Beep	80
d2 – Viewfinder grid display	
grid display	80
d3 – Viewfinder warning	00
display	80
d4 – CL mode shooting speed	80
d5 – Max. continuous	00
release	80
d6 – File number	
sequence	80
sequence d7 – Shooting info	
display	80
d8 – LCD illumination	80
d9 – Exposure delay	
mode	80
d10 – MB-D10 battery	
type	80
d11 – Battery order	81
CSM e – Bracketing / flash	81
e1 – Flash sync speed	81
e2 – Flash shutter speed	81
e3 – Flash cntrl for built-in flash	81
e4 – Modeling flash	82
e5 – Auto bracketing set	82

e6 – Auto bracketing	82
(Mode M) e7 - Bracketing order	82
CSM f – Controls	82
f1 – Multi selector center	04
button	82
f2 – Multi selector	83
f3 – Photo info / playback	83
f4 – Assign FUNC. button	83
f5 – Assign preview button	85
f6 – Assign AE-L / AF-L	
button	85
f7 – Customize	
command dials	85
f8 – Release button to	
use dial	85
f9 – No memory card?	85
f10 – Reverse indicators	8
etup Menu	86
Format memory card	86
LCD brightness	86
Clean image sensor	8
Lock mirror up for cleaning	8
Video mode	8
HDMI	8
World time	8
Language	8
Image comment	8
Auto image rotation	8
USB	8
Dust off ref photo	8
Battery info	8
Wireless transmitter	8
Image authentication	8
Save / load settings	8
GPS	8
Non-CPU lens data	8
AF fine tune	8
Firmware version	9
Retouch Menu	9
/ly Menu	9

Part II: Creating Great Images with the Nikon D300 93

Chapter 4: Selecting and Using Lenses 95

Deciphering Nikon's Lens Codes	96
Zoom versus Prime Lenses	97
Zoom lens advantages	98
Prime lens advantages	99
Crop Factor	100
Wide-Angle Lenses	101
Normal Lenses	103
Telephoto Lenses	104
Macro Lenses	106
Using VR Lenses	107
Extending the Range of Any Lens	108
Teleconverters	108
Extension tubes	109
Filters	109

Chapter 5: Essential Photography Concepts 111

Exposure Review	111
Shutter speed	112
ISO	113
Aperture	114
Understanding Depth of Field	114
Rules of Composition	116
Keep it simple	117
The Rule of Thirds	118
Leading lines and S-curves	121
Helpful hints	122
Lighting Essentials	123
Quality of light	123
Hard light	123
Soft light	124
Metering light	125

Chapter 6: Working with Light 127

Natural Light	127
D300 Flash Basics	129
Achieving proper exposures	129
Guide Number	129

Aperture	130
Distance	130
GN / Distance = Aperture	130
Flash exposure modes	130
i-TTL	130
Manual	131
Auto	131
Auto Aperture	131
Guide Number distance	
priority	131
Repeating flash	131
Flash sync modes	132
Sync speed	132
Front-curtain sync	132
Red-eye reduction	133
Slow sync	133
Rear-curtain sync	134
Flash Exposure	
Compensation	135
Fill flash	136
Bounce flash	137
kon Creative Lighting System Basics	
System Basics	139
Understanding the CLS	139
Speedlights	140
SB-800 Speedlight	140
SB-600 Speedlight	141
SB-400 Speedlight	141
SU-800 Speedlight	
commander	141
R1 / R1C1 Macro flash	142
ing the Built-In Speedlight	143
udio Strobes	144
ntinuous Lighting	147
Incandescent and halogen	148
Fluorescent	149
HMI	149
ht Modifiers	150
Umbrellas	150
Softboxes	151
Diffusion panels	152
Other light modifiers	153

Chapter 7: Real-World Applications 155

Abstract Photography	155
Inspiration	156
Abstract photography practice	157
Abstract Photography tips	158
Action and Sports Photography	158
Inspiration	160
Action and sports photograph	у
practice	161
Action and sports photograph	
tips	162
Architectural Photography	162
Inspiration	164
Architectural photography	
practice	164
Architectural photography	
tips	166
Art Photography	166
Lensbabies	166
TtV	167
Other techniques	168

Art photography practice	171
Art photography tips	172
Child Photography	172
Inspiration	173
Child photography practice	174
Child photography tips	175
Concert Photography	176
Inspiration	177
Concert photography practice	178
Concert photography tips	180
Flower and Plant Photography	180
Inspiration	183
Flower and plant	
photography practice	184
Flower and plant	
photography tips	185
Landscape Photography	186
Inspiration	187
Landscape photography	
practice	188
Landscape photography tips	190
Light Trail and Fireworks	
Photography	190
Inspiration	191
Light trail and fireworks	
photography practice	192
Light trail and fireworks	107
photography tips	193
Macro Photography	194
Inspiration	196
Macro photography practice	197
Macro photography tips	198
Night Photography	199
Inspiration	200
Night photography practice	201
Night photography tips	202
Pet Photography	203
Inspiration	204
Pet photography practice	204
Pet photography tips	205

Portrait Photography	206
Studio considerations	206
Portrait lighting patterns	207
Indoor	209
Outdoor	211
Portrait photography	
practice	212
Portrait photography tips	213
Still-life and Product	
Photography	214
Inspiration	215
Still-life and product	
photography practice	216
Still-life and product	
photography tips	217
Travel Photography	218
Inspiration	218
Travel photography practice	219
Travel photography tips	221
Wildlife Photography	221
Inspiration	222
Wildlife photography	
practice	223
Wildlife photography tips	225

Chapter 8: Viewing and In-Camera Editing 227

Viewing Your Images	227
The Retouch Menu	228
Retouch Menu Options	229
D-Lighting	229
Red-eye correction	230
Trim	230

Monochrome	231
Filter effects	231
Color balance	232
Image overlay	233
Side-by-side comparison	234

Part III: Appendixes 235

Appendix A: Accessories 237

MB-D10 Battery Grip	237
WT-4a Wireless Transmitter	239
Tripods	239
When to use a tripod	240
Which tripod is right for you?	240
Camera Bags and Cases	241

Appendix B: D300 Specifications 243

Appendix C: Online Resources 249

Informational Web Sites	249
Nikonusa.com	249
Nikonions.org	249
Photo.net	249
Photo Sharing and	
Critiquing Sites	250
Flickr.com	250
Photoworkshop.com	250
ShotAddict.com	250

Online Photography Magazines	250
Communication Arts	250
Digital Photographer	250
Digital Photo Pro	250
Outdoor Photographer	250
Photo District News	250
Popular Photography	
& Imaging	250
Shutterbug	250

Glossary 251

Index 257

Introduction

his book is intended to get you familiarized with all of the features and functions of the Nikon D300 dSLR camera. Although it covers a lot of the same material as the User's Manual, this book presents it in a format that is easier to comprehend and is much more interesting to read. In addition to covering the technical details I include some practical real world advice, tips and tricks, and explanations of how to set up your equipment to achieve interesting and compelling images.

The intention of this book is to offer something for a wide range of readers, from amateur photographers who are buying the D300 as their first dSLR to advanced photographers who have upgraded from another camera and are looking to expand the scope of their photography.

About the D300

The D300 is the long-awaited predecessor of the immensely popular D200. When the D200 was released it was a sorely needed replacement of the outdated D100. With the release of the D300 Nikon hasn't simply upgraded the D200 but they have nearly created an entirely different camera. The D300 has more in common with the newly released professional level D3 camera than it does with the D200. The D300 has a huge 3-inch LCD screen with a live preview option. The camera also has the same upgraded imaging processor as the D3, Nikon's EXPEED. Another thing the D300 has in common with the D3 is a whopping 51 Auto Focus area points.

As with the other current models of Nikon's dSLR cameras, the D300 is compatible with almost all of the Nikon lenses ever made. Nikon lenses are world renowned for their quality and durability. There are literally hundreds of different lenses that can be used on the D300. You can also be sure that any new lens that Nikon releases will be able to be used on the D300. This is a big advantage over some dSLRs that only work with specific lenses, such as the Nikon D40, which only allows AF with Nikon's newer AF-S lenses.

With the D300, you can also take advantage of Nikon's current line-up of Speedlights, the SB-400, SB-600, and the SB-800 as well as the R1C1 macro lighting kit. With the D300 you can also take advantage of the Nikon Creative Lighting System that allows you to control a number of flashes off-camera for the ultimate control of your light. The D300 can also be used with some of the older Nikon Speedlights with limited function.

xviii Introduction

As with the D200, the D300 is a powerful workhorse built to last. With a rugged magnesium body, it's built to take the normal abuse that a working photographer can dish out. It also has rubber gaskets to help keep dust and dirt out of the cameras internal systems.

Upgrades from the D200

The Nikon D300 has been significantly upgraded from the D200; some of these upgrades include a 12-megapixel CMOS sensor and the ability to record your images in the TIFF file format. One major change that is very exciting is the inclusion of a self-cleaning sensor unit that vibrates at a high frequency to remove any dust or particles that may get on the sensor.

Also revamped is the autofocus, with the addition of forty more AF points, which brings the count up to an impressive fifty-one points with 15 cross-type sensors. The single area AF has been kept, but the Dynamic Focus mode has been reworked. The Group Dynamic and Closest Subject Priority modes are gone but Nikon has included what they term as Automatic area AF.

Nikon has also changed the ISO sensitivity parameters from ISO 100 to 1600 on the D200 to ISO 200 to 3200 on the D300; you also have an ISO boost choice that allows you to effectively shoot down to ISO 100 or up to ISO 6400.

The D300 frame rate has also been increased to 6 frames per second (fps) or, with the optional MB-D10 battery pack and optional batteries, a blazing 8 fps which is unheard of for a camera in this price range. This makes it perfect for catching sports action or capturing high-speed sequence shots.

Nikon has also added Active D-Lighting to the D300. D-Lighting (an earlier non-active version), has been available in the D40, D80, and COOLPIX cameras, and is used to expand the tonal range of the image by lightening the shadows and toning down the highlights in high contrast images.

The Nikon D300 has finally been outfitted with a viewfinder that gives you a 100% view of the scene. This was previously an option only available on the pro-level dSLRs. Finally, what you see in the viewfinder is what you get in your image. The LCD monitor has also been upgraded, not only in size, but also in resolution. The D300's LCD screen is 3 inches with 922,000 pixels. This screen is a half-inch larger than the D200 with almost 700,000 more pixels, offering a much higher resolution view of your images.

Lastly, probably the most amazing breakthrough is the LCD LiveView. This feature is offered on other similar dSLR cameras, but none of the other cameras allow the camera to focus while in live preview. Nikon has installed special focus detectors to allow the camera to focus and shoot while the camera is in LiveView mode. This is currently exclusive to the Nikon D300 and D3 cameras. As a working professional, with all the upgrades and changes, the D300 has replaced my D200 as my everyday working camera and my D70 has been sold. Although Nikon will no doubt continue to make many upgrades in the future, the D300 is an amazing camera that should serve you well for many years to come.

Quick Tour

he Quick Tour is designed to cover the basic functions you need to know to get you started using your D300 right away. It is by no means meant to be an in-depth look at the menus and modes, so if you're ready for that information, you can just give this section a quick once-over and move on to the later chapters, where everything is discussed in more detail.

If you already use a Nikon dSLR, a lot of this may be familiar to you. In fact, if you use a D200, the setup for the D300 is very similar. If you are upgrading from a compact digital camera or from a smaller, consumer-level dSLR, you probably should read the entire Quick Tour to familiarize yourself with the camera layout.

This Quick Tour assumes that you have already unpacked the camera, read the manual, charged the batteries, mounted a lens, and inserted the CompactFlash (CF) card. If you haven't done these things, do them now.

I'm sure you're ready to get out there and shoot some photos with your new D300, so get going.

Selecting a Shooting Mode

After you turn on your camera, you need to decide which shooting mode you are going to use. The mode you choose depends on the various factors associated with the shooting conditions. For example, are you going to be photographing a moving subject or a still life?

Changing the shooting mode is simple: press the Mode button to the left of the Shutter Release button, and use your thumb to rotate the Main Command dial located on the toprear right of the camera body. The top-left corner of the LCD shows which mode -P, S, A, or M – the camera is in.

In This Quick Tour

Selecting a shooting mode

Choosing an ISO

Setting a release mode

Setting a metering mode

Choosing a focus mode

AF area modes

Playback

Downloading

2 + Quick Tour

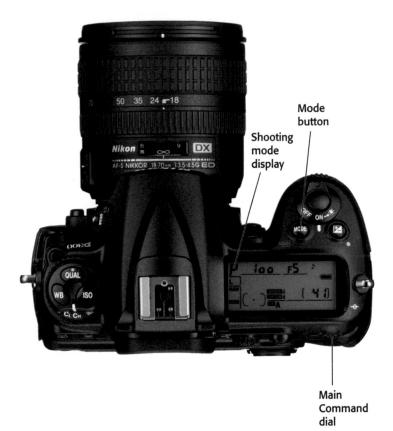

Image courtesy Nikon QT.1 Use these controls to change shooting modes.

The D300 has four shooting modes.

 P. Also known as Programmed Auto. This is a fully automatic shooting mode in which the camera decides both the aperture setting and shutter speed. You can use the Main Command dial to adjust the aperture and shutter to better suit your needs. This is known as flexible program, and it allows you to control the settings while maintaining the same exposure. Use this mode when taking snapshots or when controlling the shutter speed and the amount of the image that is in focus are not as important as simply getting the photo.

- S. Also known as Shutter Priority. This is a semiautomatic mode in which you decide the shutter speed to use and the camera chooses the appropriate aperture. Use this mode when you need fast shutter speeds to freeze action or slow shutter speeds to show motion blur. Be sure not to use this mode when you need to control the amount of the image that is in focus.
- A. Also known as Aperture Priority. This is another semiautomatic mode where you adjust the aperture to control how much of the image is in focus (the depth of field). Use this mode when you want to isolate a subject by focusing on it and letting the background go soft, or if you want to be sure that everything in the picture is in sharp focus.
- M. Also known as Manual mode. With this mode, you decide the shutter speed and aperture. You can use this mode when you want to completely control the exposure in order to achieve a certain tonality in your image by purposefully over- or underexposing the image. This is also the preferred mode when using external strobes and off-camera flash (non-CLS). To help you when using this mode, you can check the D300 light meter in the viewfinder.

Cross-Reference

For more information on aperture and its effect on depth of field, see Chapter 5. For more information on using off-camera flash and studio strobes, see Chapter 6.

Choosing an ISO

ISO rating determines how sensitive the camera sensor is to light. Lower ISO numbers, such as 200, mean the sensor is less sensitive to light while higher numbers, like 800, denote a higher sensitivity. Setting the ISO to a higher sensitivity also introduces digital *noise*. Noise is made up of randomly colored and scattered pixels that show up throughout the image but are more noticeable in the darker areas. The heat generated by the sensor as it is activated to collect photons of light, which produces your image, causes these artifacts.

Generally speaking, you want to set the ISO as low as necessary to capture the image in any given lighting situation and still maintain the exposure you need. The base ISO on the D300 is 200. This will suffice in most outdoor and well-lit situations. In darker lighting situations, such as indoors, you may need to boost the ISO as high as 3200, which is the highest base ISO setting.

Cross-Reference

For more information on ISO, see Chapter 5.

To adjust the ISO, press the ISO button on the top-left side of the camera body and turn the Main Command dial until the desired ISO is set. You can view the ISO setting on the top LCD while the ISO button is pressed, or inside the viewfinder display at all times.

4 + Quick Tour

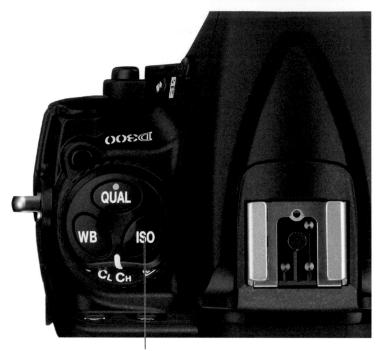

ISO button

Image courtesy Nikon QT.2 ISO button

Setting a Release Mode

The Release mode controls how the D300 shutter functions when the Shutter Release button is pressed. You can fire off a burst or you can fire a single shot. You can also choose to use the D300 LiveView function that allows you to view your image before you take it on the LCD screen.

There are six options you can choose when setting the Release mode.

 S. This is the Single shot mode. It allows the shutter to fire only once when the Shutter Release button is pressed. You can fire the shutter as many times as you want as long as you release and press the button again. Use this mode to capture a single frame. This mode is suitable for most subjects from portraits to still-life compositions.

- Cl. This is the Continuous Low mode. It allows you to shoot continuously at low speed as long as the Shutter Release button is pressed. This can be set from 1 frame per second (fps) up to 7 fps. Use this mode to capture moderate to high-speed sequence shots.
- Ch. This is the Continuous High mode. It allows you to shoot continuously at high speed as long as the Shutter Release button is pressed. You can shoot up to 8 fps. Use this mode to capture highspeed action sequence shots.

- Lv. This is the LiveView mode. It allows you to view the shot on the LCD with a live preview similar to the way a compact point-andshoot camera works. Press the Shutter Release button to activate LiveView, then press and hold the button to take the shot. Use this mode when it may be awkward to look through the viewfinder, such as when the camera must be held very high or very low to capture the shot.
- Self-timer. This allows the camera to fire a number of seconds after the Shutter Release button is pressed. The delay can bet set to 2, 5, 10, or 20 seconds. Use this

mode to take self-portraits or to minimize camera shake caused by pressing the Shutter Release button on longer exposures or at slower shutter speeds. A tripod is recommended for this mode.

Mup. This is the Mirror up mode. In this mode, the reflex mirror in the camera is raised when you press the Shutter Release button and then lowered when the button is pressed again. Use this mode when doing extreme close-ups and macro photography when the camera shake caused by the mirror moving can cause the image to blur. A tripod is recommended for this mode.

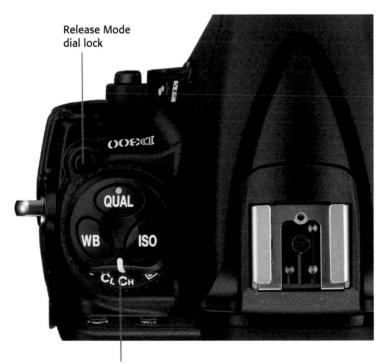

Release Mode dial Image courtesy Nikon QT.3 Release Mode dial and lock

6 + Quick Tour

Note

The D300 can only shoot up to 6 fps without the optional MB-D10 battery grip. With the MB-D10 and batteries other than the EN-EL3e the D300 can shoot up to 8 fps. The actual frame rate varies depending on the shutter speed and file size.

The Release mode can be changed by pressing the Release Mode dial lock with your left forefinger then using your thumb to rotate the Release Mode dial to the mode that you want to use.

Setting a Metering Mode

Metering modes let your camera decide how to set the exposure. There are three options:

3D Color Matrix II. This metering mode, called Matrix metering for short, takes an overall reading of the whole scene and sets the exposure to try to get everything in the scene properly exposed. The camera's processor uses color, subject distance, brightness, and composition to determine the exposure. This is the best option to use in most situations and generally works well.

- Center-weighted. In this mode, the camera takes a reading of the whole scene, but bases most of the exposure decision on the area in the center of the frame. The camera default is an 8mm area, but the size of the area can be changed in the Custom Settings menu. This is a good mode to use when shooting portraits in which the subject is in the middle of the composition and the background may be a little darker or lighter than the subject.
- Spot. With this metering mode, the camera meters just a small portion of the frame ignoring the rest of the scene. The spot meter can be linked to the focus point allowing you to meter off-center subjects without the need to recompose the shot. When using a manual focus lens or when in Auto-area AF. the spot meter defaults to the center. This mode is good to use when photographing in high-contrast lighting conditions. Use this mode when it is imperative that the subject has proper exposure, but keep in mind that other areas of the scene may be over- or underexposed, depending on the lighting conditions.

The metering mode can be changed by rotating the Metering Mode dial that is found just to the right of the viewfinder to one of the three modes.

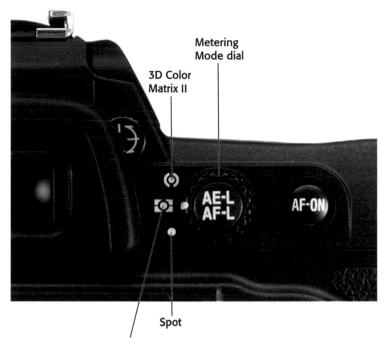

Center-weighted

Image courtesy Nikon QT.4 Metering Mode dial

Choosing a Focus Mode

The focus mode tells your camera how to focus on the subject, whether to lock focus when it's achieved or to continuously focus for moving subjects, or even if you want to manually focus the camera yourself. There are three focus modes: M. This is the Manual focus mode. When this mode is engaged you manually focus the camera by rotating the focus ring on the barrel of the lens. This option can be handy when shooting still-life compositions and you want to be absolutely sure that your subject is in focus.

8 + Quick Tour

- S. When the camera is set to Single mode, once the camera achieves focus, it locks the focus in as long as the Shutter Release button is half-pressed or if the AF-ON (Autofocus on) button is pressed. This is a good mode to use when your subject is not moving around much. This works well when shooting portraits. At the default setting, if the subject is not in focus, the camera will not fire.
- C. This is Continuous focus. With this mode, the camera constantly focuses while the Shutter Release button is half-pressed or the AF-ON button is pressed. Use this mode when shooting sports or anything where the subject is moving around a lot. When the Shutter Release button is pressed, the camera will fire whether or not it is in focus, so be aware of that.

To change the focus mode, use the Focus Mode selector on the front of the camera body to the left of the lens attachment.

Focus Mode selector

Image courtesy Nikon QT.5 Focus Mode selector

AF Area Modes

Autofocus area modes, or AF area modes are used to decide how the focus area point is determined. There are three modes:

- Single point AF. In this mode, the focus point is selected manually by you. To change the focus point, use the multi-selector on the back of the camera. The focus point can be set on any one of 51 AF points. This is a big improvement over the D200's 11-area AF system and a vast improvement over the D100's 5-area AF system.
- Dynamic area AF. While this mode is activated and the camera is in Continuous Focus mode, you set the focus point, and if your subject moves away from the focus

point, the camera automatically tracks and focuses on the subject using another focus point. When the camera is in Single Focus mode the AF functions the same as if set to Single point AF.

Auto-area AF. When set to this mode, the camera automatically determines what the subject is and focuses on it, sometimes using multiple focus points. The camera is said to be able to distinguish between people and background shapes when using a D- or G-type lens. Be careful when using this setting, especially when shooting portraits, as the camera may not focus exactly where you want it.

The AF area mode can be changed on the back of the camera using the switch just below the multi-selector.

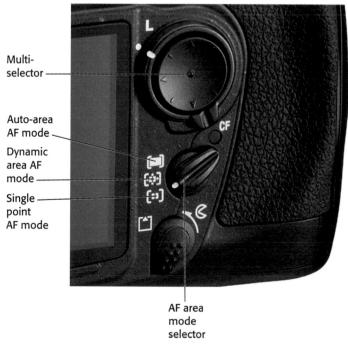

Image courtesy Nikon QT.6 AF area mode selector

10 + Quick Tour

Playback

After you shoot some images with your D300, you can look at them on the amazing new 3-inch, 920,000-dot LCD screen. To view your images, press the Play button on the top rear of the camera to the left of the viewfinder. The most recent photo taken is the first image displayed. You can use the multi-selector left/right to scroll through the images or up/down to check the settings and histograms.

To scroll through the images that are stored on the CF card, press the multi-selector button left or right. Pressing the button to the right allows you to view the images in the sequence that they were taken. Pressing the button to the left displays the images in reverse order.

They are a few other options available to you when the camera is in Playback mode:

- Press the Thumbnail/Zoom out button to view thumbnails. You can choose to view either four or nine images at a time. When in Thumbnail mode use the multiselector to navigate among the thumbnails to highlight one. You can then press the OK button to bring the selected image to a fullsize preview.
- Press the Zoom in button to magnify the image. This button allows you to check for sharpness or look for details. Pressing this button also takes you out of the thumbnail preview.
- Press the Protect button to save images from being deleted. The Protect button (denoted by a key)

locks the image to prevent you from accidentally erasing it when editing your images in the camera.

When the card is formatted, all images including the protected ones are erased.

Use the multi-selector to view image data. To check to see what settings were used when the photograph was taken press the multiselector up or down. This also allows you to check the histogram, which is a visual representation of the tonality of the image.

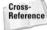

For more detailed information on histograms, see Chapter 2.

 Press the OK button to do incamera photo editing. Pressing the OK button brings you to a menu that allows you to do some rudimentary in-camera editing such as D-Lighting, fixing red-eye, and cropping.

Cross-Reference

For more detailed information on in-camera editing, see Chapter 8.

Press the Delete button to erase images. The Delete button has an icon shaped like a trashcan on it. Press this button to permanently erase the image from your CF card. When the Delete button is pressed, the camera asks for confirmation. Press the Delete button again to complete the deletion.

Cross-Reference

For more detailed information on settings, see Chapter 2 for modes and Chapter 3 for menu settings.

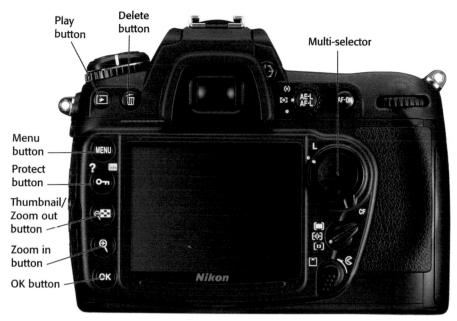

Image courtesy Nikon

QT.7 These buttons can be used in the Playback mode for a variety of functions.

Downloading

When you fill up a card or you're ready to do some post-processing of your images, you want to download them off of your CF card and onto your computer for storage. You can either download the images straight from the camera to your computer or you can remove the CF card from the camera and use a card reader to transfer the images.

To download from the camera using the USB cable, follow these steps:

 Turn off the camera. Be sure that the camera is off when connecting it to the computer to ensure that the camera's or computer's electronics are not damaged.

- Open the rubber cover that conceals the D300's output connections. On the left side of the camera with the back facing you is a cover that has the camera's USB, HDMI, and video out ports (there is also a power in port).
- 3. Connect the camera to the USB cable. Inside the box that your D300 came in there is a USB cable. Plug the small end of the cable into the camera and plug the other end into a USB slot on your computer.

12 + Quick Tour

4. Turn the camera on. Once turned on, your computer should recognize the camera as a mass storage device. You can then drag and drop your files or you can use a software program, such as Adobe Bridge or Nikon View, to transfer your files.

USB port

QT.8 The camera's USB port

To download using a CF card reader, follow these steps:

- Turn off the camera. Be sure that the camera is off when connecting it to the computer to ensure that the camera's or computer's electronics are not damaged.
- Remove the CF card. Using the CF card door lever, open the CF card door cover and press the eject button to remove the card.
- 3. Insert the CF card into the card reader. Be sure that the reader is connected to your computer. Your computer should recognize the card as a mass storage device, and you can drag and drop the files or you can use a software program, such as Adobe Bridge or Nikon View, to transfer your files.

Note

Depending on your software and how your computer is set up, your computer may offer to automatically transfer the files to a predetermined destination.

Using the Nikon D300

P

A R

П

Chapter 1 Exploring the Nikon D300

Chapter 2 Nikon D300 Essentials

Chapter 3 Setting Up the Nikon D300

Exploring the Nikon D300

his chapter covers the key components of the Nikon D300. These are the features that are most readily accessible because they are situated on the outside of the camera: the buttons, knobs, switches, and dials.

If you are upgrading from another dSLR, some of this will likely be a review, but there are some new features that you may or may not be aware of, so a quick read through is a good idea even if you are an experienced Nikon dSLR user.

Some of you who may be new to the world of dSLR cameras, are upgrading from a more basic model, or if you're just beginning in the world of dSLRs, this chapter is a great way to get acquainted with some of the terms that are used in conjunction with your new camera.

So fasten your seatbelts, and get ready to explore the D300!

Key Components of the D300

If you've read the Quick Tour, you should be pretty familiar with the basic buttons and switches that you need to do the basic settings. In this section, you look at the camera from all sides and break down the layout so that you know what everything on the surface of the camera does.

This section doesn't cover the menus, only the exterior controls. Although there are many features you can access with just the push of a button, oftentimes you can change the same setting inside of a menu option. The great thing about the buttons, however, is that they give you speedy access to important settings – settings you will use often. Missing shots because you are searching through the menu options can get

FR

LCD control panel

16 Part I + Using the Nikon D300

irritating fast, which is one of the key reasons that most people upgrade from a consumer model camera to a professionalgrade camera like the D300.

Top of the camera

The top of the D300 is where you find the most important buttons. This is where you'll find the buttons for the settings that tend to get changed most frequently. Also included in this section is a brief description of some of the things you will find on the top of the lens. Although your lens may vary, most of the features are quite similar from lens to lens.

- Shutter Release button. In my opinion, this is the most important button on the camera. Halfway pressing this button activates the camera's auto focusing and light meter. When you fully depress this button the shutter is released and a photograph is taken. When the camera has been idle and has "gone to sleep," lightly pressing the Shutter Release button wakes up the camera. When the image review is on, lightly pressing the Shutter Release button turns off the LCD and prepares the camera for another shot.
- On/Off switch / LCD illuminator. This switch is used to turn on the camera. Turn the switch all the way to the left to turn off the camera. When in the center position, the camera is turned on. Pull the switch all the way to the right to turn on the top-panel LCD illuminator. This enables you to view your settings when in a dimly lit environment. The LCD illuminator automatically turns off after a few seconds or when the shutter is released.

- Mode button. This button, when used in conjunction with the Main Command dial allows you to change among the different metering modes. You can choose Programmed Auto, Shutter Priority, Aperture Priority, or Manual modes (P, S, A, or M). This button also doubles as a format button when pressed in conjunction with the Delete button. Pressing and holding these two buttons down simultaneously allows you to format your CompactFlash (CF) card without entering the Setup menu.
- **Exposure Compensation button.** Pressing this button in conjunction with spinning the Main Command dial allows you to modify the exposure that is set by the D300's light meter or the exposure you set in Manual exposure mode. Turning the Main Command dial to the right decreases exposure, while turning the dial to the left increases the exposure. This button also doubles as the camera reset button when used in conjunction with the Quality button. Pressing these buttons at the same time restores the camera to the factory default settings.
- Focal plane mark. The focal plane mark shows you where the plane of the CMOS image sensor is inside the camera. The sensor isn't exactly where the mark is; the sensor is directly behind the lens opening. When doing certain types of photography, particularly macro photography using a bellows lens, you need to measure the length of the bellows from the front element of the lens to the focal plane. This is where the focal plane mark comes in handy.

- Hot shoe. This is where an accessory flash is attached to the camera body. The hot shoe has an electronic contact that tells the flash to fire when the shutter is released. There are also a number of other electronic contacts that allow the camera to communicate with the flash to enable the automated features of a dedicated flash unit such as the SB-600.
- Release mode dial. Rotating this dial changes the release mode of the camera. You can choose from Single frame, Continuous Low speed, Continuous High speed,

LiveView, Self-timer, and Mirror up. In order to rotate the dial you must press the Release mode dial lock release button.

- Release mode dial lock release button. This button is used to lock the Release mode dial to prevent it from accidentally being changed.
- Quality button. Press this button and rotate the Main Command dial to change the image size and quality. You can choose from RAW, TIFF, JPEG, or RAW + JPEG. You can also choose the quality at which your JPEGs are saved: Fine, Normal, or Basic.

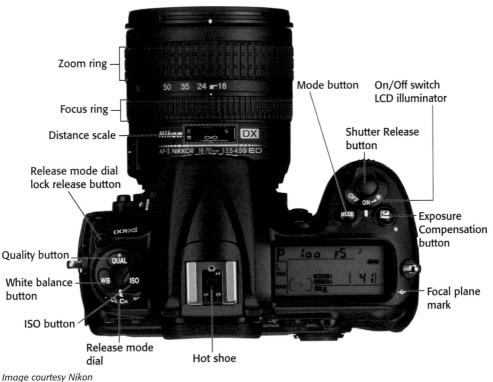

1.1 Top of the camera controls

Cross-Reference

For more information on image quality and size settings see Chapter 2.

- ISO button. Press this button and rotate the Main Command dial to change the ISO sensitivity. The higher the ISO setting, the less light is needed to make an exposure. The ISO value is displayed on the LCD control panel while the ISO button is pressed. The ISO value is also displayed in the viewfinder.
- White balance button. Press this button and rotate the Main Command dial to change the white balance (WB) setting. White balance is used to compensate for the effect that different colored light sources have on your photos. Adjusting the WB gives your images a natural look.
- Focus ring. Rotating the focus ring enables you to manually focus the camera. With some lenses, such as the Nikkor AF-S lenses, you can manually adjust the focus at any time. On other lenses, typically older and non-Nikon lenses you must switch the lens to Manual focus to disable the focusing mechanism.
- Zoom ring. Rotating the zoom ring allows you to change the focal length of the lens. Prime lenses do not have a zoom ring.

Cross-Reference See Chapter 4.

 Distance scale. This displays the approximate distance from the camera to the subject.

Back of the camera

The back of the camera is where you find the buttons that mainly control playback and menu options, although there are a few buttons that control some of the shooting functions. Most of the buttons have more than one function — a lot of them are used in conjunction with the Main Command dial or the multi-selector. On the back of the camera you also find several key features, including the all-important viewfinder and LCD.

- LCD. This is the most obvious feature on the back of the camera. This 3-inch, 920,000-dot liquid crystal display (LCD) screen is, so far, the highest resolution LCD on any camera on the market today (the D3 shares this feature). The LCD is where you review your images after shooting, or compose using LiveView. The menus are also displayed here.
- Viewfinder. This is what you look through to compose your photographs. Light coming through the lens is reflected through a series of mirrors enabling you to see exactly what you're shooting (as opposed to a rangefinder camera, which gives you an approximate view). Around the viewfinder is a rubber eyepiece that serves to give you a softer place to rest your eye and to block any extra light from entering the viewfinder as you compose and shoot your images.
- Diopter adjustment control. Just to the right of the viewfinder is the Diopter adjustment control. Use this control to adjust the viewfinder lens to suit your individual vision differences (not everyone's eyesight is the same). To

adjust this, look through the viewfinder, and press the Shutter Release button halfway to focus on something. If what you see in the viewfinder isn't quite sharp, turn the Diopter control until everything appears in focus. The manual warns you not to put your finger or fingernail in your eye. I agree that this might not be a good idea.

- Metering mode dial. This dial is used to choose the metering mode. Turn the dial to the desired mode. You can choose Matrix, Center-weighted, or Spot metering.
- AE-L / AF-L The Auto-Exposure/Auto-Focus lock button is used to lock the Auto-Exposure (AE) and Auto-Focus (AF). You can also customize the button to lock only the AE or only the AF.
- AF-ON. The Auto-Focus On button activates the AF mechanism without you having to press the Shutter Release button. When in Single focus mode the AF-ON button also locks in the focus until the button is released.
- Main Command dial. This dial is used to change a variety of settings depending on which button you are using in conjunction with it. By default, it is used to change the shutter speed when in Shutter priority and Manual mode. It can also be used with the ISO, QUAL, and WB buttons.
- Multi-selector. The multi-selector is another button that serves a few different purposes. In Playback mode the multi-selector is used to scroll through the photographs you've taken, and it can also be used to view image information such as histograms and shooting

settings. When in Shooting mode the multi-selector can be used to change the active focus point when in Single point or Dynamic area AF mode.

- Focus selector lock. This switch can be used to lock the multiselector so the focus point won't accidentally be changed. Slide the switch to the L position to lock the focus point.
- AF area mode selector. This three-position switch is used to choose among focus modes. You can choose Single area AF, Dynamic area AF, or Auto-area AF.
- Card slot cover latch. Press this latch to open the door to access the CF card when the CF card busy light is off.
- Playback button. Pressing this button displays the most recently taken photograph. You can also view other pictures by pressing the multi-selector left and right.
- Delete button. When reviewing your pictures, if you find some that you don't want to keep you can delete them by pressing this button marked with a trashcan icon. To prevent accidental deletion of images the camera displays a dialog box asking you to confirm that you want to erase the picture. Press the Delete button a second time to permanently erase the image.
- Menu button. Press this button to access the D300 menu options. There are a number of different menus including Playback, Shooting, Custom Settings, and Retouch. Use the multi-selector to choose the menu you want to view.

Protect / Info / Help button. The Protect button has the icon of a key on it. This button actually has a few different uses. The primary use of the Protect button is to lock the image to prevent it from being deleted. This function can be accessed only when the camera is in Playback mode. When viewing the image you want to protect, simply press this button. A small key icon will be displayed in the upper right-hand corner of images that are protected. When the camera is in Shooting mode, pressing

this button causes the current shooting info such as aperture, shutter speed, and other settings to be displayed on the LCD screen. Pressing the Shutter Release button lightly returns you to the default shooting mode. When viewing the menu options, pressing this button displays a help screen that explains the functions of that particular menu option.

 Thumbnail / Zoom out button. In Playback mode, pressing this button allows you to go from fullframe playback (or viewing the

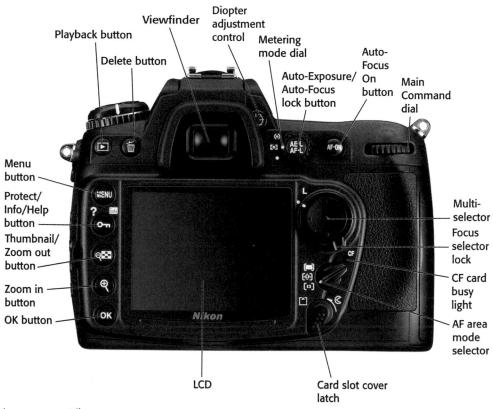

Image courtesy Nikon 1.2 Back of the camera controls

whole image) to viewing thumbnails. The thumbnails can be displayed either four images or nine images on a page.

- Zoom in button. When reviewing your images you can press the Zoom in button to get a closer look at the details of your image. This is a handy feature for checking the sharpness and focus of your shot. When zoomed in, use the multiselector to navigate around within the image. To view your other images at the same zoom ratio you can rotate the main command dial. To return to full-frame playback, press the Zoom out button. You may have to press the Zoom out button multiple times depending on how much you have zoomed in.
- OK button. When in the Menu mode, press this button to select the menu item that is highlighted.

Front of the camera

The front of the D300 (lens facing you) is where you find the buttons to quickly adjust the flash settings as well as some camera focusing options, and with certain lenses you will find some buttons that control focusing and Vibration Reduction (VR).

Right front

Built-in Speedlight. This option is a handy feature that allows you to take sharp pictures in low-light situations. Although not as versatile as one of the external Nikon Speedlights such as the SB-800 or SB-600, the built-in flash can be used very effectively and is great for snapshots. The built-in flash can also be used as a commander unit to trigger Nikon CLS-compatible Speedlights wirelessly for offcamera use.

Cross-Reference For more on using flash, see Chapter 6.

- Flash pop-up button. Press this button to open and activate the built-in Speedlight.
- Flash mode button. Pressing this button and rotating the Main Command dial on the rear of the camera allows you to choose a flash mode. You can choose from among Front-Curtain Sync, Red-Eye Reduction, Red-Eye Reduction with slow sync, Slow Sync, and Rear-Curtain Sync. Pressing the Flash mode button and rotating the Subcommand dial, located just below the Shutter Release button, allows you to adjust the flash exposure compensation (FEC). FEC allows you to adjust the flash output to make the flash brighter or dimmer depending on your needs.
- Flash sync terminal cover. Underneath this rubber cover is the flash sync terminal. This terminal, also known as PC sync, allows you to connect a PC cord to trigger an external flash or studio strobe.
- 10-pin remote terminal cover. Underneath this rubber cover is the 10-pin remote terminal. This terminal allows the camera to be connected to a variety of accessories. Some of these include a remote shutter release cord and GPS devices. See the Nikon Web site for more information regarding specific accessories.

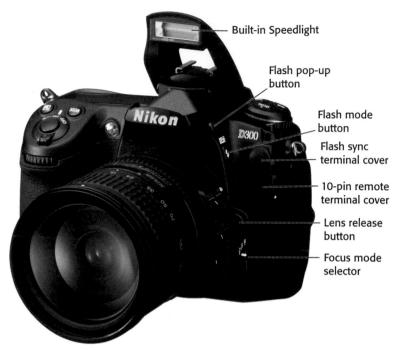

Image courtesy Nikon

1.3 Right-front camera controls

- Lens release button. This button disengages the locking mechanism of the lens, allowing the lens to be rotated and removed from the lens mount.
- Focus mode selector. This threeway switch is used to choose which focus mode the camera operates in: Single focus, Continuous focus, or Manual focus.

Left front

 AF-assist illuminator. This is an LED that shines on the subject to help the camera to focus when the lighting is dim. The AF-assist illuminator only lights when in Single focus mode and when the camera is in Auto-area AF mode, or when in Dynamic or Single area AF, and the focus point is set to the center position.

- Sub-command dial. This dial, by default, is used to change the aperture setting. It is also used to change various settings when used in conjunction with other buttons, such as the Quality button.
- Depth of field preview button. Pressing this button stops down the aperture of the lens so you can preview how much of the subject is in focus. The image in the viewfinder gets darker as the aperture decreases. The Depth of field preview button can also be customized in exactly the same way as the Function button.

Chapter 1 + Exploring the Nikon D300 23

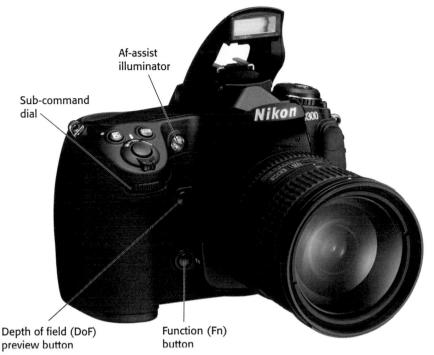

Image courtesy Nikon
1.4 Left-front camera controls

For more information on apertures, see Chapter 5.

Fn button. The Function button can be customized to perform different functions depending on user preference. It can be used to set exposure, flash, WB bracketing, flash value (FV) lock, or a number of other settings. The Fn button can be set in the Custom Settings menu (CSM) f4.

Cross-Reference

For more information on the Custom Settings menu, see Chapter 3.

Sides and bottom of camera

The sides and bottom of the camera have places for connecting and inserting things such as cables, batteries, and memory cards.

Right side

On the right side of the camera (lens facing you), are the D300's various output terminals. These are used to connect your camera to a computer or to an external source for viewing your images directly from the camera. All of these terminals are hidden under a rubber cover that helps keep out dust and moisture.

- Video out. This connection, officially called Standard video output, is used to connect the camera to a standard TV or VCR for viewing your images on-screen. The D300 is connected with the EG-D100 video cable that is supplied with the camera.
- HDMI out. The High-definition video output terminal is used to connect the camera to a high-definition TV (HDTV). The camera is connected with an optional Type A HDMI cable that can be purchased at an electronics store.
- DC in. This AC adapter input connection allows you to plug the D300 into a standard electrical outlet using the Nikon EH-5 or EH-5a AC adapter. This allows you to operate the camera without draining your batteries. The AC adapter is available separately from Nikon.
- USB port. This is where the USB cable plugs in to attach the camera to your computer to transfer images straight from the camera. The USB cable is also used to connect the camera to the computer when using Nikon's optional Camera Control Pro 2 software.

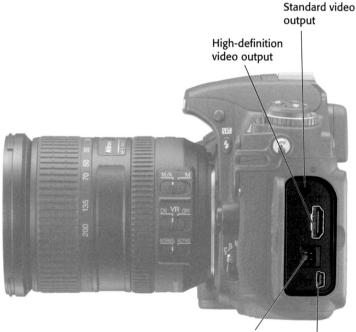

AC adapter USB port input

Image courtesy Nikon 1.5 The D300's output terminals

Left side

On the left side of the camera (lens facing you) is the memory card slot cover. When the card slot cover latch is released the cover opens so you can insert or remove your CF card.

Image courtesy Nikon
1.6 Memory card slot cover

Bottom

The bottom of the camera has a few features that are quite important.

- Battery chamber cover. This covers the chamber that holds the EN-EL3a battery that is supplied with your D300.
- Tripod socket. This is where you attach a tripod or monopod to help steady your camera.
- Contact cover. This rubber cover is used to protect the contact points for the optional MB-D10 battery grip that attaches to the bottom of the camera. The MB-D10 allows you to use a variety of battery types.

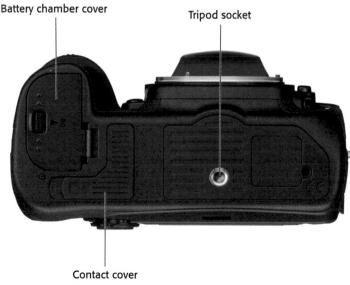

Image courtesy Nikon 1.7 Bottom of the D300

Viewfinder Display

When looking through the viewfinder you see a lot of useful information about the photo you are setting up. Most of the information is also displayed in the LCD control panel on the top of the camera, but it is less handy on top when you are composing a shot. Here is a complete list of all the information you get from the viewfinder display. Focus points. The first thing you are likely to notice when looking through the viewfinder is a small rectangle near the center of the frame. This is your active focus point. Note that the focus point is only shown full time when in the Single or Dynamic AF setting. When the camera is set to Auto-area AF, the focus point isn't shown until the Shutter Release button is

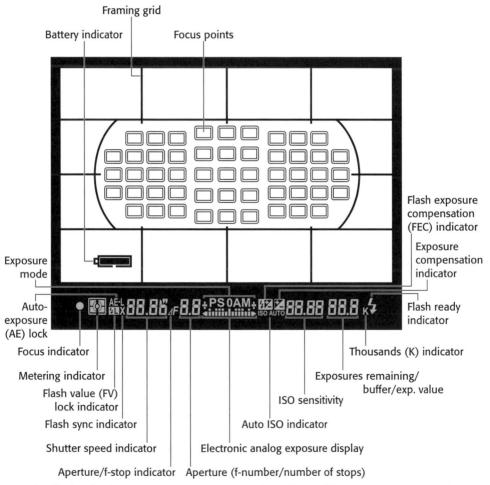

1.8 Viewfinder display. Note that this figure displays all possible focus points. Only the active focus points will be visible in actual shooting conditions.

half-pressed and focus is achieved. When in Auto-area AF and set to Continuous focus mode the focus point is not displayed at all.

- Framing grid. When this option is turned on in the CSM d2, you will see a grid displayed in the viewing area. This is to help with composition. Use the grid to help line up elements of your composition to ensure that things are straight (or not).
- Battery indicator. This is another optional display that can be turned on in the CSM d3. When this option is activated, a small battery icon appears in the bottom-left corner that displays the approximate amount of charge that is left in the battery.

Below the actual image portion of the viewfinder display is a black bar with LCD readouts on it. Not only do you find your shooting information here, depending on your chosen settings, other useful indicators appear here as well. From left to right these items are:

- Focus indicator. This is a green dot that lets you know if the camera detects that the scene is in focus. When focus is achieved, the green dot lights up; if the camera is not in focus, no dot is displayed.
- Metering indicator. This display shows which metering mode you are in: Spot, Center-weighted, or Matrix.
- AE lock. When this is lit you know that the Auto-exposure lock button has been pressed.
- FV lock indicator. When the FV lock indicator is on it means you have locked in the flash exposure

value. The flash value can only be locked when the Function button has been set to do this.

- Flash sync indicator. This indicator is displayed as a small X. This comes on when you set your camera to the sync speed that is set in CSM e1. This is only available when in Shutter Priority or Manual mode. To set the camera to the preset sync speed, dial the shutter speed down one setting past the longest shutter time, which is 30 seconds in S and bulb in M.
- Shutter speed indicator. This shows how long your shutter is set to stay open.
- Aperture / f-stop indicator. This shows what your current lens opening setting is.
- Exposure mode. This tells you which exposure mode you are currently using: P, S, A, or M.
- Electronic analog exposure display. Although Nikon gives this feature a long and confusing name, in simpler terms this is your light meter. When the bars are in the center you are at the proper settings to get a good exposure; when the bars are to the left you are underexposed; and when the bars are to the right you are overexposing your image. This feature is especially handy when using Manual exposure.
- Auto ISO indicator. This is displayed when the Automatic ISO setting is activated to let you know that the camera is controlling the ISO settings.
- FEC indicator. When this is displayed your flash exposure compensation is on.

- Exposure compensation indicator. When this appears in the viewfinder your camera has exposure compensation activated, and you may not get a correct exposure.
- ISO sensitivity. This tells you what the ISO sensitivity is currently set to.
- Exposures remaining. This set of numbers lets you know how many more exposures can fit on the CF card. The actual number of exposures may vary according to file information and compression. When the Shutter Release button is half-pressed, the display changes to show how many exposures can fit in the camera's *buffer* before the buffer is full and the frame rate slows down. The buffer is in-camera RAM that stores your image data while the data is being written to the memory card.
- K indicator. This lets you know that there are more than 1000 exposures remaining on your memory card.
- Flash ready indicator. When this is displayed the flash, whether it is the built-in flash or an external Speedlight attached to the hot shoe, is fully charged and ready to fire at full power.

LCD Control Panel

The monochrome LCD control panel on top of the camera displays some of the same shooting information that appears in the viewfinder, but there are also some settings that are only displayed here. This LCD control panel allows you to view and change the settings without looking through the viewfinder.

- Exposure mode. This tells you which exposure mode you are currently using: P, S, A, or M.
- Flexible program indicator. This is an asterisk that appears next to the Exposure mode when in P or Programmed Auto mode. This lets you know that you have changed the default auto-exposure set by the camera to better suit your creative needs.

Cross-Reference

Flexible program mode is discussed more in depth in Chapter 2.

- Flash sync indicator. This indicator is displayed as a small X. This comes on when you set your camera to the sync speed that is set in the CSM e1. This is only available when in Shutter Priority or Manual mode. To set the camera to the preset sync speed, dial the shutter speed down one setting past the longest shutter time, which is 30 seconds in S and bulb in M.
- Shutter speed/multi-function. By default this set of numbers shows you the shutter speed setting. This set of numbers also shows a myriad of other settings depending on which buttons are being pressed.
 - Exposure compensation value. When pressing the Exposure Compensation button and rotating the Sub-command dial, the EV compensation number is displayed.
 - FEC value. Pressing the Flash mode button and rotating the Sub-command dial displays the FEC value.

- ISO. The ISO sensitivity appears when the ISO button is pressed. Rotating the Main Command dial changes the sensitivity.
- WB fine-tuning. Pressing the WB button and rotating the Sub-command dial fine-tunes the white balance setting. A is warmer, and B is cooler.
- Color temperature. When the WB is set to K, the panel displays the color temperature in the Kelvin scale when you press the WB button.

Cross-Reference

For more information on white balance and Kelvin, see Chapter 2.

- WB preset number. When the WB is set to one of the preset numbers, pressing the WB button displays the preset number that is currently being used.
- Bracketing sequence. When the D300 auto-bracketing feature is activated pressing the Function button displays the number of shots left in the bracketing sequence. This includes WB, exposure, and flash bracketing.
- Interval timer number. When the camera is set to use the interval timer for time-lapse photography this displays the number of shots remaining in the current interval.
- Focal length (non-CPU lenses). When the camera's Function button is set to choose a non-CPU lens number when the Function button is pressed, the focal length of the non-CPU

lens is displayed. You must enter the lens data in the Setup menu.

- Aperture/multi-function. At default settings this displays the aperture at which the camera is set. This indicator also displays other settings as follows:
 - Auto-bracketing compensation increments. The exposure bracketing can be adjusted to over- and underexpose in 1/3stop increments. When the Function button is set to Autobracketing the number of exposure value (EV) stops is displayed in this area. The choices are 0.3, 0.7, or 1.0 EV. The WB auto-bracketing can also be adjusted; the settings are 1, 2, or 3.
 - Number of shots per interval. When the D300 is set to Interval Timer shooting the number of frames shot in the interval is displayed here.
 - Maximum aperture (non-CPU lenses). When the non-CPU lens data is activated the maximum aperture of the specified lens appears here.
 - **PC mode indicator.** When the D300 is connected to a computer via the USB cable the letters *PC* are displayed to inform you that your camera is connected.
- Beep indicator. This informs you that the camera will beep when the self-timer is activated or when the camera achieves focus when in Single focus mode.

- Multiple exposure indicator. This icon informs you that the camera is set to record multiple exposures.
- Flash mode. These icons denote which flash mode you are using. The flash modes include Red-Eye Reduction, Red-Eye with slow sync, Slow Sync, and Rear-Curtain Sync.
- Battery indicator. This display shows the charge remaining on the active battery.
- Image size. When shooting JPEG, TIFF, or RAW + JPEG files, this tells you whether you are recording Large, Medium, or Small files. This display is turned off when shooting RAW files.
- Image quality. This displays the type of file format you are recording. You can shoot RAW, TIFF, or JPEG. When shooting JPEG or RAW
 + JPEG, it displays the compression quality: FINE, NORM, or BASIC.
- FV lock indicator. When this indicator is shown the Flash value (FV) is locked. The Function button must be assigned to FV lock.
- Auto ISO indicator. This is displayed when the Automatic ISO setting is activated to let you know that the camera is controlling the ISO settings.
- Exposure compensation indicator. When this appears in the LCD control panel, your camera has exposure compensation activated. This will affect your exposure.
- FEC indicator. When this is displayed, your flash exposure compensation is on.

- Interval timer indicator. When the camera's Interval Timer option is turned on, this appears in the LCD control panel.
- GPS connection indicator. This icon appears in the LCD control panel when a GPS system is connected to the D300's 10-pin connector.
- Battery grip indicator. When the MB-D10 battery grip is attached and the camera is using the battery installed in the grip this icon is displayed.
- Clock indicator. When this appears in the LCD control panel, the camera's internal clock needs to be set.
- Image comment indicator. When this is displayed, the Image Comment option is turned on and all images recorded will have your customized comment attached in the EXIF data. Image comments can be added in the Setup menu.
- Electronic analog exposure display. This is your light meter. When the bars are in the center, you are at the proper settings to get a good exposure; when the bars are to the left, you are underexposed; when the bars are to the right, you are overexposing your image. This feature comes in especially handy when using Manual exposure.
- Shooting menu bank. The D300 allows you to save different shooting settings for different situations. This displays which bank you are in: A, B, C, or D. The bank is selected in the Shooting menu.

Chapter 1 + Exploring the Nikon D300 31

 Custom Settings menu bank. Similar to the Shooting menu bank, this is where you store Custom Settings. The banks are A, B, C, or D. This bank is chosen in the CSM.

Cross-Reference banks, see Chapter 3.

- Auto-exposure bracketing/ WB bracketing indicator. When in Auto-exposure bracketing this appears on the LCD control panel; when using WB bracketing, a WB icon also appears above the icon.
- AF area mode indicator. This display shows which AF mode your camera is currently in.
- WB indicator. This shows you which white balance setting is currently selected.

- WB fine-tuning indicator. When the white balance fine-tuning feature is activated these two arrows are displayed.
- Exposures remaining/multifunction. By default, this displays the number of exposures remaining on your CF card. When you halfpress the Shutter Release button to focus, the display changes to show the number of shots remaining in the camera's buffer. In preset WB, the icon PRE appears when the camera is ready to set a custom WB.
- K indicator. This appears when the number of remaining exposures exceeds 1000. This is not to be confused with the K that may appear in the WB area which is used to denote the Kelvin temperature.

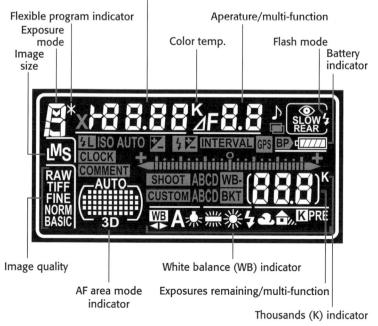

Shutter speed/multi-function

1.9 LCD display 1

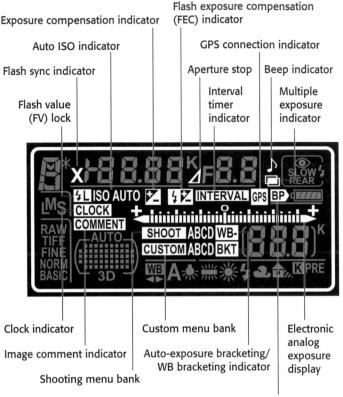

Battery grip indicator

1.10 LCD display 2

Nikon D300 Essentials

hen you familiarize yourself with the basic layout of the D300 and all of the various dials, switches, and buttons, you should find it much easier to navigate to and adjust the settings that allow you to control and fine-tune the way the camera captures images. This chapter covers some of the most commonly changed settings of the camera such as the exposure modes, metering, AF settings, white balance, and ISO. All of these settings combined are used to create your image and can be tweaked and adjusted to reflect your artistic vision or simply to be sure that your pictures come out right in tricky lighting situations.

Exposure settings include the exposure modes that decide how the camera chooses the aperture and shutter speed and the metering modes that decide how the camera gathers the lighting information so that the camera can choose the appropriate settings based on the exposure mode. You also learn more about ISO, which also plays into exposure. Exposure compensation is also covered. Exposure compensation allows you to fine-tune the exposure to suit your needs or to achieve the proper exposure in situations where your light meter may be fooled.

This chapter also explains the Auto Focus modes, which decide which areas of the viewfinder are given preference when the camera is deciding what to focus on. Discussions of white balance, Picture Controls, and LiveView round out the chapter.

Exposure Modes

Unlike some of Nikon's entry-level dSLRs such as the D40, the D300 has no *Scene modes*. Scene modes are settings that are tailored for specific shooting scenarios like sports, landscapes, or portraits. With a camera of this level you are expected to know a little more about exposure settings for different types of photography rather than relying on the camera's scene modes so the D300 only has four exposure modes: Programmed Auto, Aperture Priority, Shutter Priority, and Manual. These are all you need to achieve the correct exposure.

Although it only has four modes, these modes actually allow you the ultimate in control. To switch among these exposure modes, simply press the Mode button located next to the Shutter Release button and rotate the Main Command dial until the desired mode is displayed in the LCD control panel or in the viewfinder display.

Programmed Auto

Programmed Auto mode, or P, is a fully automatic mode suitable for use when shooting snapshots and scenes where you're not very concerned about controlling the settings.

When the camera is in Programmed Auto mode the camera decides all of the settings for you based on a set of algorithms. The camera attempts to select a shutter speed that allows you to shoot handheld without suffering from camera shake while also adjusting your aperture so that you get good depth of field to ensure everything is in focus. When the camera body is coupled with a lens that has a CPU built in (almost all AF lenses have a CPU), the camera automatically knows what focal length and aperture range the lens has. The camera then uses this lens information to decide what the optimal settings should be.

This exposure mode chooses the widest aperture possible until the optimal shutter speed for the specific lens is reached. Then the camera chooses a smaller f-stop as well as increases the shutter speed as light levels increase. For example, when using a 17-55mm f/2.8 zoom lens, the camera keeps the aperture wide open until the shutter speed reaches about 1/40 second (the minimum shutter speed to avoid camera shake). Upon reaching 1/40 second the camera adjusts the aperture to increase depth of field.

The exposure settings selected by the camera are displayed in both the LCD control panel and the viewfinder display. Although the camera chooses what it thinks are the optimal settings, the camera does not know what your specific needs are. You may decide that your hands are not steady enough to shoot at the shutter speed the camera has selected or you may want a wider or smaller aperture for selective focus. Fortunately, you aren't stuck with the camera's exposure choice. You can engage what is known as *flexible program*. Flexible program allows you to deviate from the camera's aperture and shutter speed choice when you are in P mode. This feature can be automatically engaged simply by rotating the Main Command dial until the desired shutter speed or aperture is achieved. This allows you to choose a wider aperture / faster shutter speed when rotated to the right, or a slower shutter speed / smaller aperture when the dial is rotated to the left. With flexible program, you can maintain the metered exposure while still having some control over the shutter speed and aperture settings.

Chapter 2 + Nikon D300 Essentials 35

A quick example of using flexible program would be if the camera has set the shutter speed at 1/60 second with an aperture of f/8, you're shooting a portrait and you want a wider aperture to throw the background out of focus. By rotating the Main Command dial to the right, you can open the aperture up to f/4, which causes the shutter speed to increase to 1/125 second. This is what is known as an *equivalent exposure*, meaning you get the same exact exposure but the settings are different.

When flexible program is on, an asterisk is displayed next to the P on the LCD control panel. Rotate the Main Command dial until the asterisk disappears to return to the default Programmed Auto settings.

Programmed Auto mode is not available when using non-CPU lenses. When in P mode and a non-CPU lens is attached the camera automatically selects Aperture Priority mode. The P continues to appear on the LCD control panel, but the A for Aperture Priority appears in the viewfinder display.

Note

If there is not enough light to make a proper exposure, the camera displays Lo instead of a shutter speed denomination.

Aperture Priority

Aperture Priority mode, or A, is a semiautomatic mode. In this mode, you decide which aperture to use and the camera sets the shutter speed for the best exposure based on your chosen aperture. Situations where you may want to select the aperture include when you're shooting a portrait and want a large aperture (small f/number) to blur out the background, and when you're shooting a landscape and you want a small aperture (large f/number) to ensure the entire scene is in focus.

Note In Aperture Priority mode, if there is not enough light to make a proper exposure, the camera displays Lo in place of the shutter speed setting.

Shutter Priority

Shutter Priority mode, or S, is another semiautomatic mode. In this mode, you choose the shutter speed and the camera sets the aperture. This mode is good to use when shooting moving subjects or action scenes where you need to be sure to have a fast shutter speed to freeze the motion of your subject and prevent blur. You can also select a slower shutter speed to *add* motion blur as a creative photographic technique.

> In Shutter Priority mode, if there is not enough light to make a proper exposure, the camera displays Lo in place of the aperture setting.

Manual

Note

When in the Manual mode, or M, both the aperture and shutter speed settings are set by you. You can estimate the exposure, use a handheld light meter, or use the D300's electronic analog exposure display to determine the exposure needed.

For more info on the electronic analog exposure display, see the Quick Tour.

Probably the main question that people have about Manual exposure is why use it when you have these other modes? There are a few reasons why you may want to set the exposure manually:

- To gain complete control over exposure. Most times the camera decides the optimal exposure based on technical algorithms and an internal database of image information. Oftentimes, what the camera decides is optimal is not necessarily what is optimal in your mind. You may want to underexpose to make vour image dark and foreboding, or you may want to overexpose a bit to make the colors pop (making colors bright and contrasty). If your camera is set to M, you can choose the settings and place your image in whatever tonal range you want without having to fool with exposure compensation settings.
- When using studio flash. When using studio strobes or external nondedicated flash units, the camera's metering system isn't used. When using external strobes, a flash meter or manual calculation is necessary to determine the proper exposure. Using the Manual exposure mode you can quickly set the aperture and shutter speed to the proper exposure; just be sure not to set the shutter speed above the rated sync speed of 1/250 second.

When using non-CPU lenses. When using older non-CPU lenses the camera is automatically set to Aperture Priority with the camera choosing the shutter speed. Switching to Manual allows you to select both the shutter speed and aperture while using the camera's analog light meter seen in the viewfinder display.

Metering Modes

The D300 has three metering modes that you can choose from to help you get the best exposure for your image. You can change the modes by using the metering selector dial directly to the right of the viewfinder.

Metering modes decide how the camera's light sensor collects and processes the information used to determine exposure. Each of these modes is useful for different types of lighting situations.

Matrix

The default metering system that Nikon cameras use is a proprietary system called 3D Color Matrix II, or Matrix metering for short. Matrix metering takes an evaluative reading of the light falling on the entire scene, also taking into account the color information. Then the camera runs the data through some sophisticated algorithms and determines the proper exposure for the scene. When using a Nikkor D- or G-type lens, the camera also takes the focusing distance into consideration.

Cross-Reference

For more info on lenses and lens specifications, see Chapter 4.

The D300 has a 1005-pixel RGB sensor that measures the intensity of the light and the color of a scene. The camera then compares the information to information from 30,000 images stored in its database. Then the D300 determines the exposure settings based on the findings from the comparison. Simplified, it works like this: You're photographing a portrait outdoors, and the sensor detects that the light in the center of the frame is much dimmer than the edges. The camera takes this information along with the focus distance and compares it to the

Chapter 2 + Nikon D300 Essentials 37

ones in the database. The images in the database with similar light and color patterns and subject distance tell the camera that this must be a close-up portrait with flesh tones in the center and sky in the background. From this information the camera decides to expose primarily for the center of the frame although the background may be over- or underexposed. The RGB sensor also takes note on the quantity of the colors and also uses that information.

To take complete advantage of the 3D Color Matrix II metering system you must be using a Nikkor G- or D-type lens. When using other lenses equipped with a CPU, usually third-party lenses, the distance information is not used to calculate the exposure, leaving you with Color Matrix II metering. When using a non-CPU lens, the D300 automatically switches to Center-weighted metering unless you enter the lens data in the Shooting menu. When the non-CPU lens data is entered, the camera defaults to Color Matrix metering.

The Matrix metering setting is highly intuitive, and Nikon has been refining it over a number of years, so it works very well for most subjects. I almost always have my camera set to Matrix.

2.1 The D300's 1005-pixel RGB sensor

Center-weighted

When the camera's metering mode is switched to Center-weighted, the meter takes a light reading of the whole scene, but bases the exposure settings mostly from the light falling on the center of the scene. The camera determines about 75 percent of the exposure from a circular pattern in the center of the frame and 25 percent from the edges.

By default, the circular pattern is 8mm in diameter, but you can choose to make the circle bigger or smaller depending on the subject. Your choices are 6, 8, 10, or 13mm. There is also a setting for Average. When set to Average the camera takes a reading of the full frame and decides on an average setting. I'm not sure why the Average option is included in the Center-weighted menu because it is not center-weighted at all, but I digress. Averaging meters were one of the first types of meters used in SLR cameras and although they worked okay, in even moderately tricky lighting situations you had to know when to use your exposure compensation or your image would come out flat and, well, average. An example of this would be a snowy landscape-the averaging meter takes a look at all that white and wants to make it an 18 percent gray causing the snow to look dingy. This is when you would have to know to adjust your exposure compensation +1 or 2 stops. Unless you're photographing something that is uniform in color and has very little contrast, I advise staying away from using the Average option.

On the other hand, true Center-weighted metering is a very useful option. It works great when shooting photos where you know the main subject will be in the middle of the frame. This metering mode is useful when photographing a dark subject against a bright background, or a light subject against a dark background. This mode

works especially well for portraits where you want to preserve the background detail while exposing correctly for the subject.

Center-weighted metering can provide you consistent results without worrying about the fluctuations in exposure settings that can sometimes happen when using Matrix metering.

The center-weighted circle diameter can be changed in the Custom Settings menu (CSM b5), which are explained in more detail in Chapter 3.

Spot

In Spot meter mode the camera does just that: meters only a spot. This spot is only 3mm in diameter and only accounts for 2 percent of the entire frame. The spot is linked to the active focus point, which is good, so you can focus and meter your subject at the same time, instead of metering the subject, pressing AE-L, then recomposing the photo.

Spot metering is for use when the subject is the only thing in the frame that you want the camera to expose for. For example, when you are photographing a subject on a completely white or black background, you need not be concerned with preserving detail in the background; therefore, exposing just for the subject works out perfectly. One instance where this mode works well is when doing concert photography where the musician or singer is lit by a bright spotlight. You can capture every detail of the subject and just let the shadow areas go black.

When using a non-CPU lens with Spot metering, the center spot is automatically selected.

Exposure Compensation

Your camera's meter is not always completely accurate. There are a lot of variables in most scenes, and large bright or dark areas can trick the meter into thinking a scene is brighter or darker than it really is, causing the image to be over- or underexposed. Exposure compensation is a feature of the D300 that allows you to fine-tune the amount of exposure to vary from what is set by the camera's exposure meter. If after taking the photograph you review it and it's too dark or too light you can adjust the exposure compensation and retake the picture to get a better exposure. Exposure compensation is adjusted by pressing the Exposure Compensation button, next to the Shutter Release button, and rotating the Main Command dial to the left for more exposure (+EV) or to the right for less exposure (-EV). Depending on your settings, the exposure compensation is adjusted in 1/3, 1/2, or 1 stops of light. You can change this setting in the Custom Settings menus (CSM b3).

The exposure compensation can be adjusted up to +5EV and down to -5EV, which is a large range of 10 stops. To remind you that exposure compensation has been set, the exposure compensation indicator is displayed on the top LCD control panel and the viewfinder display. It also appears on the rear LCD when the shooting info is being displayed.

Be sure to reset the exposure compensation to 0 after you're done to avoid unwanted overor underexposure.

Chapter 2 + Nikon D300 Essentials 39

Histograms

The easiest way to determine if you need to adjust the exposure compensation is to simply preview your image. If it looks too dark, add some exposure compensation; if it's too bright, adjust the exposure compensation down. This, however, is not the most accurate method of determining how much exposure compensation to use. To accurately determine how much exposure compensation to add or subtract, look at the *histogram.* A histogram is a visual representation of the tonal values in your image. Think of it as a graph that charts the lights, darks, and mid-tones in your picture.

The histogram charts a tonal range of about 5 stops, which is about the limit of what the D300's sensor can record. This range is broken down into 256 separate brightness levels from 0 (absolute black) to 255 (absolute white), with 128 coming in at middle or 18 percent gray.

I've purposefully not taken into account the effects of Active D-Lighting and 14-bit RAW in this explanation of a histogram.

Ideally, you want to expose your subject so that it falls right about in the middle of the tonal range, which is why your camera's meter exposes for 18 percent gray. If your histogram graph has most of the information bunched up on the left side, then your image is probably underexposed; if it's bunched up on the right side, then your image is probably overexposed. Ideally, with most average subjects that aren't bright white or extremely dark, you want to try to get your histogram to look sort of like a Bell curve, with most of the tones in the middle range tapering off as they get to the dark and light ends of the graph. But, this is only for most average types of images. As with almost everything in photography, there are exceptions to the rule. If you take a photo of

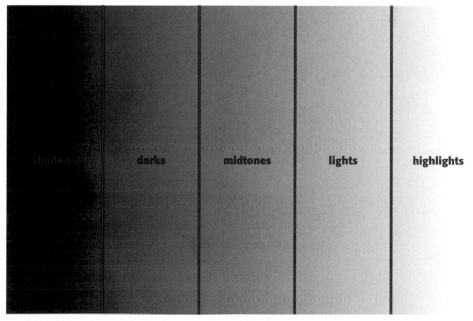

2.2 Representation of the tonal range of a histogram

a dark subject on a dark background (a *low-key* image), then naturally your histogram will have most of the tones bunched up on the left side of the graph. Conversely, when taking a photograph of a light subject on a light background (a *high-key* image) then the histogram will have most of the tones bunched up to the right.

The most important thing to remember is that there is no such thing as a perfect histogram. A histogram is just a factual representation of the tones in the image. The other important thing to remember is that although it's okay for the graph to be near one side or the other, you usually don't want your histogram to have spikes bumping up against the edge of the graph; this indicates your image has blown-out highlights (completely white, with no detail) or blocked-up shadow areas (completely black, with no detail).

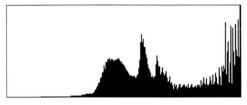

2.3 Example of a histogram from an overexposed image (no highlight detail). Notice the spikes at the far right of the graph.

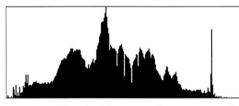

2.5 Example of a histogram from a properly exposed image. Notice that the graph does not spike against the edge on the left or the right, but tapers off.

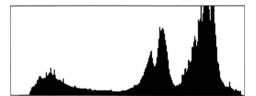

2.7 Example of a histogram from a high-key image. Notice that although the graph is mostly on the right, it does not spike against the edge indicating that there is highlight detail in the image.

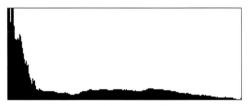

2.4 Example of a histogram from an underexposed image (no shadow detail). Notice the spikes at the far left of the graph.

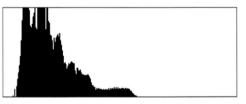

2.6 Example of a histogram from a low-key image. Notice that although the graph is mostly on the left, it does not spike against the edge indicating that there is shadow detail in the image.

Chapter 2 + Nikon D300 Essentials 41

Now that you know a little bit about histograms, you can use them to adjust exposure compensation. Here is a good order of operations to follow when using the histogram as a tool to evaluate your photos:

- After taking your picture, review its histogram on the LCD. To view the histogram in the image preview, press the Playback button to view the image. Press the multiselector to the right, and the histogram appears directly to the right of the image preview.
- Look at the histogram. An example of an ideal histogram can be seen in figure 2.5.
- 3. Adjust the exposure compensation. To move the tones to the right to capture more highlight detail add a little exposure compensation by pressing the Exposure Compensation button and rotating the Main Command dial to the left. To move the tones to the left by underexposing, press the Exposure Compensation button and rotate the Main Command dial to the right.
- 4. Retake the photograph if necessary. After taking another picture, review the histogram again. If needed, adjust the exposure compensation more until you achieve the desired exposure.

Bracketing

Another way to ensure that you get the proper exposure is to *bracket* your exposures. Bracketing is a photographic technique in which you vary the exposure of your subject over three or more frames. By doing this you can ensure you get the proper exposure in difficult lighting situations where your camera's meter can be fooled. Bracketing is usually done with at least one exposure under and one exposure over the metered exposure.

You can bracket your images manually or you can choose to use the D300's auto-bracketing function. To use the auto-bracketing function, you must set the Function button for Auto-bracketing. To do this, follow these steps:

- 1. Press the Menu button.
- Use the multi-selector to enter the CSM. Scroll down to CSM f / Controls. Press the multi-selector right.
- Scroll down to CSM f4, Assign FUNC. button. Press the multiselector right to choose the FUNC button options.
- Use the multi-selector button to choose the FUNC button + dials option. Press the multi-selector right.
- Choose Auto-bracketing from the FUNC button + dials options menu.
- Press the OK button. The Function button is now assigned to be used for auto-bracketing.

Note

Auto-bracketing can also be assigned to the Preview button. To set Auto-bracketing to the Preview button, use CSM f5.

The D300 offers a few different types of exposure bracketing:

 Auto-exposure and flash. This bracketing option varies both the exposure compensation and the flash output.

- Auto-exposure only. This bracketing option varies the exposure compensation.
- Flash only. This bracketing option adjusts the flash output.
- White Balance bracketing. White Balance bracketing takes a series of pictures and modifies the WB setting a bit with each photo taken to ensure that you get the proper WB. This option cannot be used when shooting RAW files.

To set the exposure or WB bracketing:

- Press the Menu button to display menu options. Use the multi-selector to enter the CSM.
- Scroll down to CSM. Press the multi-selector right.
- Use the multi-selector up/down to highlight CSM e5 (Autobracketing set). Press the multiselector right to display options.
- 4. Use the multi-selector to highlight the type of bracketing you want. This can be AE only, Flash, WB, and so on). Press the OK button or multi-selector right to set.

Once you turn on auto-bracketing, you can choose to set it in a number of different ways.

- Choose 3, 5, 7, or 9 frames. This option gives you more variations of the exposure or WB.
- Vary the exposure increments from 0.3, 0.7, and 1.0 stops.
 Choosing a higher exposure increment gives you a wider variation than choosing a lower increment.
 For example, choosing a 5-frame

bracket at 0.3 EV gives you a series of exposures resulting in your images ranging only $\pm 2/3$ stop over and under the original exposure. The series of exposure compensation will range as follows: -0.7, -0.3, 0, +0.3, +0.7. Choosing a 5-frame bracket at 1.0 EV gives a much wider series of exposures. This gives you a 5 stop range: 2 stops over, 2 stops under, plus the original exposure. The range of exposure compensation is as follows: -2.0, -1.0, 0, +1.0, +2.0.

Choose 2 frames under- or overexposed, or 3 frames over- or underexposed. When you choose to only overexpose or only underexpose your bracketed shots, choosing +2 gives you one image shot at normal exposure and one shot overexposed; choosing +3 gives you two shots overexposed and one normal exposure. Conversely, choosing -2 or -3 gives you the same range as the overexposures except the images are underexposed. As with the other settings, the increments can be adjusted from 0.3, 0.7, or 1.0 EV.

Now that you understand all your options, to activate auto-bracketing, follow these steps:

- Press and hold the Function button. Look at the LCD control panel on the top of the camera. If auto-bracketing is off, the LCD displays OF, meaning you are not bracketing any frames.
- 2. While still holding the Function button, rotate the Main Command dial to the right to

choose the number of frames to bracket. Choose from 3, 5, 7, or 9 shots. Rotate the dial to the left to choose +2, +3, -2, or -3 (2 frames over or under or 3 frames over or under).

- 3. With the Function button still pressed, rotate the Sub-command dial to choose the exposure compensation increments. Choose from 0.3, 0.7, or 1.0 EV.
- 4. Shoot the photos. Shoot the specified number of images for your bracket set. You can choose to shoot them one at a time using the Single shooting mode, or in Continuous shooting mode, you can press and hold the shutter until the bracket set is completed.

In addition to helping ensure that you got the correct exposure, you can also use different elements from the exposures and combine them using image-editing software to give you a final image that has a wider tonal range than is possible for your image sensor to capture.

When using WB bracketing the set up is the same, but there's some different terminology and some different effects happening. The WB bracketing gives you a shot with a standard WB and also gives you shots that are cooler (blue) or warmer (amber).

You still choose the number of frames using the Main Command dial right, but rotating the Main Command dial left gives you the options of A2, B2, A3, or B3. These settings give you 2 or 3 frames that are more amber, or 2 or 3 frames that are bluer. Instead of setting the EV increments with the Sub-command dial, for the WB option you adjust the WB increments. The options are 1, 2, or 3. Here we could go into a detailed explanation about "mired color values," but that is an advanced topic. Simply knowing that the higher numbers give you a more pronounced change in the WB is enough.

The following is a sequence of bracketed images. The Auto-bracketing was set to AE only, 5 frames and the EV increment was set to 1 to show the broad range of exposures you can get with bracketing.

2.8 An image bracketed at -2 EV

2.9 An image bracketed at -1 EV

2.11 An image bracketed at +1 EV

2.10 An image bracketed at 0 EV

2.12 An image bracketed at +2 EV

You must go back into the Autobracketing menu and change the setting to OF to disable Autobracketing, otherwise the camera will continue to bracket all of your images whether you want it to or not.

Autofocus Modes

The Nikon D300 has three autofocus (AF) modes: Continuous, Single, and Manual. Each mode is useful for different types of shooting conditions, from sports to images to still-life photographs. To change the AF mode simply flip the switch that's located near the base of the lens (labeled with an M, S, and C).

Continuous

When the camera is set to Continuous AF, as long as the Shutter Release button is halfway pressed (or the AF-ON button is pressed), the camera continues to focus. If the subject moves, the camera activates Predictive Focus Tracking. With Predictive Focus Tracking on, the camera will track the subject to maintain focus and will attempt to predict where the subject will be when the shutter is released. When in Continuous AF mode, by camera default, the camera fires when the Shutter Release button is pressed whether or not the subject is in focus (release priority). If you want to be sure that the camera is in focus before the shutter is released, you can change the setting to focus priority. When the focus priority option is selected, the camera will continue to focus while the Shutter Release button is pressed but the shutter will be released only when the subject is in focus. This may cause your frame rate to slow down. You can choose between focus or release priority in CSM a1. This is the AF-C mode you want to use when shooting sports or any subject that may be moving erratically.

Single

In Single AF mode the camera focuses when the Shutter Release button is pressed halfway. When the camera achieves focus, the focus locks. The focus remains locked until the shutter is released or the Shutter Release button is no longer pressed. By default, the camera does not fire unless focus has been achieved (focus priority). This is the AF mode to use when shooting portraits, landscapes, or other photos where the subject is relatively static. You can change this setting in the CSM a2.

Manual

When set to the Manual mode, the D300 AF system is off. The camera can only be focused by rotating the focus ring of the lens. The focus indicator light in the viewfinder display appears when the camera is in focus. Manual focus can be used when shooting still-life photographs or other nonmoving subjects, and when you want total control of the focus.

AF Area Modes

With the D300, Nikon has added a completely new AF module: the Multi-CAM 3500DX. The D300 focusing system has 15 cross-type sensors and 36 horizontal sensors for an impressive 51-point AF system. This is a huge improvement over the 11point AF system of the D200.

The 51 AF points can be used individually in Single area AF mode or they can be set to use in groups of 9, 21, or 51 when in Dynamic area AF mode.

Nikon has also introduced 3D tracking, which enables the camera to switch focus points as a moving subject crosses the frame. 3D tracking is made possible by the camera recognizing color and light information and using this to track the subject.

Nikon's new Scene Recognition System uses the 1005-pixel RGB sensor to recognize color and lighting patterns in order to determine the type of scene that you are photographing. This enables the AF to work faster than in previous Nikon dSLRs, and it also helps to achieve more accurate exposure and white balance.

Single area AF

Single point AF area mode is the easiest mode to use when you're shooting slowmoving or completely still subjects. You use the multi-selector to choose one of the 51 AF points. The camera only focuses on the subject if it is in the selected AF area. Once the point is selected, in can be locked by rotating the AF area mode selector switch on the outside of the multi-selector to the L position. When selecting the AF point it will be lit up in the viewfinder.

Dynamic area AF

Dynamic area AF mode also allows you to select the AF point manually, but unlike Single area AF the remaining unselected points remain active so just in case the subject moves out of the selected focus area the camera's AF can track it across the frame. The Dynamic area can be selected to function with 9, 21, or 51 points. This can be selected in CSM a3.

Cross-Reference For more information on the CSM, see Chapter 3.

9 points

When set to 9-point AF area mode, you can select any one of the camera's 51 AF points to be the priority focus point. If your subject moves out of the selected point, the AF system uses the 8 AF points immediately surrounding the selected point to achieve focus. This is the best setting to use when photographing slower-moving subjects that you are able to track easily.

21 points

As with the 9-point mode, you can select the primary focus point from any one of the 51 points. The camera then uses information from the surrounding 20 points if the subject moves away from the selected focus area. The 21-point area gives you a little more leeway with moving subjects because the active AF areas are in a larger pattern. This mode is good for shooting subjects that are moving somewhat quickly or erratically.

51 points

This mode gives you the widest area of active focus points. You can select the primary focus point the same as with the 9point and 21-point options. The camera then keeps the surrounding 50 points active in case the subject leaves the selected focus area. This is the best mode to use when the subject is very unpredictable and moving around the frame quite a bit.

51 points (3D tracking)

This mode has all 51 AF points active. You select the primary AF point, but if the subject moves, the camera uses 3D tracking to automatically select a new primary AF point. 3D tracking is accomplished by the camera using color information from the area immediately surrounding the focus point. The camera uses this color information to determine what the subject is, and if the subject moves, the camera selects a new focus point. This mode works very well for subjects moving unpredictably; however, you need to be sure that the subject and the background aren't similar in coloring. When photographing a subject that is close in color with the background the camera may lock focus on the wrong area, so use this mode carefully.

Automatic area AF

This mode is exactly what it sounds like: the camera automatically determines the subject and chooses one or more AF points to lock focus. Due to some sophisticated internal software, when used with a Nikkor D- or G-type lenses, the D300 is able to recognize human subjects. This means that the camera has a better chance of focusing where you want it rather than accidentally focusing on the background when shooting a portrait. Normally, I tend not to use a fully automatic setting such as this, but I've found that it works reasonably well and recommend using this setting when shooting candid

photos. When the camera is set to Single AF mode the active AF points light up in the viewfinder for about 1 second when the camera attains focus; when in Continuous AF mode no AF points appear in the viewfinder.

ISO Sensitivity

ISO, which stands for International Organization for Standardization, is the rating for the speed of film, or in digital terms, the sensitivity of the sensor. The ISO numbers are standardized, which allows you to be sure that when you shoot at ISO 100 you get the same exposure no matter what camera you are using.

The ISO for your camera determines how sensitive the image sensor is to the light that is reaching it through the lens opening. Increasing or reducing the ISO affects the exposure by allowing you to use faster shutter speeds or smaller apertures (raising the ISO), or using a slower shutter speed or wider aperture (lowering the ISO).

You can set the ISO very quickly on the D300 by pressing and holding the ISO button and rotating the Main Command dial until the desired setting appears in the LCD control panel. As with other settings for controlling exposure the ISO can be set in 1/3, 1/2, or 1 stop increments. You can choose the ISO increments in CSM b1.

The D300 has an ISO range of 200 to 3200. In addition to these standard ISO settings, the D300 also offers some settings that extend the available range of the ISO so you can shoot in very bright or very dark situations.

These are labeled as H (high speed) and L (low speed). The H and L options are set in 1/3-stop adjustments. The options are

- H0.3, H0.7, and H1.0. These settings are equivalent to approximately ISO 4200, 5500, and 6400.
- L0.3, L0.7, and L1.0. These settings are equivalent to approximately ISO 150, 125, and 100.

The ISO can also be set by going into the Shooting menu and choosing the ISO sensitivity settings option.

Using the H and L settings will not produce optimal results. Using the L setting can result in images that are low in contrast, and using the H setting can cause your images to have a high amount of digital noise.

Auto ISO

The D300 also offers a feature where the camera adjusts the ISO automatically for you when there isn't enough light to make a proper exposure. Auto ISO is meant to free you up from making decisions about when to raise the ISO. The Auto ISO can be set in the Shooting menu under the ISO sensitivity settings option.

By default, when Auto ISO is on, the camera chooses an ISO setting from 200 up to H1 whenever the shutter speed falls below 1/30 second. Basically what this means is that when Auto ISO is turned on, if you manually change the ISO, the camera can not be set to a lower ISO than what the Auto ISO was set to in the Shooting menu. So, if you set it to ISO 800, then when you are shooting, Auto ISO will not lower the ISO below 800. You can also limit how high the ISO can be set so you can keep control of the noise created when a higher ISO is used (although the amount of overall noise generated by the D300 is much lower than any of the preceding camera models).

On the opposite end of the spectrum, if you manually set the ISO to 400, the Auto ISO function will not allow the ISO to go lower than ISO 400, no matter how bright the scene is. So when using the Auto ISO feature, be sure to set your ISO to 200 to ensure that you can get the full range of ISO settings.

Using Auto ISO can yield questionable results because you can't be sure what ISO adjustments the camera will make. So if you're going to use it be sure to set it to conditions that you deem acceptable to be sure that your images will be neither blurry nor noisy.

Be sure to set the following options in the Shooting menu / ISO sensitivity settings:

- Maximum Sensitivity. Choose an ISO setting that allows you to get an acceptable amount of noise in your image. If you're not concerned about noisy images then you can set it all the way up to H1. If you need your images to have less noise you can choose a lower ISO; the choices are 400, 800, 1600, 3200, and H1.
- Minimum Shutter Speed. This setting determines when the camera adjusts the ISO to a higher level. At the default, the camera bumps up the ISO when the shutter speed falls below 1/30 second. If you're using a longer lens or you're photographing moving

Chapter 2 + Nikon D300 Essentials 49

subjects you may need a faster shutter speed. In that case you can set the minimum shutter speed up to 1/250. On the other hand, if you're not concerned about camera shake, or if you're using a tripod, you can set a shutter speed as slow as 1 second.

Note

The minimum shutter speed is only taken into account when using Programmed Auto or Shutter Priority modes.

Noise reduction

Since the inception of digital cameras, they've been plagued with what is known as noise. Noise, simply put, is randomly colored dots that appear in your image. It's is basically caused by extraneous electrons that are produced when your image is being recorded. When light strikes the image sensor in your D300, electrons are produced. These electrons create an analog signal that is converted into a digital image by the Analog to Digital (A/D) converter in your camera. There are two specific causes of noise. The first is heat generated or thermal noise. While the shutter is open and your camera is recording an image, the sensor starts to generate a small amount of heat. This heat can free electrons from the sensor. which in turn contaminate the electrons that have been created as a result of the light striking the photocells on your sensor. This contamination shows up as noise.

The second cause of digital noise is known as *high ISO noise*. In any type of electronic device there is background electrical noise. For the most part it's very miniscule and you never notice it. Cranking up the ISO amplifies the signals (photons of light) your sensor is receiving. Unfortunately, as these signals are amplified so is the background electrical noise. The higher your ISO, the more the background noise is amplified until it shows up as randomly colored specks.

Digital noise is composed of two different elements, *chrominance* and *luminance*. Chrominance refers to the colored specks and luminance refers mainly to the size and shape of the noise.

Fortunately, with every new camera released, the technology gets better and better, and the D300 is no exception. The D300 has one of the lowest signal-to-noise ratios of any camera on the market; thus you can shoot at ISO 1600 and not worry about excessive noise. In previous cameras, shooting at ISO 1600 produced a very noisy image that was not suitable for large prints.

Although very low in noise, there is noise there, especially when shooting above ISO 1600 or when using long exposure times. For this reason most camera manufacturers have built-in noise reduction (NR) features. The D300 has two types of NR, Long exposure NR and High ISO NR. Each one approaches the noise differently to help reduce it.

Long exposure NR

When this setting is turned on, the camera runs a noise reduction algorithm to any shot taken with a long exposure (8 seconds or more). Basically, how this works is that the camera takes another exposure, this time with the shutter closed, and compares the noise from this dark image to the original one. The camera then applies the NR. The noise reduction takes about the same amount of time to process as the length of the shutter speed; therefore expect to

double the time it takes to make one exposure. While the camera is applying NR, the LCD panel blinks a message that says "Job nr." No additional images can be taken until this process is finished. If the camera is switched off before the NR is finished, no noise reduction is applied.

Long exposure NR can be turned on or off by accessing it in the Shooting menu.

High ISO NR

When this option is turned on, any image shot at ISO 800 or higher is run through the noise reduction algorithm. This feature works by reducing the coloring in the chrominance of the noise and combining that with a bit of softening of the image to reduce the luminance noise. You can set how aggressively this effect is applied by choosing the High, Normal, or Low settings.

Note

Note

When shooting in RAW no actual noise reduction is applied to the image.

For the most part, I choose not to use either of these in-camera NR features. In my opinion, even at the lowest setting, the camera is very aggressive in the NR, and for that reason, there is a loss of detail. For most people this is a minor quibble and not very noticeable, but for me, I'd rather keep all of the available detail in my images and apply noise reduction in post processing. This way I can decide for myself how much to reduce the chrominance and luminance rather than letting the camera do it. The camera doesn't know whether you're going to print the image at a large size or just display it on screen. I say it's better to be safe than sorry.

> Noise reduction can be applied in Capture NX, or by using Photoshop's Adobe Camera Raw or some other image editing software.

White Balance

Light, whether it is sunlight, from a light bulb, fluorescent, or from a flash, all has its own specific color. This color is measured using the Kelvin scale. This measurement is also known as color temperature. The white balance allows you to adjust the camera so that your images can look natural no matter what the light source. Since white is the color that is most dramatically affected by the color temperature of the light source. this is what you base your settings on, hence the term white balance. The white balance can be changed in the Shooting menu or by pressing the WB button on the top of the camera and rotating the Main Command dial

The term *color temperature* may sound strange to you. "How can a color have a temperature?" you might think. Once you know about the Kelvin scale, things make a little more sense.

What is Kelvin?

Kelvin is a temperature scale, normally used in the fields of physics and astronomy, where absolute zero (0 K) denotes the absence of all heat energy. The concept is based on a mythical object called a *black body radiator*. Theoretically, as this black body radiator is heated, it starts to glow. As it is heated to a certain temperature, it glows a specific color. It is akin to heating a bar of iron with a torch. As the iron gets hotter it turns red then yellow then eventually white before it reaches its melting point (although the theoretical black body does not have a melting point).

The concept of Kelvin and color temperature is tricky as it is the opposite of what you likely think of as "warm" and "cool" colors. For example, on the Kelvin scale, red is the lowest temperature increasing through orange, yellow, white, and to shades of blue, which are the highest temperatures. Humans tend to perceive reds, oranges, and yellows as warmer and white and bluish colors to be cold. However, physically speaking, the opposite is true as defined by the Kelvin scale.

White balance settings

Now that you know a little about the Kelvin scale, you can begin to explore the white balance settings. The reason that white balance is so important is to ensure that your images have a natural look. When dealing with different lighting sources, the color temperature of the source can have a drastic effect on the coloring of the subject. For example, a standard light bulb casts a very yellow light; if the color temperature of the light bulb is not compensated for by introducing a bluish cast, the subject can look overly yellow and not quite right.

In order to adjust for the colorcast of the light source, the camera introduces a colorcast of the complete opposite color temperature. For example, to combat the green color of a fluorescent lamp the camera introduces a slight magenta cast to neutralize the green.

The D300 has nine white balance settings:

AUTO Auto. This setting is best for most circumstances. The camera takes a reading of the ambient light and makes an automatic adjustment. This setting also works well when using a Nikon CLS compatible Speedlight because the color temperature is calculated to match the flash output. I actually recommend using this setting as opposed to the Flash WB setting.

- PRE **PRE.** This setting allows you to choose a neutral object to measure for the white balance. It's best to choose an object that is either white or light gray. There are some accessories that you can use to set the white balance from. One accessory is a gray card, which are fairly inexpensive. Simply put the gray card in the scene and balance off of it. Another accessory is the Expodisc. This attaches to the front of your lens like a filter: you then point the lens at the light source and set your WB. This setting (PRE) is best used under difficult lighting situations such as when there are two different light sources lighting the scene (mixed lighting). I usually use this setting when photographing with my studio strobes.
- *

Incandescent. Use this setting when the lighting is from a standard household light bulb.

Fluorescent. Use this setting when the lighting is coming from a fluorescent-type lamp. You can also adjust for different types of fluorescent lamps including high-pressure sodium and mercury vapor lamps. To make this adjustment, go to the Shooting menu and choose White Balance, then fluorescent. From there, use the multiselector to choose one of the seven types of lamps.

Daylight. Use this setting outdoors in direct sunlight.

Cloudy. Use this setting under overcast skies.

Shade. Use this setting when your are in the shade of a tree or a building or even under an overhang or a bridge. Any place where the sun is out but is being blocked. K. This setting allows you to adjust the white balance to a particular color temperature that corresponds to the Kelvin scale. You can set it between 2500K (red) to 10000K (blue).

Tip

By keeping your digital camera set to the Automatic WB setting, you can reduce the amount of images taken with incorrect color temperatures. In most lighting situations, the Automatic WB setting is very accurate. You may discover that your camera's ability to evaluate the correct white balance is more accurate than setting white balance manually.

Figures 2.13 to 2.19 show the different looks of the white balance settings.

2.13 Auto, 5750K

2.14 Incandescent, 2850K

Chapter 2 + Nikon D300 Essentials 53

2.15 Fluorescent, 3800K

2.17 Daylight, 5500K

2.16 Flash, 5500K

2.18 Cloudy, 6500K

2.19 Shade, 7500K

Picture Controls

With the D300 Nikon has introduced their Picture Control System. This feature allows you to quickly adjust your image settings to your preferences. Another fantastic thing about the Picture Control System is that you can set it to emulate the color modes from other Nikon cameras. This is great for photographers who shoot more than one camera and do batch processing to their images. It allows both cameras to record the images the same so global image correction can be applied without worrying about differences in color, tone, saturation, and sharpening.

Picture Controls can also be saved to the CF card and imported into Nikon's image editing software, Capture NX, or View NX. You can then apply the settings to RAW images or even to images taken with other camera models. These Picture Control files can also be saved and shared with other Nikon users, either by importing them to Nikon software or loading them directly to another D300.

In addition to the four standard Picture Controls already on the camera, Nikon is also offering Custom Picture Controls available for download on the Nikon Web site. At the time of this writing, Nikon only offers three Custom Picture Controls. These Picture Controls offer the same Color Mode settings that are available on D2X/s cameras; they are called the D2XMODE1, D2XMODE2, and D2XMODE3. More information on these Picture Controls can be found on the Nikon Web site.

Original Picture Controls

Right out of the box the D300 comes with four Picture Controls installed.

- SD. This is the Standard setting. This applies slight sharpening and a small boost of contrast and saturation. This is the recommended setting for most shooting situations.
- NL. This is the Neutral setting. This setting applies a small amount of sharpening and no other modifications to the image. This setting is preferable if you do extensive postprocessing to your images.
- VI. Also referred to as the Vivid setting. This setting gives your images a fair amount of sharpening, the contrast and saturation is boosted highly resulting in brightly colored

images. This setting is recommended for printing directly from the camera or flash card as well as for shooting landscapes. Personally, I feel that this mode is a little too saturated and often results in unnatural color tones. This mode is not recommended for portrait situations, as skin tones are not reproduced well.

 MC. This is the Monochrome setting. As the name implies, this option makes the images monochrome. This doesn't simply mean black and white, you can also simulate photo filters and toned images such as sepia, cyanotype, and more.

Custom Picture Controls

All of the Original Picture Controls can be customized to fit your personal preferences. You can adjust the settings to your liking, giving the images more sharpening and less contrast or a myriad of other options.

Note

Although you can adjust the Original Picture Controls you cannot save over them, so there is no need to worry about losing them.

There are a few different customizations to choose from:

- Quick adjust. This option only works with SD and VI. This option exaggerates or deemphasizes the effect of the Picture Control in use. Quick adjust can be set from ±2.
- Sharpness. This controls the apparent sharpness of your images. You can adjust this setting

from 0-9, 9 being the highest level of sharpness. You can also set this to Auto (A) to allow the camera's imaging processor to decide how much sharpening to apply.

- Contrast. This setting controls the amount of contrast your images are given. In photos of scenes with high contrast (sunny days), you may want to adjust the contrast down; in low contrast scenes, you may want to add some contrast by adjusting the settings up. You can set this from ±3 or to A.
- Brightness. This adds or subtracts from the overall brightness of your image. You can choose 0 (default) + or -.
- Saturation. This setting controls how vivid or bright the colors in your images are. You can set this between ±3 or set to A. This option is not available in the MC setting.
- Hue. This setting controls how your colors look. You can choose ±3. Positive numbers make the reds look more orange, the blues look more purple, and the greens look more blue. Choosing a negative number causes the reds to look more purple, the greens to look more yellow, and the blues to look more green. This setting is not available in the MC Picture Control setting. I highly recommend leaving this in the default setting of 0.
- Filter Effects. This setting is only available when set to MC. The monochrome filters approximate the types of filters traditionally used with black and white film.

These filters increase contrast and create special effects. The options are:

- Yellow. Adds a low level of contrast. It causes the sky to appear slightly darker than normal and anything yellow to appear lighter.
- Orange. Adds a medium amount of contrast. The sky will appear darker, giving greater separation between the clouds. Orange objects appear light grey.
- Red. Adds a great amount of contrast, drastically darkening the sky while allowing the clouds to remain white. Red objects appear lighter than normal.
- Green. Darkens the sky and lightens any green plant life. This color filter can be used for portraits as it softens skin tones.
- Toning. Toning adds a color tint to your monochrome (black and white) images.
 - B&W. The black and white option simulates the traditional black and white film prints done in a darkroom. The camera records the image in black, white, and shades of gray. This mode is suitable for use when the color of the subject is not important. It can be used for artistic purposes or, as with the sepia mode, to give your image an antique or vintage look.
 - Sepia. The sepia color option duplicates a photographic toning process that is done in a

traditional darkroom using silver-based black and white prints. Sepia toning a photographic image requires replacing the silver in the emulsion of the photo paper with a different silver compound thus changing the color or tone of the photograph. Antique photographs were generally treated to this type of toning; therefore the sepia color option gives the image an antique look. The images have a reddish brown look to them. You may want to use this option when trying to convey a feeling of antiquity or nostalgia to your photograph. This option works well with portraits as well as still life and architecture. You can also adjust the saturation of the toning from 1 to 7, with 4 being the default and the middle ground.

Cyanotype. The Cyanotype is another old photographic printing process; in fact it's one of the oldest. When exposed to the light the chemicals that make up the cyanotype turn a deep blue color. This method was used to create the first blueprints and was later adapted to photography. The images taken when in this setting are in shades of cyan. Because cyan is considered to be a cool color, this mode is also referred to as cool. This mode can be used to make very interesting and artistic images. You can also adjust the saturation of the toning from 1 to 7, 4 being the default setting.

Chapter 2 + Nikon D300 Essentials 57

• Color toning. You can also choose to add colors to your monochrome images. Although this is similar to Sepia and Cyanotype, this type of toning isn't based on traditional photographic processes. This is simply adding a colorcast to a black and white image. There are seven different color options you can choose from: red, yellow, green, blue-green, blue, purple-blue, and red-purple. As with Sepia and Cyanotype, you can adjust the saturation of these toning colors.

To customize an Original Picture Control:

- 1. Go to the Set Picture Control option in the Shooting menu. Press the multi-selector right.
- Choose the Picture Control you want to adjust. For small adjustments choose the NL or SD option. To make larger changes to color and sharpness, choose the VI mode. To make adjustments to monochrome images, choose MC. Press the multi-selector right.
- 3. Press the multi-selector up or down to highlight the setting you want to adjust (sharpening, contrast, brightness, and so on). When the setting is highlighted, press the multi-selector left or right to adjust the settings. Repeat this step until you've adjusted the settings to your preferences.
- Press the OK button to save the settings. To return the settings to default (reset), press the Delete button. A confirmation dialog box appears.

- 5. Select Yes and press the OK button to reset. Select No and press the OK button to cancel the reset.
- Note When the Original Picture Control settings have been altered, an asterisk is displayed with the Picture Control setting (SD*, VI*, and so on).

To save a Custom Picture Control, follow these steps:

- Go to the Manage Picture Control option in the Shooting menu. Press the multi-selector right.
- 2. Press the multi-selector up or down to select Save/edit. Press the multi-selector right.
- 3. Choose the Picture Control to edit.
- 4. Press the multi-selector up or down to highlight the setting you want to adjust (sharpening, contrast, brightness, and so on). When the setting is highlighted, press the multi-selector left or right to adjust the settings. Repeat this step until you've adjusted the settings to your preferences.
- Press the OK button to save the settings. To return the settings to default (reset), press the Delete button. A confirmation dialog box appears.
- 6. Select Yes and press the OK button to reset. Select No and press the OK button to cancel the reset. Once you press the OK button to accept the settings, the camera displays the Save as menu.

- 7. Use the multi-selector to highlight the Custom Picture Control you want to save to. You can store up to nine Custom Picture Controls; they are labeled C-1 through C-9. Press the multi-selector right.
- 8. When the Rename menu appears, press the Zoom in button and press the multi-selector left or right to move the cursor to any of the 19 spaces in the name area of the dialog box. New Picture Controls are automatically named with the Original Picture Control name and a two digit number (STANDARD _02 or VIVID_03).
- 9. Press the multi-selector (without pressing the Zoom) to select letters in the keyboard area of the dialog box. Press the multiselector center button to set the selected letter and press the Delete button to erase the selected letter in the Name area. Once you have typed in the name you want, press the OK button to save it. The Custom Picture Control is then saved to the Picture Control menu and can be accessed through the Set Picture Control option in the Shooting menu.

Your Custom Picture Controls can be renamed or deleted at any time by using the Manage Picture Control option in the Shooting menu. You can also save the Custom Picture Control to your memory card so that you can import the file to Capture NX or View NX. To save a Custom Picture Control to the memory card:

- Go to the Manage Picture Control option in the Shooting menu. Press the multi-selector right.
- Press the multi-selector up or down to highlight the Load/save option. Press the multi-selector right.
- Press the multi-selector up or down to highlight the Copy to card option. Press the multiselector right.
- Press the multi-selector up or down to select the Custom Picture Control to copy. Press the multi-selector right.
- Select a destination on the memory card to copy the Picture Control file to. Each CF card is given 99 slots in which to store Picture Control files.
- Once you've chosen the destination, press the multi-selector right. The file is then stored to your CF card.

After you've copied your Custom Picture Control file to your card, you can then import the file to the Nikon software by mounting the CF card to your computer by your usual means (card reader or USB camera connection). See the software user's manual for instructions on importing to the specific program.

Chapter 2 + Nikon D300 Essentials 59

You can also upload Picture Controls that are saved to a CF card to your camera:

- Go to the Manage Picture Control option in the Shooting menu. Press the multi-selector right.
- Press the multi-selector up or down to highlight the Load/save option. Press the multi-selector right.
- Press the multi-selector up or down to highlight the Copy to camera option. Press the multiselector right.
- Select the Picture Control to copy. Press the OK button or multi-selector right to confirm.
- The camera then displays the Picture Control settings. Press the OK button. The camera automatically displays the Save as menu.
- Select an empty slot to save to (C-1 through C-9).
- 7. Rename the file if necessary. Press the OK button.

Image Size and Compression

When saving to JPEG format, the D300 allows you to choose an image size. Reducing the image size is like reducing the resolution on your camera; it allows you to fit more images on your card. What size you choose depends on what your output is going to be. If you know you will be printing your images at a large size, then you definitely want to record large JPEGS. If you're going to print at a smaller size (8×10 or 5×7), you can get away with recording at the medium or small setting. Image size is expressed in pixel dimensions. The large setting records your images at 4288×2848 pixels; this gives you a file that is equivalent to 12.3 megapixels. Medium size gives you an image of 3216×2136 pixels, which is in effect the same as a 6.8 megapixel camera. The small size gives you a dimension of 2144×1424 pixels, which gives you about a 3 megapixel image.

Other than the size setting, which changes the pixel dimension, you have the compression settings Fine, Normal, and Basic. There considerable controversy regarding is whether compressing a JPEG to a smaller size reduces the actual resolution. This controversy stems from the fact that when a JPEG file is closed, it compresses to a smaller size, discarding some of the image information to save space. When set to Basic or Normal, more information is discarded, supposedly resulting in less image detail. Some photographers say that using the Fine setting is the only way to go while others profess that the Normal setting is perfectly good for print use.

I don't want to choose sides in this controversy. The advice that I offer is this; set up a shot and take one at each of the settings, make a print of each and decide for yourself whether or not you can see an appreciable difference.

Bit Depth

Simply put, bit depth is how many separate colors your sensor can record. The term bit depth is derived from digital terminology. A bit is the smallest unit of data; it is expressed in digital language as either a 1 or a 0. Most digital images saved as JPEG or TIFF are recorded in 8 bits or 1 byte per channel (each primary color being a separate color: red, green, and blue [RGB]) resulting in a 24-bit image. For each 8 bits there are 256 possible colors; multiply this by 3 channels and you get over 16 million different colors, which is plenty enough information to create a realistic looking digital image. By default the D300 records its RAW files using a bit depth of 12 bits per channel giving you a 36-bit image. What this means is that your sensor can recognize far more shades of color, which gives you a smoother gradation in tones, allowing the color transitions to be much smoother. In addition to the 12-bit setting, the D300 also offers the option of recording your RAW files at 14 bits per channel, which gives you even more color information to deal with when processing your images.

All of this comes with a cost; the higher the bit depth, the more information contained in the file. This makes your files pretty big, especially when shooting 14-bit RAW files, which can give you absolutely huge files. When shooting at 14 bits, the camera has much more image data to contend with, so your frame rate is reduced to 2.5 fps.

I find that for most applications shooting RAW files at 12-bit is more than enough color information. I only switch to 14-bit when shooting portraits, especially when the portraits are low-key. This helps get much smoother transitions from the shadow areas to the highlights.

LiveView

LiveView is one of the newest innovations in dSLR technology. This feature allows you to use the LCD preview screen as a viewfinder. This feature can be very helpful when you are taking pictures where the camera is at an awkward angle. An example of this would be at a concert you could hold the camera over your head and use the screen to frame the shot.

There are two LiveView options, hand-held and tripod. Obviously, the hand-held mode is for when you are shooting the camera while handholding it. When the camera is in this mode, the camera functions more or less like a point and shoot camera. There are some differences though. In order for the camera to focus, the mirror must flip down, temporarily interrupting the LiveView preview. You must also press the shutter release button multiple times to actually fire the shutter and get an exposure. I must admit, although I have found myself using the hand-held option more frequently than I expected to, I find it kind of tricky to get it to work properly.

To operate the camera in hand-held LiveView mode:

 Turn the release mode dial to Lv (LiveView). Be sure that the LiveView mode is set to hand-held. This can be found in the Shooting menu under LiveView.

- Press the Shutter Release button to raise the mirror. The LCD then displays what the lens is seeing.
- Use the LCD to frame your subject.
- 4. Once your subject is framed, press the Shutter Release button halfway or press the AF-ON button. The camera's mirror then flips down, interrupting the LiveView. If the button is released, the mirror flips back up and LiveView returns without taking a picture.
- 5. To take the picture, press the Shutter Release button fully.

The Tripod mode is for use when shooting still subjects while the camera is mounted to a stationary object (tripod). The Tripod mode functions a bit differently than handheld mode. When the camera is in handheld mode, the camera uses what is known as phase-detection focus. This is the normal way the D300 determines the focus for the camera. Phase-detection focus works by obtaining information from a special focusing sensor inside the camera. When the camera's LiveView is set to Tripod mode, the focusing is obtained by the contrast-detection method. This is the same method that compact point and shoot digital cameras use to determine focus. This method works by reading data directly from the imaging sensor. The camera adjusts the lens until the sensor detects the greatest amount of contrast in the image. This method takes longer to achieve proper focus, hence the shutter lag (delay) that occurs with most point and shoot cameras.

To use LiveView in Tripod mode:

- 1. Attach the camera to a tripod or set the camera on a stable object.
- 2. Turn the Release mode dial to Lv (LiveView).
- 3. Use the viewfinder to frame the subject.
- 4. Press the multi-selector button to navigate to the AF point to the area of the frame that you want to focus on. Be sure to choose a spot that has adequate contrast or the camera will not be able to achieve focus.
- Press the AF-ON button to focus. The camera will NOT focus by pressing the Shutter Release button halfway.
- Press the Shutter Release button fully. The mirror flips up and the image is displayed in the LCD monitor.
- 7. Check the image in the LCD monitor. You can use the Zoom in button to view the image closer to ensure that it's in focus. Use the multi-selector to scroll around to areas that aren't in view when the image is zoomed in. Press the OK button to exit zoom. You can also press the AF-ON button to refocus, and you can use the multi-selector to change AF points (as long as you are not zoomed in).
- 8. Press the Shutter Release button to take the picture.

Some other information on shooting in the LiveView Tripod mode:

- HDMI. If the camera is connected to an HDTV, the LCD monitor is switched off, and the TV can be used to preview the image.
- Shooting info. The shooting information which is normally displayed on the image can be turned off by pressing the INFO button.
- Monitor brightness. You can adjust the brightness of the LCD monitor by pressing the Play button and using the multi-selector up/down buttons.
- Remote release. If using an optional remote release cable, you can activate the AF by pressing the button halfway for over a second. If the button is fully depressed without activating the AF, your image may be blurry.

Setting up the Nikon D300

he first few sections of the book cover how to change the main settings of your D300. In this chapter, I delve a little more in depth into the menu options. Here you can custom tailor the D300 options to fit your shooting style, to help refine your workflow, or to make adjustments to refine the camera settings to fit different shooting scenarios.

Some of these options are the same as those you can access and adjust by pushing a button and/or rotating a command dial. Most of the options, though, are to change things that don't need to be changed very often or quickly.

The menus are accessed by pressing the Menu button on the back of the camera. Use the multi-selector to scroll through the toolbar on the right side of the LCD. When the desired menu is highlighted, press the OK button or multi-selector right to enter the menu. Pressing the Menu button again or tapping the Shutter Release button exits the Menu mode screen and readies the camera for shooting.

Playback Menu

The Playback menu is where you manage the images stored on your flash card. The Playback menu is also where you control how the images are displayed and what image information is displayed during review. There are nine options available from the Playback menu, which are explained in the following sections.

In This Chapter Playback menu Shooting menu Custom Settings menu Setup menu Retouch Menu My Menu

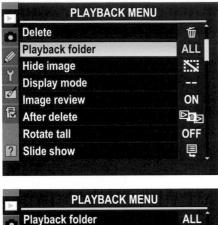

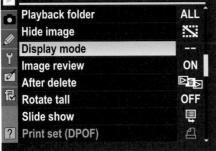

3.1 The Playback menu – the top image shows the first eight options, the bottom is scrolled to show the last option, Print set (DPOF).

Delete

This option allows you to delete selected images from your memory card or to delete all of the images at once.

To delete selected images:

1. Press the multi-selector right, highlight Selected (default), and press the multi-selector to the right again. You can now select the image you want to delete.

- 2. Use the multi-selector to choose the image. You can also use the Zoom in button to review the image close up before deleting. Press the center button of the multi-selector to set the image for deletion; more than one image can be selected.
- Press the OK button to erase the selected images. The camera will ask you for confirmation before deleting the images.
- Select Yes then press the OK button to delete. To cancel the deletion, highlight No (default), then press the OK button.

To delete all images:

- 1. Use the multi-selector to highlight All, and then press the OK button. The camera will ask you for confirmation before deleting the images.
- 2. Select Yes, and then press the OK button to delete. To cancel deletion, highlight No (default), then press the OK button.

Playback folder

This menu allows you to choose the folder from which to display images for review. The default setting is ND300, which displays images from all folders created with the D300. Selecting All also displays images from all folders. Selecting Current displays images only from the folder to which the camera is actively saving at the time.

Changing the active folder is covered later in this chapter.

Hide image

This option allows you to protect an image from being viewed during playback. To select images to be hidden, press the multiselector right, highlight Select/set (default), and press the multi-selector right. Use the multi-selector to highlight the thumbnail images you want to hide and press the OK button.

To allow the hidden images to be displayed, highlight Deselect all. When the camera asks for confirmation before revealing the images, select Yes and press the OK button to display during playback. To cancel and continue hiding the images, highlight No (default) and press the OK button.

Display mode

The Display mode settings allow you to customize the information that is shown when reviewing the images that are stored on your CF card.

The Display mode options are:

- Highlights. When this option is activated any highlights that are blown out will blink. If this happens, you may want to apply some exposure compensation or adjust your exposure to be sure to capture highlight detail.
- Focus point. When this option is set the focus point that was used is overlaid on the image to be reviewed. No focus point is displayed if the camera did not achieve focus or if Continuous AF was used in conjunction with Autoarea AF.

- RGB Histogram. When this option is turned on you can view the separate histograms for the Red, Green, and Blue channels along with a standard histogram.
- Data. This option allows you to review the shooting data (metering, exposure, lens focal length, and so on).

To select a display mode, follow these steps:

- 1. Enter the Display mode menu by pressing the multi-selector right.
- 2. Use the multi-selector to highlight the option you want to set, and then press the multi-selector right or the OK button to set the display feature. The feature is set when a checkmark appears in the box to the left of the setting.
- Scroll up to Done and press the OK button to set the display. If this step is not completed, the information will not appear in the display.

Image review

This option allows you to choose whether the image is shown on the LCD immediately after the image is taken. When this option is turned off (default), the image can be viewed only by pressing the Playback button.

After delete

This allows you to choose which image is displayed after you delete an image during playback.

The options are:

- Show next. This is the default setting. The next image taken is displayed after the selected image is deleted. If the image deleted is the last image, the previous image is displayed.
- Show previous. After the selected image is deleted the one taken before it is displayed. If the first image is deleted the following image is displayed.
- Continue as before. This option allows you to continue in the order that you were browsing the images. If you are scrolling through as shot, the next image is displayed (Show next). If you are scrolling through in reverse order, the previous image is shown (Show previous).

Rotate tall

This rotates images that are shot in portrait orientation to be displayed upright on the LCD screen. I usually turn this option off because the portrait orientation image appears substantially smaller when displayed upright on the LCD.

The options are:

 On. The camera automatically rotates the image to be viewed while holding the camera in the standard upright position. When this option is turned on, the camera orientation is recorded for use in image-editing software. Off (default). When the auto-rotating function is turned off, images taken in portrait orientation are displayed on the LCD sideways in landscape orientation.

Slide show

This allows you to display a slide show of images from the current active folder. You can choose an interval of 2, 3, 5, or 10 seconds.

While the slide show is in progress, you can use the multi-selector to skip forward or back (left or right), and view shooting info or histograms (up or down). You can also press the Menu button to return to the Playback menu, press the Playback button to end the slide show, or press the Shutter Release button lightly to return to Shooting mode.

Print set (DPOF)

DPOF stands for Digital Print Order Format. This option allows you to select images to be printed directly from the camera. This can be used with Pict-bridge-compatible printers or DPOF-compatible devices such as a photo kiosk at your local photo printing shop. This is a pretty handy feature if you don't have a printer at home and want to get some prints made quickly, or if you do have a printer and want to print your photos without downloading them to your computer.

To create a print set:

1. Use the multi-selector to choose the Print set (DPOF) option, and then press the multi-selector right to enter the menu.

- 2. Use the multi-selector to highlight Select/set, then press the multi-selector right to view thumbnails. Press the Zoom in button to view a larger preview of the selected image.
- **3. Use the multi-selector to highlight an image to print.** When the desired image is highlighted, press the Protect (key) button and press the multi-selector up/down to choose the number of prints you want of that specific image. You can choose from 1 to 99. The number of prints and a small printer icon appears on the thumbnail. Continue this procedure until you have selected all of the images that you want to print.
- Press the OK button. A menu appears with three options:
 - **Done (default).** Press the OK button to save and print the images as they are.
 - **Data imprint.** Press the multiselector right to set. A small check appears in the box next to the menu option. When this option is set, the shutter speed and aperture setting appear on the print.
 - **Date imprint.** Press the multiselector right to set. A small check appears in the box next to the menu option. When this option is set, the date the image was taken appears on the print
- If you choose to set the imprint options, be sure to return to the Done option and press the OK button to complete the print set.

Shooting Menu

The Shooting menu is where you can change the different options of how the images are stored as well as other settings

SHOOTING ME	NU
Shooting menu bank	A
Reset shooting menu	
Active folder	100
File naming	JDT
Image quality	RAW
Image size	
JPEG compression	-
NEF (RAW) recording	Ē

SHOOTING MEN	U
White balance	AUTO
Set Picture Control	⊡ SD
Manada Distura Control	
Color space	sRGB
Active D-Lighting	BE H
Long exp. NR	OFF
High ISO NR	OFF
ISO sensitivity settings	Ē

Color space	sRGB
Active D-Lighting	BE H
Long exp. NR	OFF
High ISO NR	OFF
ISO sensitivity settings	
Live view	Ē
Multiple exposure	OFF
Interval timer shooting	OFF

3.2 The Shooting menu – here shown in three sections so you can see all the available options

such as white balance and JPEG compression. There are 19 options in the Shooting menu.

Shooting menu bank

The Shooting menu bank allows you to store different combinations of settings for use during different shooting scenarios. If you shoot a variety of subjects and you change your settings depending on the subject, you can save your shooting settings so you can pull up the settings quickly rather than changing them all separately. For example, when you shoot landscapes, you may want to shoot RAW images at 14-bit. with your white balance set to Daylight, and the Picture Control set to Vivid: but when you shoot portraits, you like to shoot Large JPEG images, with the white balance set to Auto, and Picture Control set to Standard. You can save these groups of settings to separate banks and recall them when shooting that particular type of subject.

You have four banks available where you can save your settings: A, B, C, and D. Each of these banks can be renamed so you can easily remember which bank is for what subject. To rename the bank, use the Rename option at the bottom of the menu.

Reset shooting menu

Choosing this menu option resets the current Shooting menu bank to camera default, which is bank A.

Active folder

This allows you to select a folder to which the images can be recorded. You may want to choose a new folder to help keep your images separated by subject.

File naming

When image files are created, the D300 automatically assigns a filename. The default filenames start with DSC_ followed by a four-digit number and the file extension (DSC_0123.jpg) when using the sRGB color space. When using the Adobe RGB color space, the filenames start with _DSC followed by a four-digit number and the file extension (_DSC0123.jpg).

This menu option allows you to customize the filename by replacing the DSC prefix with any three letters of your choice. For example, I customized mine so that the filename reads JDT_0123.jpg.

To customize the filename:

- Highlight the File naming option in the Shooting menu. Press the multi-selector right to enter the menu.
- The menu shows a preview of the filename (sRGB: DSC_1234 / Adobe RGB: _DSC1234). Press the multi-selector right to enter a new prefix.
- **3. Use the multi-selector to choose the letters and/or numbers.** Press the OK button when finished.

Image quality

This menu option allows you to change the image quality of the file. You can choose from these options:

 NEF (RAW) + JPEG fine. This option saves two copies of the same image, one in RAW and one in JPEG with minimal compression.

- NEF (RAW) + JPEG normal. This option saves two copies of the same image, one in RAW and one in JPEG with standard compression.
- NEF (RAW) + JPEG basic. This option saves two copies of the same image, one in RAW and one in JPEG with high compression.
- NEF (RAW). This option saves the images in RAW format.
- TIFF (RGB). This option saves the images in TIFF format.
- JPEG fine. This option saves the images in JPEG with minimal compression.
- JPEG normal. This option saves the images in JPEG with standard compression.
- JPEG basic. This option saves the images in JPEG with high compression.

These settings can also be changed by pressing the QUAL button and rotating the Main Command dial. The setting can be viewed on the LCD control panel on the top of the camera.

For more information on image quality, compression, and file formats, see Chapter 2.

Image size

This allows you to choose the size of the TIFF and JPEG files.

For more information on image size, see Chapter 2.

The choices are:

- Large. This setting gives you a full resolution image of 4288 × 2848 pixels or 12.2 megapixels.
- Medium. This setting gives you a resolution of 3216 × 2136 pixels or 6.9 megapixels.
- Small. This setting gives your images a resolution of 2144 × 1424 pixels or 3.1 megapixels.
- Note Image quality, size, and JPEG compression can also be changed by pressing the QUAL button and rotating the Main Command dial. The settings are shown on the LCD control panel on the top of the camera.

JPEG compression

This menu allows you to set the amount of compression applied to the images when recorded in the JPEG file format.

The options are:

- Size Priority. With this option the JPEG images are compressed to a relatively uniform size. Image quality can vary depending on the amount of color information in the scene. Use this option when memory card space is limited.
- Optimal quality. This option provides the best compression algorithm. The file sizes vary with the information contained in the scene recorded. Use this mode when image quality is a priority.

(NEF) RAW recording

This option is for setting the amount of compression applied to RAW files. This menu is also where you choose the bit depth of the RAW file.

Use the Type sub-menu (accessed from the RAW recording menu) to choose the compression. The options are:

- Lossless compressed. This is the default setting. The RAW files are compressed reducing the file size from 20-40 percent with no apparent loss of image quality.
- Compressed. The RAW file is compressed by 40-50 percent. There is some file information lost.
- Uncompressed. The RAW file is saved to the card exactly as it was recorded. There is no compression. The file sizes can be very large.

Use the NEF (RAW) bit depth sub-menu to choose the bit depth of the RAW file; there are two options:

- 12 bit. This records the RAW file with 12 bits of color information.
- 14 bit. This records the RAW file with 14 bits of color information. The file size is significantly larger, but there is much more color information for smoother color transitions in your images.

For more information on RAW compression and bit depth, see Chapter 2.

White balance

You can change the white balance options using this menu option. The white balance can also be changed using the WB button on the top of the camera.

For detailed information on white balance settings, see Chapter 2.

Set Picture Control

Nikon has included what is called Picture Controls in the D300. These controls allow you to choose how the images are processed and they can also be used in Nikon's image-editing software Nikon View and Nikon Capture NX. These Picture Controls allow you to get the same results when using different cameras that are compatible with the Nikon Picture Control System.

There are four standard Nikon Picture Controls:

- Standard (SD). This applies slight sharpening and a small boost of contrast and saturation. This is the recommended setting for most shooting situations.
- Neutral (NL). This setting applies a small amount of sharpening and no other modifications to the image. This setting is preferable if you often do extensive post-processing to your images.

Chapter 3 + Setting up the Nikon D300 71

- Vivid (VI). This setting gives your images a fair amount of sharpening. The contrast and saturation are boosted dramatically resulting in brightly colored images. This setting is recommended for printing directly from the camera or flash card as well as for shooting landscapes. Personally, I feel that this mode is a little too saturated and often results in unnatural color tones. This mode is not recommended for portrait situations, as skin tones are not reproduced well.
- Monochrome (MC). As the name implies, this option makes the images monochrome. This doesn't simply mean black and white, but you can also simulate photo filters and toned images such as sepia, cyanotype, and more.

All of these standard Nikon Picture Controls can be adjusted to suit your specific needs or tastes. In the color modes – SD, NL, and VI – you can adjust the sharpening, contrast, brightness, hue, and saturation. In MC mode you can adjust the filter effects and toning. After the Nikon Picture Controls are adjusted you can save them for later use. You can do this in the Manage Picture Control option described in the next section.

For detailed information on customizing and saving Picture Controls, see Chapter 2.

Manage Picture Control

This menu is where you can edit, save, and rename your Custom Picture Controls. There are four menu options:

- Save / edit. In this menu, you choose a Picture Control, make adjustments to it, then save it. You can rename the Picture Control to help you remember what adjustments were made or to remind you of what the Custom Picture Control is to be used for. For example, I have one named SuperVivid, which has the contrast, sharpening, and saturation boosted as high as it can go. I sometimes use this setting when I want crazy, oversaturated, unrealistic-looking images for abstract shots or light trails.
- Rename. This menu allows you to rename any of your Custom Picture Controls. You cannot, however, rename the standard Nikon Picture Controls.
- Delete. This menu gives you the option of erasing any Custom Picture Controls you have saved. This menu only includes controls you have saved or may have downloaded from an outside source. The standard Nikon Picture Controls cannot be deleted.
- Load / save. This menu allows you to upload Custom Picture Controls to your camera from your memory card, delete any Picture Controls saved to your memory, or you can save a Custom Picture Control to your memory card to export to Nikon View or Capture NX or to another camera that is compatible with Nikon Picture Control.

Cross-Reference

For detailed information on creating and managing Picture Controls, see Chapter 2.

Color space

Color space simply describes the range of colors, also known as the gamut, that a device can reproduce. You have two choices of color spaces with the D300: sRGB and Adobe RGB. The color space you choose depends on what the final output of your images will be.

- sRGB. This is a narrow color space, meaning that it deals with fewer colors and also less-saturated colors than the larger Adobe RGB color space. The sRGB color space is designed to mimic the colors that can be reproduced on most low-end monitors.
- Adobe RGB. This color space has a much broader color spectrum than is available with sRGB. The Adobe gamut was designed for dealing with the color spectrum that can be reproduced with most high-end printing equipment.

This leads to the question of which color space you should use. As I mentioned earlier, the color space you use depends on what the final output of your images is going to be. If you take pictures, download them straight to your computer, and typically only view them on your monitor or upload them for viewing on the Web, then sRGB will be fine. The sRGB color space is also useful when printing directly from the camera or memory card with no post-processing.

If you are going to have your photos printed professionally or you intend to do a bit of post-processing to your images, using the Adobe RGB color space is recommended. This allows you to have subtler control over the colors than is possible using a narrower color space like sRGB. For the most part, I capture my images using the Adobe RGB color space. I then do my post-processing and make a decision on the output. Anything that I know I will be posting to the Web I convert to sRGB; anything destined for my printer is saved as Adobe RGB. I usually end up with two identical images saved with two different color spaces. Because most Web browsers don't recognize the Adobe RGB color space, any images saved as Adobe RGB and posted on the Internet will usually appear dull and flat.

Active D-Lighting

Active D-Lighting is a setting that is designed to help ensure that you retain highlight detail when shooting in a high-contrast situation, such as shooting a picture in direct bright sunlight, which can cause dark shadows and bright highlight areas. Active D-Lighting basically tells your camera to underexpose the image a bit; this underexposure helps keep the highlights from becoming blown out and losing detail. The D300 also uses a subtle adjustment to avoid losing any detail in the shadow area that the underexposure may cause.

Caution

Active D-Lighting is a separate and different setting than the D-Lighting option found in the Retouch menu. For more information on standard D-Lighting, see Chapter 8.

Long exp. NR

This menu option allows you to turn on noise reduction (NR) for exposures longer than 8 seconds. When this option is on, after taking a long exposure photo the camera runs a noise-reduction algorithm, which reduces the amount of noise in your image giving you a smoother result.

High ISO NR

This allows you to choose how much noise reduction (NR) is applied to images that are taken at ISO 800 or higher. There are four settings:

- High. This setting applies a fairly aggressive NR. A fair amount of image detail can be lost when this setting is applied.
- Normal. This is the default setting. Some image detail may be lost when using this setting.
- Low. A small amount of NR is applied when this option is selected. Most of the image detail is preserved when using this setting.
- Off. When this setting is chosen, no NR is applied to images taken between ISO 100 (L 0.1) and 3200; however, a very small amount of NR is applied to images shot at ISO 4200 (H 0.3) and above.

ISO sensitivity settings

This menu option allows you to set the ISO. This is the same as pressing the ISO button and rotating the Main Command dial. You also use this menu to set the Auto ISO parameters.

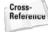

For more information on ISO settings and noise reduction, see Chapter 2.

Live view

This is where you can change the settings for the LiveView feature of the D300. There are two settings:

- Hand held. This is the default setting. This setting is to be used when you are holding the camera. When set to this option the camera uses a phase-detection focus, which is the same way the camera focuses when shooting normally. The image in the viewfinder is blacked out when the camera is focusing.
- Tripod. Use this option when the camera is attached to a tripod for shooting nonmoving subjects. When the option is activated, the camera uses contrast-detection to focus on the subject. The camera analyzes the data directly from the image sensor to determine the proper focus. This method takes a little longer to achieve focus; therefore, it is unsuitable for moving subjects.

You can also set the release mode for shooting (Single, Continuous Low, or Continuous High) through the Release mode sub-menu.

Multiple exposure

This allows you to record multiple exposures in one image. You can record from two to ten shots in a single image.

To use this feature, follow these steps:

- 1. Select Multiple exposure from the Shooting menu, and then press the multi-selector right.
- 2. Select the Number of shots menu option, and then press the multi-selector right.
- Press the multi-selector up or down to set the number of shots. Press the OK button when the number of shots selected is correct.

- Select the Auto gain option, and then press the multi-selector right.
- 5. Set the gain, and then press the OK button. Using auto gain enables the camera to adjust the exposure according to the number of images in the multiple exposures. This is the recommended setting for most applications. Setting the gain to Off does not adjust the exposure values and can result in an overexposed image. The Gain-off setting is recommended only in low-light situations. When the desired setting is chosen, press the OK button.
- Use the multi-selector to highlight Done, then press the OK button. This step is very important. If you do not select Done, the camera will not be in Multiple exposure mode.
- 7. Take your pictures. Once the selected amount of images has been taken, the camera exits Multiple exposure mode and returns to the default shooting setting. To do additional multiple exposures repeat the steps.

Interval timer shooting

This menu option allows you to set the camera's time-lapse photography option. This allows you to set your camera to shoot a specified number of shots at specified intervals throughout a set period of time. You can set:

- Starting time. The camera can be set to start 3 seconds after the settings have been completed (Now) or you can set to start photographing at a predetermined time in the future.
- Interval. This determines how much time is elapsed between each shot. You can set Hours, Minutes, and Seconds.
- Number of intervals. This sets how many times you want photos to be shot.
- Shots per interval. This sets how many shots are taken at each interval.
- On or Off. This starts or stops the camera from shooting with the current settings.

Custom Settings Menu

The Custom Settings menu (CSM) is where you really start getting into customizing your D300 to shoot to your personal preferences. You can also choose four banks in which to store your settings for different shooting situations, similar to the Shooting Menu banks. This is a very in-depth menu system with a lot of submenus so here I just give a brief description of what each setting is used for.

Custom setting bank

You can choose up to four banks in which to store your specialized settings for easy recall. Simply select a bank -A, B, C, or D - then change any of the custom settings to the option of your choice. The changed settings are stored until you choose to reset custom settings (described in the next section).

You can also choose to select the Rename option in the Custom setting bank menu to add a descriptive name to your Custom setting bank to help you remember what your Custom setting bank is to be used for.

The active Custom setting bank is displayed in the LCD control panel on the top of the camera and can also be seen in the Shooting info display on the main LCD when the Info button is pressed.

Reset custom settings

Use this option to restore the camera default settings for the active Custom shooting bank. So if the Custom setting bank is set to A, all of the settings in bank A will return to camera default.

CSM a - Autofocus

The CSM submenu a controls how the camera performs its autofocus (AF) functions. There are 16 choices to choose from.

a1 - AF-C priority selection

This chooses how the camera AF functions when in Continuous autofocus (AF-C) mode. You can choose from three modes:

- Release. This is the default setting. It allows the camera to take a photo whenever the Shutter button is pressed regardless of whether the camera has achieved focus or not.
- Release + focus. This allows the camera to take pictures when the subject is not in focus, but slows the frame rate to allow the camera more time to focus on the subject.
- Focus. This allows the camera to take photos only when the camera achieves focus and the focus indicator (green dot in the lower-left corner of the viewfinder) is displayed.

	a Autofocus	
-	a1 AF-C priority selection	
	a2 AF-S priority selection	
5	å 3 Dynamic AF area	[¢]3D
T	å4 Focus tracking with lock-on	OFF
đ	a5 AF activation	ON
	å6 AF point illumination	ON
	a7 Focus point wrap-around	ON
?	a8 AF point selection	AF51

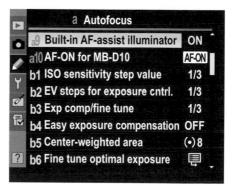

3.3 CSM a – shown in two sections so all options are visible

a2 – AF-S priority selection

This sets how the camera AF functions when in single autofocus (AF-S) mode. You can choose from these two settings.

- Release. This is the default setting. It allows the camera to take a photo whenever the Shutter Release button is pressed regardless of whether the camera has achieved focus or not.
- Focus. This allows the camera to take photos only when the camera achieves focus and the focus indicator (green dot in the lower-left corner of the viewfinder) is displayed.

a3 – Dynamic AF area

This allows you to set how many focus points to use when using Dynamic AF area. Choose the amount of focus points by determining how much your subject may move. You can choose from four options – 9, 21, or 51 points, or also 51 points with 3D Tracking.

Cross-Reference For more information on Dynamic AF area, see Chapter 2.

a4 - Focus tracking with lock-on

When photographing in busy environments, things can often cross your path resulting in the camera refocusing on the wrong subject. Focus tracking lock-on allows the camera to hold focus for a time before switching to a different focus point. This helps stop the camera from switching focus to an unwanted subject passing through your field of view.

You can choose Long, Normal, or Short delay times. You can also set the focus tracking lock-on to off, which allows your camera to quickly maintain focus on a rapidly moving subject. Normal is the default setting.

a5 – AF activation

By default the camera's AF system is activated by half-pressing the Shutter Release button or by pressing the AF-ON button. This option allows you to set the D300 so that the AF is activated only when pressing the AF-ON button. If the camera is set to AF-ON, half pressing the shutter only activates the camera's metering system. This is a personal preference, and I like to use the Shutter Release button to engage the AF.

a6 – AF point illumination

This menu option allows you to choose whether the active AF is shown in the viewfinder. When choosing Auto, which is the default, the focus point is lit only to establish contrast from the background. When set to On, the active AF point is always lit even when the background is bright. When set to Off, the active AF point is not shown.

a7 – Focus point wrap-around

When using the multi-selector to choose your AF point, this setting allows you to be able to keep pressing the multi-selector in the same direction and wrap around to the opposite side or stop at the edge of the focus point frame (no wrap).

a8 - AF point selection

This option allows you to choose the number of available focus points for you to choose from when using AF. You can set 51 points, which allows you to choose all of the D300's available focus points. You can also set it to 11 points, which allows you to choose from only 11 focus points similar to the D200. Use the 11-point option to select your focus points much more quickly than using 51 points. The 51 point option allows you to more accurately choose where in the frame the camera will focus on.

a9 – Built-in AF-assist illuminator

The AF-assist illuminator lights up when there isn't enough light for the camera to focus properly. In certain instances, you may want to turn this option off, such as when shooting faraway subjects in dim settings (concerts or plays). When set to On, the AFassist illuminator lights up in a low-light situation only when in AF-S mode and Auto-area AF is chosen. When in Single point mode or Dynamic area AF is chosen, the center AF point must be active.

When set to Off, the AF-assist illuminator does not light at all.

a10 - AF-ON for MB-D10

This allows you to assign a specific function to the AF-ON button on the optional MB-D10 battery grip. You can choose from:

- AF-ON. This is the default setting. Pressing this button activates the camera's AF.
- AE/AF Lock. This locks the camera's focus and exposure while the button is pressed.
- AE Lock only. This only locks the exposure while the button is pressed.
- AE Lock (Reset on release). This locks the exposure. The exposure remains locked until the button is pressed again, the shutter is released, or the camera's exposure meter is turned off.

- AE Lock (hold). The exposure is locked when the button is pressed and remains locked until the button is pressed again or until the exposure meter turns off.
- AF Lock only. Locks the focus until the button is released.
- Same as Func. button. This sets the MB-D10 AF-ON button to the same settings as the camera's Function button. The Function button is set in CSM f4.

CSM b – Metering/ exposure

This is where you change the settings that control exposure and metering. These settings allow you to adjust the exposure, ISO, exposure compensation adjustment increments. Setting the increments to 1/3 stops allows you to fine tune the settings with more accuracy than setting them to 1/2 or 1 full stop. There are six options to choose from.

3.4 CSM b menu, which follows the CSM a menu directly

b1 - ISO sensitivity step value

This is where you control whether the ISO is set in 1/3-, 1/2-, or 1-stop increments.

b2 – EV steps for exposure cntrl.

This determines how the shutter speed, aperture, and bracketing increments are set. The choices here are also 1/3, 1/2, or 1 stop. Choosing a smaller increment gives a much less drastic change in exposure in your bracketed images.

b3 – Exp comp/fine tune

This allows you to choose whether the exposure compensation is set in 1/3-, 1/2-, or 1-stop increments.

b4 – Easy exposure compensation

By default, to set the exposure compensation, you must first press the EV button and use the Main Command dial to add or subtract from the selected exposure. If you tend to use exposure compensation frequently, you can save yourself some time by using this option to set Easy exposure compensation. When this function is set to On, it's not necessary to press the EV button to adjust the exposure compensation. Simply rotate the Main Command dial when in Aperture Priority mode or the Sub-command dial when in Programmed Auto or Shutter Priority mode to adjust the exposure compensation. The exposure compensation is then applied until you rotate the appropriate command dial until the exposure compensation indicator disappears from the LCD control panel.

If you choose to use Easy exposure compensation, probably the best setting to use is the On (Auto reset) setting. This allows you to adjust your exposure compensation while shooting, but returns the exposure compensation to default (0) when the camera is turned off or when the camera's exposure meter turns off. If you've ever accidentally left exposure compensation adjusted and ended up with wrongly exposed images the next time you used your camera, you will appreciate this helpful feature.

When set to Off, exposure compensation is applied normally.

b5 – Center-weighted area

This menu allows you to choose the size of your center-weighted metering area. You can choose from four sizes: 6, 8, 10, or 13mm. You also have the option of setting the meter to Average.

Choose the spot size depending on how much of the center of the frame you want the camera to meter for. The camera determines the exposure by basing 75 percent of the exposure on the circle.

Cross-Reference

For more information on centerweighted metering, see Chapter 2.

b6 – Fine tune optimal exposure

If your camera's metering system consistently over- or underexposes your images, you can adjust it to apply a small amount of exposure compensation for every shot. You can apply a different amount of exposure fine-tuning for each of the metering modes: Matrix, Center-weighted, and Spot metering.

You can set the EV ± 1 stop in 1/6 stop increments.

Caution

When Fine tune optimal exposure is on, there is no warning indicator that tells you that exposure compensation is being applied.

CSM c – Timers / AE lock

This small submenu controls the D300's various timers and also the Auto-exposure lock setting. There are 4 options to choose from.

Shutter-release button AE-L	OFF
c2 Auto meter-off delay	● 6s
č3 Self-timer delay	Ö 2s
c4 Monitor off delay	@20
ð1 Beep	OFF
å2 Viewfinder grid display	ON
d3 Viewfinder warning display	ON
d4 CL mode shooting speed	- 단 3

3.5 CSM c menu options

c1 - Shutter-release button AE-L

Set to default (Off), the camera only locks exposure when the AE-L/AF-L button is pressed. When set to On, the auto-exposure settings are locked when the camera's Shutter Release button is half-pressed.

c2 - Auto meter-off delay

The menu option is used to determine how long the camera's exposure meter is active before turning off when no other actions are being performed. You can choose 4, 6, 8, 16, or 30 seconds; or 1, 5, 10, or 30 minutes. You can also specify for the meter to remain on at all times while the camera is on (no limit).

c3 - Self-timer delay

This setting puts a delay on when the shutter is released after the Shutter Release button is pressed. This is handy when you want to do a self-portrait and you need some time to get yourself into the frame. The selftimer can also be employed to reduce camera shake caused by pressing the Shutter Release button on long exposures. You can set the delay at 2, 5, 10, or 20 seconds.

c4 - Monitor off delay

This controls how long the LCD monitor remains on when no buttons are being pushed. Because the LCD monitor is the main source of power consumption for any digital camera, choosing a shorter delay time is usually preferable. You can set the monitor to turn off after 10 or 12 seconds, or 1, 5, or 10 minutes.

CSM d - Shooting / display

CSM submenu d is where you make changes to some of the minor shooting and display details. There are 11 options to choose from.

Beep	OFF
å2 Viewfinder grid display	ON
d3 Viewfinder warning display	ON
å4 CL mode shooting speed	묩6
d5 Max. continuous release	100
d6 File number sequence	ON
å7 Shooting info display	W
d8 LCD illumination	OFF

	and the fact that the
Exposure delay mode	OFF
d10 MB-D10 battery type	û NHMH
å11 Battery order	MB-D10
Flash sync speed	1/200
e2 Flash shutter speed	1/60
e3 Flash cntrl for build-in flash	TTL4
ê4 Modeling flash	OFF
65 Auto bracketing set	WB

3.6 CSM d – shown on two screens so all options are visible

d1 – Beep

When this option is on, the camera emits a beep when the self-timer is counting down or when the AF locks in Single focus mode. You can choose High, Low, or Off.

d2 – Viewfinder grid display

Set this option to display grids in the viewfinder (or the LCD when in LiveView) to assist you with composition of the photograph.

d3 – Viewfinder warning display

This option allows you to choose whether the camera warns you of low battery power in the viewfinder display. When set to Off, no warning is displayed. The warning however is still displayed in the LCD control panel on the top of the camera.

d4 – CL mode shooting speed

This allows you to set the maximum frame rate in the Continuous Low shooting mode. You can set the frame rate between 1 and 7 fps. This setting limits your burst rate for shooting slower moving action.

The maximum continuous frame rate without the optional MB-D10 battery grip is 6 fps.

d5 – Max. continuous release

This option sets the maximum number of images that can be captured in a single burst when the camera is set to Continuous shooting mode. You can set this anywhere from 1 to 100.

d6 – File number sequence

The D300 names files by sequentially numbering them. This option controls how the sequence is handled. When set to Off, the file numbers reset to 0001 when a new folder is created, a new memory card is inserted, or the existing memory card is formatted. When set to On, the camera continues to count up from the current number until the file number reaches 9999. The camera then returns to 0001 and counts up from there.

d7 - Shooting info display

This controls how the shooting info display on the LCD panel is colored. When set to Auto (default), the camera automatically sets it to White on Black or Black on White to maintain contrast with the background. You can also choose for the information to be displayed consistently no matter what the background is. You can choose B (black lettering on a light background) or W (white lettering on a dark background).

d8 – LCD illumination

When this option is set to Off (default), the LCD control panel is lit only when the power switch is turned all the way to the right. When set to On, the LCD control panel is lit as long as the camera's exposure meter is active.

d9 – Exposure delay mode

Turning this option on causes the shutter to open about 1 second after the Shutter Release button is pressed and the reflex mirror has been raised. This option is for shooting long exposures with a tripod where camera shake from pressing the Shutter Release button and mirror slap vibration can cause the image to be blurry.

d10 – MB-D10 battery type

When using the optional MB-D10 battery pack with AA batteries, use this option to specify what type of batteries are being used to ensure optimal performance. Your choices are:

Chapter 3 + Setting up the Nikon D300 81

- LR6 (AA alkaline)
- + HR6 (AA Ni-Mh)
- FR6 (AA Lithium)
- ZR6 (AA Ni-Mn)

d11 – Battery order

This option is used to set which order the batteries are used when the optional MB-D10 battery grip is attached. Choose MB-D10 to use the battery grip first, or choose D300 to use the camera battery first.

CSM e – Bracketing / flash

This submenu is where you set the controls for the built-in Speedlight. Some of these options affect external Speedlights. This menu is also where the controls for Bracketing images are located. There are seven choices.

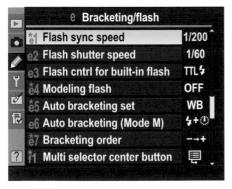

3.7 CSM e

e1 - Flash sync speed

This is where you determine what shutter speed your camera uses to sync with the Speedlight. You can set the sync speed between 1/60 and 1/250 second. When using an optional SB-800 or SB-600, you can also set the sync to 1/250 or 1/320 (Auto FP); this allows you to use faster shutter speeds to maintain wider apertures if needed.

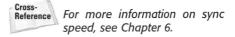

e2 - Flash shutter speed

This option lets you decide the slowest shutter speed that is allowed when you do flash photography using front curtain sync or Red-Eye Reduction mode when the camera is in P or A exposure mode. You can choose from 1/60 second all the way down to 30 seconds.

When the camera is set to Shutter priority or the flash is set to any combination of Slow sync, this setting is ignored.

e3 - Flash cntrl for built-in flash

This submenu has other submenus nested within it. Essentially, this option controls how your built-in flash operates. The four submenus are:

- TTL. This is the fully auto flash mode. Minor adjustments can be made using FEC (Flash Exposure Compensation).
- Manual. You choose the power output in this mode. You can choose from Full power all the way down to 1/128 power.
- Repeating flash. This mode fires a specified number of flashes.
- Commander mode. Use this setting to control a number of offcamera CLS-compatible Speedlights.

Cross-Reference

For more information on flash photography, see Chapter 6 or pick up a copy of the Nikon Creative Lighting System Digital Field Guide (Wiley).

e4 - Modeling flash

When using an optional SB-600 or SB-800 Speedlight, pressing the Depth of Field preview button fires a series of low-power flashes that allow you to preview what the effect of the flash is going to be on your subject. You can set this to On or Off.

e5 – Auto bracketing set

This option allows you to choose how the camera brackets when Auto-bracketing is turned on. You can choose for the camera to bracket AE and flash, AE only, Flash only, or WB bracketing. WB bracketing is not available when the image quality is set to record RAW images.

e6 - Auto bracketing (Mode M)

This determines which settings the camera changes to adjust the exposure when using Auto-bracketing in Manual exposure mode. The options are:

- Flash / speed. The camera varies the shutter speed and flash output (when set to AE + flash), or the shutter speed only (when set to AE only).
- Flash / speed / aperture. The camera varies the shutter speed, aperture, and flash output (when set to AE + flash), or the shutter speed and aperture (when set to AE only).

- Flash / aperture. The camera varies the aperture and flash level (when set to AE + flash) or the aperture only (when set to AE only).
- Flash only. The camera varies the flash level only (when set to AE + flash).

e7 - Bracketing order

This determines the sequence in which the bracketed exposures are taken. When set to default (N), the camera first takes the metered exposure, the underexposures next, then the overexposures. When set to (- -> +), the camera starts with the lowest exposure increasing the exposure as the sequence progresses.

CSM f – Controls

This submenu allows you to customize some of the functions of the different buttons and dials of your D300. There are ten options to choose from.

f1 - Multi selector center button

This allows you to set specific options for pressing the center button of the multiselector. The options vary depending on whether the camera is in Shooting or Playback mode.

Shooting mode

In Shooting mode, the options are as follows:

 Select center focus point. This allows you to automatically select the center focus point by pressing the center button of the multiselector.

Chapter 3 + Setting up the Nikon D300 83

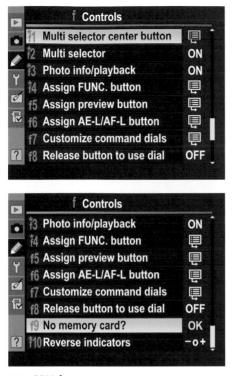

3.8 CSM f

- Highlight selected focus point. This causes the active focus point to light up in the viewfinder when the center button of the multiselector is pressed.
- Not used. The center button has no effect when in shooting mode.

Playback mode

In Playback mode the options are as follows:

 Thumbnail on/off. This allows you to switch between full-frame Playback and Thumbnail view by pressing the center button of the multi-selector.

- View histogram. This option displays the histogram of the current image selected when the center button of the multi-selector is pressed.
- Zoom on/off. Pressing the center button of the multi-selector allows you to automatically zoom in to the selected image to check focus. You can choose Low, Medium, or High magnification.
- Choose folder. Pressing the center button of the multi-selector displays the list of folders currently on the flash card. You can then choose a folder to play back images from.

f2 – Multi selector

This allows you to set the multi-selector to turn on the exposure meter when pressed. By default, the meter will not turn on when the multi-selector is pressed in shooting mode.

f3 – Photo info / playback

When in Playback mode, the left and right buttons on the multi-selector scroll through the images while the up/down buttons display additional information such as histograms and shooting info. Using this option allows you to reverse the way these buttons function.

f4 - Assign FUNC. button

This button chooses what functions the Function button performs when pressed. The options are:

- Preview. The Depth of Field preview is activated.
- FV lock. The flash exposure value locks, allowing you to meter the subject then recompose the shot without altering the flash exposure.
- AE/AF Lock. The focus and exposure lock when the button is pressed and held.
- AE lock only. The exposure locks when the button is pressed and held.
- AE lock (reset on release). The exposure locks when the button is pressed. The exposure remains locked until the shutter is released, the Function button is pressed again, or the exposure meter turns off.
- AE Lock (hold). The exposure locks until the button is pressed a second time.
- AF Lock only. The focus locks while the button is pressed and held.
- Flash off. The flash does not fire when the Function. button is pressed and held.
- Bracketing burst. The camera fires a burst of shots when the Shutter Release button is pressed and held while in Single shot mode when Auto-bracketing is turned on. The number of shots fired depends on the Auto-bracketing settings. When in Continuous shooting mode, the camera continues to run through the bracketing sequence as long as the Shutter button is held down.
- Matrix metering. Allows you to automatically use Matrix metering no matter what the metering mode dial is set to.

- Center-weighted. Allows you to automatically use Center-weighted metering no matter what the metering mode dial is set to.
- Spot metering. Allows you to automatically use Spot metering no matter what the metering mode dial is set to.
- None. The default setting. No function is performed when the button is pressed.

A second subset in this menu is Func. + dials. This allows you to use the Function button in combination with the Main Command or Sub-command dial to perform certain functions. The options are:

- 1 step spd / aperture. When the Func. button is pressed, the aperture and shutter speed are changed in 1-stop intervals.
- Choose non-CPU lens number. Press the Function button and rotate the Main Command dial to choose one of your presets.
- Auto-bracketing. This is the default setting. Pressing and holding the Function button and rotating the Main Command dial changes the number of shots in the bracketing series. Rotating the Main Command dial allows you to change the EV increments.
- Dynamic area AF mode. This allows you to choose the number of focus points when using Dynamic AF-area mode by pressing the Function button and rotating either the Main Command or Subcommand dial. Note that the camera must be in AF-C and Dynamic AF-area mode.
- None. No functions are performed.

f5 - Assign preview button

This allows you to assign a function to the Depth of Field preview button. The choices are exactly the same as that of the Function button.

f6 - Assign AE-L / AF-L button

This allows you to assign a function to the AE-L/AF-L button. The choices are exactly the same as that of the Function button with the addition of an AF-ON setting.

f7 – Customize command dials

This menu allows you to control how the Main Command and Sub-command dials function. The options are:

- Reverse rotation. This causes the settings to be controlled in reverse of what is normal. For example, by default, rotating the Sub-command dial right makes your aperture smaller. Reversing the dials gives you a larger aperture when rotating the dial to the right.
- Change main / sub. This switches functions of the Main Command dial to the front and the Subcommand dial to the rear of the camera.
- Aperture setting. This allows you to change the aperture only using the aperture ring of the lens. Note that most newer lenses have electronically controlled apertures (Nikkor G lenses) and do not have an aperture ring. When used with a lens without an aperture ring the Sub-command dial controls the aperture by default.

Menus and playback. This allows you to use the Command dials to scroll the menus and images in much the same fashion that the multi-selector is used. In playback mode, the main command dial is used to scroll through the preview images and the Sub-command dial is used to view the shooting information and/or histograms. When in Menu mode, the Main Command dial functions the same as the multi-selector up/down and the Sub-command dial operates the same as the multi-selector left/right.

f8 – Release button to use dial

When changing the Shooting mode, exposure compensation, Flash mode, WB, QUAL, or ISO, you must press and hold the corresponding button by default. This setting allows you to press and release the button, make changes using the command dials, then press the button again to set.

f9 – No memory card?

This setting controls whether the shutter will release when no memory card is present in the camera. When set to Enable release, the shutter fires and an image is displayed in the monitor but will not be saved. When set to Release locked, the shutter will not fire.

f10 – Reverse indicators

This allows you to reverse the indicators on the electronic light meter displayed in the viewfinder and on the LCD control panel on the top of the camera. For some, the default setting showing the overexposure on the left and the underexposure on the right is counterintuitive. Reversing these makes more sense to some people (including me).

Setup Menu

This menu contains a smattering of options, most of which aren't changed very frequently. Some of these settings include the time and date and the video mode. A couple of other options are the Clean image

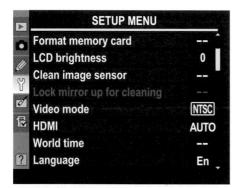

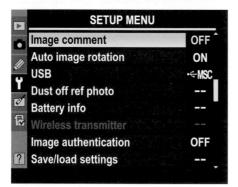

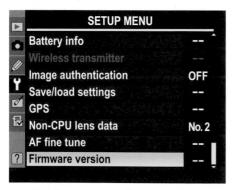

3.9 The Setup Menu shown in three frames to fit it all in

sensor and Battery info, which you may want to access from time to time. There are 20 different options.

Format memory card

This allows you to completely erase everything on your CF card. Formatting your memory card erases all of the data on the card. It's a good idea to format your card everytime you download the images to your computer (just be sure all of the files are successfully transferred before formatting). Formatting the card helps protect against corrupt data. Simply erasing the images leaves the data on the card and allows it to be overwritten; sometimes this older data can corrupt the new data as it is being written. Formatting the card gives your camera a blank slate on which to write.

You can also format the card using the much more convenient two-button method (pressing and holding the Delete and MODE button simultaneously).

LCD brightness

This menu sets the brightness of your LCD screen. You may want to make it brighter when viewing images in bright sunlight or make it dimmer when viewing images indoors or to save battery power.

Clean image sensor

This is one of the best new features on the D300. The camera uses ultrasonic vibration to knock any dust off the filter in front of the sensor. This helps keep most of the dust off of your sensor but is not going to keep it absolutely dust free forever. You may have to have the sensor professionally cleaned periodically. There are two options you can

Chapter 3 + Setting up the Nikon D300 87

choose for cleaning the sensor. You can choose Clean now, which cleans the image sensor immediately, or you can choose for the camera to clean the image sensor whenever the camera is turned on or off.

Lock mirror up for cleaning

This locks up the mirror to allow access to the image sensor for inspection or for additional cleaning. The sensor is also powered down to reduce any static charge that may attract dust. I recommend taking your camera to an authorized Nikon service center for any sensor cleaning.

Video mode

There are two options in this menu: NTSC and PAL. Without getting into too many specifics, these are types of standards for the resolution of televisions. All of North America, including Canada and Mexico, use the NTSC standard, while most of Europe and Asia use the PAL standard. Check your television owner's manual for the specific setting if you plan to view your images on a TV directly from the camera.

HDMI

The D300 has an HDMI (high-definition multi-media interface) output that allows you to connect your camera to a high-definition TV to review your images. There are five settings: 480p, 576p, 720p, 1080i, and Auto. The Auto feature automatically selects the appropriate setting for your TV. Before plugging your camera in to an HD TV I recommend reading your TV's owner's manual for specific settings.

World time

This is where you set the camera's internal clock. You also select a time zone, choose the date display options, and turn the daylight-saving time options on or off.

Language

This is where you set the language that the menus and dialog boxes display.

Image comment

You can use this feature to attach a comment to the images taken by your D300. You can enter the text using the Input Comment menu. The comments can be viewed in Nikon's Capture NX or View NX software or can be viewed in the photo info on the camera. Setting the attach comment option applies the comment to all images taken until this setting is disabled. Some comments you may want to attach are copyright information or your name, or even the location where the photos were taken.

Auto image rotation

This tells the camera to record the orientation of the camera when the photo is shot (portrait or landscape). This allows imageediting software to show the photo in the proper orientation so you don't have to take the time in post-processing to rotate images shot in portrait orientation.

USB

This option tells your camera in which mode to operate when connected to your computer via the USB cable. There are two options:

- Mass Storage (MSC). This allows your camera to show up on your computer as an external hard drive. The files on the memory card can be directly accessed and you can then drag and drop them to the desired place on your computer.
- MTP/PTP (M/P). This stands for Media Transfer Protocol / Picture Transfer Protocol. Simply put, this allows your camera to interact with your computer and specific software on a two-way basis. So you can use software such as Capture NX to give instructions to the camera on where and how to transfer your images. The camera must be set to PTP in order to use Nikon's Camera Control Pro software, which allows you to control your camera settings from your computer.

Dust off ref photo

This option allows you to take a dust reference photo that shows any dust or debris that may be stuck to your sensor. Capture NX then uses the image to automatically retouch any subsequent photos where the specks appear.

Battery info

This handy little menu allows you to view information about your batteries. It shows you the current charge of the battery as a percentage and how many shots have been taken using that battery since the last charge. This menu also shows the remaining charging life of your battery before it is no longer able to hold a charge. I find myself accessing this menu quite a bit to keep a real-time watch on my camera's power levels.

When using the MB-D10 and AA batteries, the number of pictures taken and charging life are not shown.

Wireless transmitter

This option is used to change settings of the optional WT-4a wireless transmitter. You cannot access this menu option when the WT-4a is not attached.

Image authentication

This allows you to embed information to your images while they are being captured. Any subsequent altering of the images can be detected using Nikon's optional Image Authentication Software. Police and government agencies usually use this option to verify that an image hasn't been manipulated and therefore can be used as evidence in court.

Save / load settings

This allows you to save the current camera settings to the memory card. You can then load these settings back to your camera in case of an accidental reset or load them onto a second D300 to duplicate the settings quickly.

GPS

This menu is used to adjust the settings of an optional GPS unit, which can be used to record longitude and latitude to the image's EXIF data. The GPS is connected to the camera's ten-pin remote terminal using an optional MC-35 GPS adapter.

Non-CPU lens data

This menu is used to input lens data from a non-CPU lens. You can save focal length and aperture values for up to nine lenses. This feature is handy because if the camera knows the focal length and aperture of the lens attached, it can apply the information to some of the automatic settings that wouldn't normally be available without the lens communicating with the camera body. Some of the automatic settings referred to include the Auto-zoom on optional SB-600 and 800 Speedlights, the focal length and aperture appear in the EXIF data, flash level can be adjusted automatically for changes in aperture, and color matrix metering can be used.

To set the lens data when using a non-CPU lens, follow these steps:

- 1. Select non-CPU lens data from the Setup menu using the multiselector, and then press the multi-selector right.
- 2. Select a lens number to set the information to using the multiselector left/right button, and choose from 1 to 9. Press the multi-selector down button.
- Select the focal length of your non-CPU lens. You can use a lens from as wide as 6mm to as long as 4000mm. Press the multi-selector down.
- Choose the maximum aperture of your lens. You can choose from f/1.2 to f/22.
- Using the multi-selector, scroll up to highlight Done, and press the OK button to save the lens data.

AF fine tune

This option allows you to adjust the AF to fit a specific lens. Lenses are manufactured to tight specifications, but every once in a while there may be something a little off in the manufacturing process that might cause the lens to mount a little differently or perhaps one of the lens elements has shifted a few microns. These small abnormalities can cause the lens to shift its plane of focus behind or in front of the imaging sensor. I would say that this is probably a rare occurrence, but it's a possibility.

You can now fine-tune the camera's AF to correct for any focusing problems. Another good thing about this feature: If you're using a CPU lens, the camera remembers the finetuning for that specific lens and adjusts it for you automatically.

Because there is really no simple way to determine if your lens needs an AF fine tune adjustment unless it's so out of whack that it's completely obvious, I recommend leaving this feature alone for the most part. A little Unsharp Mask in post-processing usually cures any minor blurring issues.

I'm sure there are a few of you out there who will insist on testing out this feature so here is a very brief description on how to go about doing it:

- 1. Using the multi-selector, choose AF fine tune from the Setup menu and press the OK button.
- 2. Turn AF fine tune on by selecting it in the menu, and press the OK button.
- 3. Highlight Saved value and press the OK button.

90 Part I + Using the Nikon D300

- 4. Use the multi-selector up and down portions to adjust the plane of focus. You'll have to use a little guesswork. Determine if the camera is focusing behind the subiect or in front of it and if so, how far?
- 5. Once it's adjusted, press the OK button
- 6. Set the Default. This should be set to 0. Press the OK button.
- Note

The saved value stores separate tuning values for each individual lens. This is the value that will be applied when the specific lens is attached and the AF fine tune is turned on.

When the AF fine tune is on and a lens without a stored value is attached, the camera will use the default setting. This is why I recommend setting the default to 0 until you can determine whether the lens needs fine tuning or not.

Each CPU lens you fine-tune is saved into the menu. To view them, select List Saved Values. From there you can assign a number to the saved values from 0-99 (although the camera only stores 12 lens values). I'm not sure what the reasoning is behind this odd numbering system.

The best thing to do when attempting to fine-tune your lenses is to set them up one by one and do a series of test shots. The test shots have to be done in a controlled manner so there are no variables to throw off your findings.

The first thing to do is to set up a still life. You want the subject to be fairly high in contrast with a good amount of depth so you can determine if you need to adjust the finetuning forward or backward. The subject needs to be lit well for maximum contrast.

Next, set your camera Picture Control to ND or neutral. Ensure that all in-camera sharpening is turned off and contrast adjustments are at zero. This is to be sure that you are seeing actual lens sharpness, not sharpness created by post-processing.

Mount the camera on a tripod and adjust the camera so that the lens is perpendicular to the subject and about the same height. Set the camera to Single area AF mode and pick a spot to focus on. Be sure not to change the focus point or move the tripod while making your tests. Set the camera to Aperture priority and open the aperture to its widest setting to achieve a narrow depth of field (this makes it easier to figure out where the focus is falling-in the front or the back). Shoot a series of images. The first image should be shot with no AF fine-tuning. Next, make some large adjustments to the AF fine-tuning (+5, -5, +10, -10, +15, -15, +20, -20), taking a shot at each setting. Be sure to defocus and refocus after adjusting the settings to ensure accurate results. Compare these images and decide which setting brings the focus closest to the selected focus point. After comparing them vou may want to do a little more finetuning, to -7 or +13, for example.

This can be a very tedious and timeconsuming project. That being said, most lenses are already spot on and it probably isn't necessary to run a test like this on your lens unless it is extremely noticeable that the lens is consistently out of focus.

Firmware version

This menu option displays which firmware version your camera is currently operating under. Firmware is a computer program that is embedded in the camera that tells it how to function. Camera manufacturers routinely update the firmware to correct for any bugs

or to make improvements on the camera's functions. Nikon posts firmware updates on its Website at www.nikonusa.com.

Note

As of this writing Nikon has posted a firmware update to address some instances of banding that may affect some cameras when doing exposures over 8 seconds long. Banding is the appearance of light or dark stripes in the image. This is most noticeable in the shadow areas of the image. Although most cameras are not affected by this problem it's recommended that you complete the firmware update.

Retouch Menu

The Retouch menu allows you to make changes and corrections to your images with the use of imaging-editing software. As a matter of fact, you don't even need to download your images. You can make all of the changes in-camera using the LCD preview (or hooked up to a TV if you prefer).

The options include D-Lighting, Red-eye correction, Trim, Monochrome, Color effects, Color balance, and Image overlay.

The Retouch Menu is discussed at length in Chapter 8.

My Menu

This is a great new menu option. It replaces the Recent Settings menu in the D200.

Although the Recent Settings option was handy, the My Menu option allows you to create your own customized menu by choosing the options. You can also set the different menu options to whatever order you want. This allows you to have all of the settings you change the most right at your fingertips without having to go searching through all the menus and submenus. For example, I have the My Menu option set to display all of the menu options I frequently use, including Set Picture Control, Battery info, CSM e3, and Active D-Lighting among a few others. This saves me an untold amount of time because I don't have to go through a lot of different menus.

To set up your custom My Menu:

- 1. Select My Menu, and press the OK button.
- 2. Select add item and press the OK button.
- Use the multi-selector to navigate through the menus to add specific menu options, and press the OK button.
- Use the multi-selector to position where you want the menu item to appear and press the OK button to save the order.
- Repeat steps 2 to 4 until you have added all of the menu items you want.

Creating Great Images with the Nikon D300

In This Part

Chapter 4 Selecting and Using Lenses

Chapter 5 Essential Photography Concepts

Chapter 6 Working with Light

Chapter 7 Real-World Applications

Chapter 8 Viewing and In-Camera Editing

Selecting and Using Lenses

A lthough your D300 may have come with a kit lens – either the 18-135mm f/3.5-4.5G ED-IF AF-S DX or one of the other kit lenses – one of the best parts about owning a digital SLR camera is the ability to change out lenses to fit the specific photographic style or scene that you want to capture. After a while you may find that the kit lens isn't suiting your needs and you want to upgrade. The best part about owning a *Nikon* dSLR is that you have hundreds of different lenses to choose from, and Nikon's expertise in the field of lens manufacturing.

Arguably the most important part of the camera is the lens, especially when using a camera with a high resolution like the 12-megapixel D300. You want to have the best quality glass you can afford. The high-resolution imaging sensors can magnify any flaws in the lens, such as scratches or chromatic aberration. I don't recommend using low-price budget lenses with a camera of this caliber. You may save a few dollars in the beginning, but you will notice your images aren't as sharp or don't have as much contrast as images taken with high-end lenses with better quality glass.

If you've decided to upgrade your kit lens – or you just want to add to your lens collection – there are literally hundreds of options to choose from. You have a lot to consider when purchasing a lens; whether it's a zoom or prime lens, a wideangle or telephoto lens, or any of the numerous other options. The goal of this chapter is to give you a head start on knowing what kind of lens you want before you actually start looking. C H A P T E R

In This Chapter

Deciphering Nikon's lens codes

Zoom versus prime lenses

Crop factor

Wide-angle lenses

Normal lenses

Telephoto lenses

Macro lenses

Using VR lenses

Extending the range of any lens

Filters

Deciphering Nikon's Lens Codes

When shopping for lenses, you may notice all sorts of strange letter designations in the lens name. For example, the kit lens is the Nikkor 18-70mm f/3.5-4.5G ED-IF AF-S DX. So, what do all those letters mean? Here's a simple list deciphering all of the perplexing designations.

- AI / AIS. These are auto-indexing lenses that automatically adjust the aperture diaphragm down when the Shutter Release button is pressed. All lenses made after 1977 are AI lenses. These are all manual focus lenses.
- E. These lenses were Nikon's budget series lenses made to go with the lower-end film cameras: the EM, FG, and FG-20. Although these lenses are compact and are often constructed with plastic parts, some of theses lenses, especially the 50mm f/1.8, are of quite good quality and can be bought for next to nothing. These lenses are also manual focus only.
- D. Lenses with this designation convey distance information to the camera to aid in metering for exposure and flash.
- G. These are newer lenses that lack a manually adjustable aperture ring. The aperture must be set on the camera body.
- AF, AF-D, AF-I, and AF-S. All of these denote that the lens is an autofocus lens. The D is for distance, the I stands for internal focus, and the S is for Silent Wave (more on this later).

- DX. This lets you know the lens was designed for use only on a digital camera with an APS-C sized sensor (all Nikon dSLRs, with the exception of the D3). If you try to use a DX lens on a film camera, you will get severe vignetting in the image area.
- VR. This code denotes the lens is equipped with Nikon's Vibration Reduction system. VR shifts the lens elements to counteract camera shake when shooting at slower shutter speeds.
- ED. This indicates the glass in the lens is extra low dispersion, which means the lens is less prone to lens flare and chromatic aberrations than lenses without this type of glass.
- Micro. Even though they are labeled as micro, these are Nikon's macro lenses.

Courtesy of Nikon, Inc.

4.1 The Nikkor 18-70mm f/3.5-4.5G ED-IF AF-S DX. This lens is a G lens (no aperture ring) with extra-low dispersion glass, internal focusing, Silent Wave autofocus, and is made for use with APS-C sized digital sensors.

- IF. IF stands for internal focus. The focusing mechanism is inside the lens, so the lens doesn't change length and the front of the lens doesn't rotate when focusing. This feature is useful when you don't want the front of the lens element to move; for example, when you use a polarizing filter. The internal focus mechanism also allows for faster focusing.
- Note

Nikon is by no means the only manufacturer of lenses. Many different companies make lenses specifically to fit the Nikon, including Tamron, Sigma, and Tokina, to name a few.

Zoom versus Prime Lenses

A little more than a decade ago, zoom versus prime would have been a very hotly debated topic. In the past, zoom lenses, which can be adjusted between different focal lengths, had a very bad rap for good reason. They were heavy, badly designed, and slow. However, all of that is in the past. With the advent of new, more precise lens manufacturing technology – and new lightweight composites – zoom lenses today are almost, if not as good as, prime lenses (which have a fixed focal length that cannot be adjusted).

Backwards Compatibility

Nikon has been manufacturing its own lenses since about 1937, and with this history backing it up, you can be sure Nikon knows how to make some quality lenses. Although Nikon has been manufacturing lenses for many decades, with the D300 you can use almost every Nikon lens made since about 1977. In 1977, Nikon introduced the AI or Auto Indexing lens. Auto indexing allows the aperture diaphragm on the lens to stay wide open until the shutter is released; the diaphragm then closes down to the desired f-stop. This allows maximum light to enter the camera, which makes focusing easier. You can also use some of the earlier lenses, known now as pre-AI, but most need some modifications to work with the D300.

All of these early lenses are manual focus, but the D300 light meter still works when using them. You lose some of the D300's functions, however, such as 3D Color Matrix metering and Balanced Fill-Flash.

In the 1980s, Nikon started releasing AF lenses. Many of these lenses are very high quality and can be found at a much lower cost than their 1990s counterparts, the AF-D lenses. The main difference between the lenses is the D lenses provide the camera with distance information based on the focus of the subject. This distance information is not very crucial to exposure, so saving a little money by purchasing a non-D lens may be the way to go.

Zoom lens advantages

One of the main advantages of the zoom lens is its versatility. You can attach one lens to your camera and use it in a wide variety of situations. Gone is the need for constantly changing out lenses, which is a very nice feature because every time you take the lens off of your camera, the sensor is vulnerable to dust and debris.

Although today's zoom lenses can be just as sharp as a prime lens, you do have to pay for this quality. A \$150 zoom lens is not going to give you nearly the same quality as a \$1500 zoom lens. The good news is there is software with image sharpening features available that can tune up your image a little bit if you don't have or can't afford the sharpest zoom lens.

These days you can easily find a fast zoom lens. A fast zoom lens is a lens with an aperture of at least f/2.8. Years ago, finding a zoom lens with an aperture that fast was nearly impossible, unless you had an exorbitant amount of dispensable cash. Because you can easily change the ISO on a digital camera, and the noise created from using a high ISO is lessening, a fast zoom lens is not a complete necessity these days. I prefer a zoom lens with a wider aperture – not so much for the speed of the lens, but for the option of being able to achieve a shallower depth of field, which is very important in shooting portraits.

The range of the zoom lens has vastly improved over the years. Nikon makes an 18-200mm zoom lens that almost makes it unnecessary to ever take your lens off. This is an amazing range, spanning from a wideangle 18mm all the way to a long telephoto at 200mm. Of course, a zoom range like this comes with a few drawbacks. For example, the lens has a maximum aperture of f/3.5 at the 18mm setting (which is not bad) but a maximum of f/5.6 at the 200mm setting (which is very slow). Nikon makes up for the aperture by adding Vibration slow Reduction, which allows you to hand hold the camera at much slower shutter speeds. For the most part, you can get a full range of focal lengths with a fast aperture by buying only two lenses, an 18-70mm and a 70-200mm.

Courtesy of Nikon, Inc. 4.2 The Nikkor 18-200mm f/3.5-4.5G ED-IF AF-S DX Super-zoom lens

Prime lens advantages

Before zoom lenses were available, the only option a photographer had was using a prime lens, which is also called a fixed focal length lens. Because each lens is fixed at a certain focal length, such as 50mm, when the photographer wants to change the angle of view, he has to either physically move farther away from or closer to the subject or swap out the lens with one that has a focal length more suited to the range.

One might say, "Well, if I can buy one zoom lens that encompasses the same range as four or five prime lenses, then why bother with prime lenses?" While this may sound logical, there are a lot of reasons why you might choose a prime lens over a zoom lens.

In the past, prime lenses were far superior to zoom lenses. While this is no longer the case, prime lenses still offer some advantages over zoom lenses. For example, prime lenses don't require as many lens elements (pieces of glass) as zoom lenses do, and this means prime lenses are almost always sharper than zoom lenses. The differences in optical quality are not as noticeable as they were in the past, but with digital camera resolutions getting higher, the differences are definitely becoming more noticeable.

The most important features of the prime lens are the fact that they can have a faster maximum aperture, they are far lighter, and they cost much less. The standard prime lenses aren't very long, so the maximum aperture can be faster than with zoom lenses. Standard primes also require fewer lens elements and moving parts, so the weight can be kept down considerably; and because there are fewer elements, the overall cost of production is less, therefore you pay less. Note

Most serious photographers have some prime lenses that actually overlap the coverage of their zoom lenses.

One of the most widely sought after prime lenses is the Nikkor 50mm f/1.8. This lens is a must-have for anyone wishing to delve into the portraiture aspect of photography. The very wide aperture of this lens allows vou to blur out the background of the image, making the subject stand out. Although this lens was originally introduced as a normal lens for film cameras, with the dSLR cameras' smaller sensor and the 1.5X crop factor, this lens is now equivalent to a 75mm lens - perfect for portraits. The most popular portrait lens for the film camera was the 85mm f/1.8, so the 50mm essentially replaces that for the digital DX format cameras. One great thing about the Nikkor 50mm f/1.8 is that you can find them new for just over \$100 and used for less than \$100. The other great thing about this lens is it is one of the sharpest lenses you can buy

Courtesy of Nikon, Inc.

4.3 The Nikkor 50mm f/1.8 D fixed focal length prime lens. This is one of Nikon's sharpest and lowest-priced lenses.

for your camera. As long as it's in focus, you can be sure to capture an amazing amount of detail. This lens is not only great for portraits, but for still life and many other types of photography, especially in low light. I wholeheartedly advise anyone with a Nikon dSLR to buy this lens. It is simply amazing, not only in quality, but in price as well.

Crop Factor

Before you get too far into a discussion of lens focal lengths, you need to understand *crop factor.* Crop factor is a ratio that describes the size of a camera's imaging area as compared to another format; in the case of SLR cameras, the reference format is 35mm film.

SLR camera lenses were designed around the 35mm film format. Photographers use lenses of a certain focal length to provide a specific field of view. The field of view, also, called the angle of view is the amount of the scene that is captured in the image. This is usually described in degrees. For example, a 16mm lens when used on a 35mm camera captures almost 180-degrees horizontally of the scene, which is guite a bit. Conversely, when using a 300mm focal length the field of view is reduced to a mere 6.5-degrees horizontally, which is a very small part of the scene. The field of view was consistent from camera to camera because all SLRs used 35mm film which had an image area of 24 \times 36mm.

With the advent of digital SLRs, because the sensors are expensive to manufacture, the sensor was made smaller than a frame of 35mm film to keep costs down. The lenses that are used with dSLRs have the same

focal length they've always had, but because the sensor doesn't have the same amount of area as the film, the field of view is effectively decreased. This causes the lens to provide the field of view of a longer focal when compared to 35mm film images.

Fortunately, the digital sensors are a uniform size, thereby supplying consumers with a standard to determine how much the field of view is reduced on a dSLR with any lens. The digital sensors in Nikon cameras have a 1.5X crop factor, which means that to determine the equivalent focal length of a 35mm camera, you simply have to multiply the focal length of the lens by 1.5. Therefore, a 28mm lens provides an angle of coverage similar to a 42mm lens, a 50mm is equivalent to a75mm, and so on.

Early on, when dSLRs were first introduced, all lenses were based on 35mm format film. The crop factor effectively reduced the coverage of these lenses, causing ultra-wideangle lenses to act like wide-angles. wide-angle lenses performed like normal lenses, normal lenses provided the same coverage as short telephotos, and so on. Since then camera and lens manufacturers went to work creating specific lenses for dSLRs with digital sensors; these lenses are known as DX format. The focal lengths of these lenses were shortened to fill the gap to allow true super-wide angle lenses. These DX format lenses were also redesigned to cast a smaller image inside the camera so that the lenses could actually be made smaller and use less glass than conventional lenses. The downside is these lenses can't be used with 35mm film cameras because the image won't completely fill an area the size of the film sensor.

Chapter 4 + Selecting and Using Lenses 101

There is an upside to this crop factor. Lenses with longer focal lengths now provide a bit of extra reach. A lens set at 200mm now provides the same amount of coverage as a 300mm lens, which can be a great advantage for sports and wildlife photography or when you simply can't get close enough to your subject.

Wide-Angle Lenses

Wide-angle lenses, as the name implies, provide a very wide angle of view of the scene you are photographing. Wide-angle lenses are great for photographing a variety of subjects, but they really excel in subjects such as landscapes and group portraits where you need to capture a wide area of view.

Wide-angle lenses provide a larger depth of field than normal and telephoto lenses, so if you are photographing a landscape in which everything needs to be in focus, then you want to use a wide-angle lens.

Cross-Reference For more information on depth of field, see Chapter 5.

Another benefit to using wide-angle lenses is they work well for shooting in low light because you can use a longer shutter speed with less worry about camera shake blurring your photos. Wide-angle lenses also come in handy in a tight situation, such as photographing in a small room, because they do capture a wide area, so you can get very close to your subject.

Wide-angle lenses for the D300 range from about 10mm up to 24mm. Most of the wide-angle lenses commonly available on the market today are wide-angle zoom lenses with a zoom range of 12-24mm. These lenses are designed to be *rectilinear*, which means additional lens elements are built in to the lens to correct the distortion that is common with wide-angle lenses; this way, the lines near the edges of the frame appear straight.

Some lens manufacturers also offer super wide-angle *fisheye* lenses. A fisheye lens provides an angle of coverage of at least 180 degrees. A fisheye lens is not rectilinear, so the image will be distorted (resembling what a fish may see when looking out of a fishbowl), and the lines at the edges of the frame will appear bowed out and very exaggerated.

4.4 The image on the top is taken with a wide-angle zoom setting of 17mm, and the image on the bottom uses a moderate telephoto zoom setting of 50mm.

4.5 An image taken with a fisheye lens

Some of the drawbacks to wide-angle lenses can be obvious distortion at the edges of the frame and *vignetting*, or the darkening of the corners of the image. These problems tend to be more pronounced in the lower-priced lenses, and most of these problems can be fixed in post-processing using software such as Adobe Photoshop.

Another possible drawback to using a wideangle lens is the potential for *perspective distortion*. This happens when the lens is too close to the subject causing certain parts of the image to appear too large while other parts appear too small. This is especially evident with close-up portraits in which the subject's nose can appear huge and the face looks distorted. On the other hand, perspective distortion can be used creatively, allowing you to show an everyday object with a different point of view.

4.6 Wide-angle perspective distortion can also be used creatively.

I don't find the drawbacks to be much of a problem when using wide-angle lenses. I actually like to use them to my advantage. With perspective distortion, I get low and shoot upward at a subject, or get up high and shoot down, and I find that a lot of times making things look a little different than normal can make a mundane, everyday subject more interesting. Additionally, the vignetting issue can also be used to your advantage. Sometimes, the darkening of the corners in the image can draw the viewer's eve to the center of the frame, placing emphasis on the subject. I normally add a slight vignette to my images in post-processing anyway, so having the camera lens provide it for me actually saves me time!

Normal Lenses

A normal lens approximates the field of view of the human eye. In the past, with 35mm film cameras, the normal lens focal length was 50mm. dSLR cameras have a sensor that is smaller than a frame of 35mm film, so the normal lens focal length has shortened to a range from 28 to 35mm to accommodate for the smaller sensor size to see the same field of view as the 50 on 35mm.

Normal lenses are very versatile and can be used in a variety of shooting situations. Everything from landscapes to portraits can be photographed using a normal lens with very good results.

Most cameras today usually come equipped with a zoom lens that encompasses a wideangle to short telephoto zoom, such as the 18-135mm lens. It has the normal focal length somewhere in between the wide and telephoto settings, but a good 28 or 35mm prime lens can be found relatively inexpensively. And, either of these prime lenses are lighter and usually have a faster aperture than a common zoom lens. Therefore, one of these lenses can be very useful if you need to pack light or if you are shooting in low-light conditions.

Some people may shy away from normal lenses because they are referred to as normal. They can still produce very unique images. Ultimately, the lens doesn't make the photographs interesting, the photographer does. The 28mm f/2.8D is a fast and durable normal lens. This lens was almost the only one I ever used on my film camera, and it still finds its way onto my D300. It's much sharper than my zoom lens at a 28mm setting with an aperture of f/2.8, and when I need sharpness but I don't need a wide lens, this is the one I use. You can usually find this lens new for less than \$250.

4.7 Landscape photo shot with a 28mm lens

The Nikkor 35mm f/2 is also a great lens that can be found for around \$300. It's a little longer than the 28mm, but it's also about a half-stop faster, making this lens good for low-light situations.

Telephoto Lenses

Telephoto lenses are lenses with very long focal lengths and are used to get close-up photos of distant subjects. These lenses provide a very narrow field of view and are handy when trying to focus on the details of a subject. Telephoto lenses have a much shallower depth of field than wide-angle and normal lenses and can be used effectively to blur out background details to isolate the subject. Telephoto lenses are commonly used for subjects such as sports and wildlife photography. The shallow depth of field available makes them one of the top choices for photographing portraits as well.

As with wide-angle lenses, telephoto lenses also have optical aberrations, such as perspective distortion. As you may have guessed, telephoto perspective distortion is the opposite of the wide-angle variety. Because everything in the photo is so far away with a telephoto lens, the lens tends to compress the image. Compression causes the background to look too close to the foreground. Of course, this effect can also be used creatively. For example, compression can flatten out the features of a model, resulting in a pleasing effect. Compression is another reason why photographers often use a telephoto lens for portrait photography.

4.8 A portrait shot with a telephoto lens

Chapter 4 + Selecting and Using Lenses 105

A standard telephoto zoom lens usually has a range of about 70-200mm. If you want to zoom in close to a subject that is very far away, you may need an even longer lens. These super-telephoto lenses can act like telescopes, really bringing the subject in close. These long lenses range from about 300mm up to about 800mm. Almost all super-telephoto lenses are prime lenses, and they are very heavy, bulky, and expensive to buy. A lot of these lenses are a little slower than your normal telephoto zoom lens, usually having a maximum aperture of about f/4 or smaller.

When using a camera with a high-resolution sensor, such as the D300, you need to spend the extra money on quality lenses to be sure your images look as good as they can; otherwise, you may as well be shooting with a lower-resolution camera. Budget priced lenses such as the Nikkor 70-300mm f/4-5.6 will show a lower image quality due to the lower quality of the lens elements.

That being said, Nikon offers many highquality telephoto zoom lenses, and the most expensive one is not necessarily going to be the best one for the job. I have owned both the nearly \$2000 Nikkor 70-200 f/2.8G AF-S VR and the just under \$1000 Nikkor 80-200mm f/2.8D. I ended up reselling the more expensive lens because the image quality was about the same as the other lens. The bells and whistles, such as the VR and the Silent-Wave motor, aren't necessarily worth the extra money depending on where and what you shoot. When I compared the results from the two, they were nearly identical. The only difference seemed to be the 80-200mm focuses a little slower than the 70-200mm with the VR off.

4.9 Although these mountains are miles apart, the compression from the lens makes them look like they are stacked right on top of each other.

When I'm using a telephoto lens of this size, I'm usually at a racetrack photographing cars or at a concert or other sporting event, so the quiet AF isn't important. As for the VR, for my needs, I haven't been convinced it works well enough to justify the extra money. The moral is, don't be too budget-minded when buying a lens, but also don't be taken in by added features you may not need.

Macro Lenses

A macro lens is a special-purpose lens used in macro and close-up photography. The macro lens allows you to have a closer focusing distance than regular lenses, which in turn allows you get more magnification of your subject, revealing small details that would otherwise be lost. True macro lenses offer a magnification ratio of 1:1; that is, the image projected onto the sensor through the lens is the exact same size as the actual object being photographed.

Some lower-priced macro lenses offer a 1:2 magnification ratio, which is half the size of the original object.

One major concern with a macro lens is the depth of field. When focusing at such a close distance, the depth of field becomes very shallow, so often it is advisable to use a small aperture to maximize your depth of field and ensure everything is in focus. Of course, as with any downside, the shallow depth of field can also be used creatively. For example, you can use it to isolate a detail in the subject.

Macro lenses come in a variety of different focal lengths, with the most common being 50mm. Some macro lenses have substantially longer focal lengths, which allow more distance to be put between the lens and the subject. This comes in handy when the subject needs to be lit with an additional light source. A lens that is very close to the subject while focusing can get in the way of the light source causing a shadow to be cast on it.

When buying a macro lens, there are a few things you may want to consider: How often are you going to use the lens? Can it be used for other purposes? Do you need autofocus? Because newer dedicated macro lenses can be pricey, you may want to consider some cheaper alternatives.

The first thing you should know is that it's not absolutely necessary to have an AF lens. When shooting very close up, the depth of focus is very small, so all you need to do is move slightly closer or further away to achieve focus. This makes an AF lens a bit unnecessary. You can find plenty of older Nikon MF macro lenses that are very inexpensive, and the good thing is the lens quality and sharpness are still superb.

Note

Some other manufacturers also make very good quality MF macro lenses. The lens I use is a f/4 Macro-Takumar 50mm made for early Pentax screwmount camera bodies. I bought this lens for next to nothing, and I found an inexpensive adapter that allows it to fit the Nikon Fmount. The great thing about this lens is that it's super sharp and allows you to focus close enough to get a 4:1 magnification ratio, which is 4X life size.

Chapter 4 + Selecting and Using Lenses 107

4.10 A shot taken with a 50mm macro lens with a magnification ratio of 4:1 or 4X the original size

Using VR Lenses

Nikon has an impressive list of lenses that offer Vibration Reduction (VR). This technology is used to combat image blur caused by camera shake that occurs, especially when handholding the camera at long focal lengths. The VR function works by detecting the motion of the lens and shifting the internal lens elements. This allows you to shoot up to three stops slower than you would normally. If you're an old hand at photography, you probably know this rule of thumb: To get a reasonably sharp photo when handholding the camera, you should use a shutter speed that corresponds to the reciprocal of the lens' focal length. In simpler terms, when shooting at a 200mm zoom setting, your shutter speed should be at least 1/200 second. When shooting with a wider setting, such as 28mm, you can safely hand hold at around 1/30 second. Of course, this is just a guideline; some people are naturally steadier than others and can get sharp shots at slower speeds. With the VR enabled, you should be able to get a reasonably sharp image at a 200mm setting with a shutter speed of around 1/30 second.

Although the VR feature is good for providing some extra latitude when shooting with low light, it's not made to replace a fast shutter speed. To get a good, sharp photo when shooting action, you need to have a fast shutter speed to freeze the action. In this case, a VR lens may not be what you want.

Another thing to consider with the VR feature is that the lens' motion sensor may overcompensate when panning, causing the image to actually be blurrier. So, in situations where you need to pan with the

4.11 The Nikon 70-200 f/2.8 ED-IF AFS with VR

subject, you may need to switch off the VR. The VR function also slows down the AF a bit, so when catching the action is very important, you may want to keep this in mind as well.

While VR is a great advancement in lens technology, few things can replace a good exposure and a solid monopod or tripod for a sharp image.

Extending the Range of Any Lens

There are several ways to extend the range of the lenses you already own – from extending the focal length to focusing closer to magnifying the image.

Teleconverters

In some cases, you may need a lens that has a longer focal length than the lenses you own. You may want a 600mm lens to really get close up to a far-away subject, but you don't necessarily want to spend the money on an expensive 600mm prime lens. Fortunately, Nikon, as well as some other lens manufacturers, offer *teleconverters;* a teleconverter attaches to your camera between the lens and the camera body and extends the focal length giving you extra zoom and magnification. There are different sizes of teleconverters; Nikon offers a 1.4X, a 1.7X, and a 2X model. Some other manufacturers offer different sizes including and up to 3X.

There are some drawbacks to using teleconverters. With the extended range you gain in focal length, you lose some light. The teleconverter effectively makes your lens anywhere from one to 3 stops slower than normal. The 1.4X tele-converter causes you to lose one stop of light, while using a 3X model causes you to lose a very noticeable 3 stops of light. This will cause your f/2.8 lens to function with an effective f/8 aperture. While this may not be a problem during a bright sunny day, in a low-light condition you may run into some problems. Additionally, the AF systems on most cameras need a specific amount of light to function. Attaching a teleconverter to a lens with a maximum aperture of less than f/2.8 can cause the AF function to not work properly or to not work at all.

Finally, with the inclusion of additional lens elements and the longer focal length, teleconverters cause you to lose some sharpness in your image. The higher-priced teleconverters like the ones offered by Nikon give you sharper overall images than the lower-priced teleconverters offered by third-party manufacturers. Teleconverters are available in both AF and MF versions.

Not all teleconverters work with all lenses and some lenses cannot work with a teleconverter at all. Additionally, some teleconverters can cause damage to the lens or camera if used improperly. Check with a reputable camera shop before using a teleconverter.

Extension tubes

Extension tubes are used like a tele-converter, but they function completely differently. While the tele-converter allows you to increase the focal length of your lens, an extension tube simply moves the lens farther from the image sensor. Extension tubes give you a closer focusing distance so your lens can get more magnification of the subject, making it possible to take macro photos with a regular lens and giving you increased magnification when used with a macro lens.

Like teleconverters, when adding an extension tube, you effectively reduce your maximum aperture and lose some light. Unlike teleconverters, extension tubes have no optical elements in them; they are simply open tubes. Additionally, extension tubes are offered in both AF and MF options.

Filters

In the days before Photoshop when photographers needed to add a special effect to their photographs, they often would add a filter to the lens. Filters provide a wide range of effects: some filters add a color tint to the photograph while others neutralize a color cast (for example, you might use a filter to compensate for the color of a tungsten light bulb). Other filters block certain wavelengths of light or add a special effect, such as a star pattern in the highlight areas of a photograph. Many traditional photo filters can now be replicated using Photoshop or some other image-editing software. However, a few filters cannot be replicated with software, such as the following:

Cross-Reference

For more info on color casts and white balance, see Chapter 2.

UV (ultraviolet) filters. This is by far the most common filter found on camera lenses these days. UV filters block UV light resulting in a sharper image. These filters can also reduce the effect of atmospheric haze in landscape photos of distant subjects. Most people also use these filters to protect the front element of the lens from getting scratched or damaged. To be fair, there are those people who doubt the validity of using these filters because, at lower elevations, UV light is not abundant enough to adversely affect the image. In addition, the sensors on dSLR cameras usually already have some sort of

UV filter built in. Some people also claim that putting a lower-quality glass filter on an expensive lens lessens the quality of the images. I have a UV filter on almost all of my lenses at all times. Ultimately, the decision is yours.

- ND (neutral density) filters. This is another commonly used filter. This filter reduces the amount of light that reaches the sensor without changing the color. It is used to prevent blown-out highlights caused by extremely bright lighting conditions, such as when you're at a beach with white sand on a bright sunny day. These filters can also be used to slow down your shutter speed when you need a long exposure, there is too much light on the subject, and reducing the ISO is out of the question. You can also use these filters to increase the shutter speed and use a wider aperture to achieve a shallow depth of field. ND filters normally come in three versions: ND-2, which absorbs 1 stop of light; ND-4, which absorbs 2 stops of light; and ND-8, which absorbs 3 stops of light. You can also find an ND-400 filter, which effectively reduces the amount of light by 9 stops.
- Polarizing filters. When light is reflected off any surface, it tends to scatter randomly, and the polarizing filter takes these random scattered light rays and makes them directional, thereby reducing or even eliminating the glare from

reflective surfaces. Polarizing filters are almost invaluable when photographing landscapes; they can cut down the atmospheric haze and add contrast to the image. Its effect on skies is most evident; the use of a polarizer will increase the contrast between the clouds and the sky. Many people also use the polarizer as a type of ND filter because it reduces the exposure by 1/2 to 1 stop of light.

Caution

When purchasing a polarizer for your camera, be sure to buy a circular polarizer because a linear polarizer may cause your cameras' AF and metering not to function properly.

IR (infrared) filters. These filters block almost the entire visible light spectrum allowing only infrared light that is invisible to the naked eye to pass through to the sensor. The resulting images are very ethereal, dreamlike, and often surreal. In infrared photography, the skies are very dark and vegetation glows a ghostly white. Because almost all of the light is being blocked, IR photography requires long shutter speeds and a tripod.

Cross-Reference

For more in-depth information on IR photography, see Chapter 7.

This is just a list of the most common and useful filters. There are many more types of filters available (warming filters, cooling filters, star filters, and so forth). A quick search on the Web will yield many more results.

Essential Photography Concepts

his chapter may contain well-known concepts to some D300 users, while others may need a refresher. Some of this information may be brand-new to people who are just stepping into the world of dSLR photography. If you are an advanced user, you may want to skip this chapter although you may discover some new information or something you may have forgotten. This chapter covers information on exposure, the effects aperture has on depth of field, and some tips and hints on composition.

Exposure Review

An exposure is made of three elements that are all interrelated. Each depends on the others to create a good exposure. If one of the elements changes, the others must increase or decrease proportionally. The following are the elements you need to consider.

- Shutter speed. The shutter speed determines the length of time the sensor is exposed to light.
- ISO sensitivity. The ISO setting you choose influences your camera's sensitivity to light.
- Aperture / f-stop. How much light reaches the sensor of your camera is controlled by the aperture, or f-stop. Each camera has an adjustable opening on the lens. As you change the aperture (the opening), you allow more or less light to reach the sensor.

Understanding depth of field

Rules of composition

Lighting essentials

5.1 In this image, the background is metered to capture the beautiful colors of the sunset while allowing the Joshua tree to fall into silhouette.

Shutter speed

Shutter speed is the amount of time light entering from the lens is allowed to expose the image sensor. Obviously, if the shutter is open longer, more light can reach the sensor. The shutter speed can also affect the sharpness of your images. When using a longer focal length lens a faster shutter speed is required to counteract against camera shake, which can cause blur. When taking photographs in low-light a slow shutter speed is often required, which can also cause blur from camera shake or fast moving subjects. The shutter speed can also be used to show motion. Panning, or moving the camera horizontally with a moving subject, while using a slower shutter speed can cause the background to blur while keeping the subject in focus. This is an effective way to portray motion in a still image. On the opposite end, using a fast shutter speed can freeze action such as the splash of water from a surfer, which can also give the illusion of motion in a still photograph.

Shutter speeds are indicated in fractions of a second. Common shutter speeds (from slow to fast) are: 1 second, 1/2, 1/4, 1/8,

Chapter 5 + Essential Photography Concepts 113

1/15, 1/30, 1/60, 1/125, 1/500, 1/1000, and so on. Increasing or decreasing shutter speed by one setting doubles or halves the exposure, respectively. The D300 also allows you to adjust the shutter speed in 1/3-stops. It may seem like math (okay, technically it does involve math), but it is relatively easy to figure out. For example, if you take a picture with a 1/2-second shutter speed and it turns out too dark, logically, you'll want to keep the shutter open longer to let in more light. To do this, you need to adjust the shutter speed to 1 second, which is the next full stop, letting in twice as much light.

ISO

The ISO (International Organization for Standardization) setting is how your camera determines how sensitive your camera is to light. The higher the ISO number is, the less light you need to take a photograph, meaning the more sensitive the sensor is to light. For example, you might choose an ISO of 200 on a bright, sunny day when you are photographing outside because you have plenty of light. However, on a dark, cloudy day you want to consider an ISO of 400 or higher to make sure your camera captures all the available light. This allows you to use a faster shutter speed should it be appropriate to the subject you are photographing.

It is helpful to know that each ISO setting is twice as sensitive to light as the previous setting. For example, at ISO 400, your camera is twice as sensitive to light as it is at ISO 200. This means it needs only half the light at ISO 400 that it needs at ISO 200 to achieve the same exposure.

5.2 In this image, a long shutter speed is used to allow the waters of Minnehaha Falls to blur, creating a surreal effect.

5.3 This image shows digital noise resulting from using a high ISO. Notice that the noise is more prevalent in the darker areas of the image.

Additionally, the D300 allows you to adjust the ISO in 1/3-stop increments (100, 125, 160, 200...), which enables you to fine-tune your ISO to reduce the noise inherent with higher ISO settings.

Aperture

Aperture is the size of the opening in the lens that determines the amount of light that reaches the image sensor. The aperture is controlled by a metal diaphragm, which operates in a similar fashion to the iris of your eye. Aperture is expressed as f-stop numbers, such as f/2.8, f/5.6, and f/8. Here are a few important things to know about aperture:

- Smaller f-numbers equal wider apertures. A small f-stop such as f/2.8, for example, opens the lens so more light reaches the sensor. If you have a wide aperture (opening), the amount of time the shutter needs to stay open to let light into the camera decreases.
- Larger f-numbers equal narrower apertures. A large f-stop such as f/11, for example, closes the lens so less light reaches the sensor. If you have a narrow aperture (opening), the amount of time the shutter needs to stay open to let light into the camera increases.

Deciding what aperture to use depends on what kind of photo you are going to take. If you need a fast shutter speed to freeze action, and you don't want to raise the ISO, you can use a wide aperture to let more available light in to the sensor. Conversely, if the scene is very bright, you may want to use a small aperture to avoid overexposure.

Understanding Depth of Field

Depth of field is the distance range in a photograph in which all included portions of an image are at least acceptably sharp. It is heavily affected by aperture, but how far your camera is from the subject can also have an affect. Here's how it works.

If you focus your lens on a certain point, everything that lies on the horizontal plane of that same distance is also in focus. This means everything in front of the point and everything behind it is technically not in focus. Because our eyes aren't acute

Chapter 5 + Essential Photography Concepts 115

enough to discern the minor blur that occurs directly in front of and directly behind the point of focus, it still appears sharp to us. This is known as the zone of acceptable sharpness, which we call depth of field.

This zone of acceptable sharpness is based on the *circle of confusion*. The circle of confusion simplified is the largest blurred circle that is perceived by the human eye as acceptably sharp.

Note

There are a few factors that go into determining the size of the circle of confusion such as visual acuity, viewing distance, and enlargement size.

Circles of confusion are formed by light passing through the body of a lens. Changing the size of the circle of confusion is as easy as opening up or closing down your aperture. Therefore, when you open up the aperture, the circle of confusion is larger, resulting in decreased depth of field and a softer, more blurred background (and foreground). When the aperture is closed down, the circle of confusion is smaller, resulting in increased depth of field and causing everything in the image to appear sharp.

Shallow depth of field. This results in an image where the subject is in sharp focus, but the background has a soft blur. You likely have seen it used frequently in portraits. Using a wide aperture, such as f/2.8, results in a subject that is sharp with a softer background. Using a shallow depth of field is a great way to get rid of distracting elements in the background of an image.

5.4 An image with a shallow depth of field has only the main subject in focus.

- Deep depth of field. This results in an image that is reasonably sharp from the foreground to the background. Using a narrow aperture, such as f/11, is ideal to keep photographs of landscapes or groups in focus throughout.
- Tip Remember, to enlarge your depth of field, you want a large f-number; to shrink your depth of field, you want a small f-number.

When working with depth of field, you must consider your distance from the subject. The farther you are from the subject you are focusing on the greater the depth of field in your photograph. For example, if you stand in your front yard to take a photo of a tree a block away, it will have a deep depth of field with the tree, background, and foreground all in relatively sharp focus. If you stand in that same spot and take a picture of your dog who is standing just several feet away, your dog is in focus, but that tree a block away will be just a blur of color.

Rules of Composition

Although many of you are likely well versed in these concepts regarding composition, some of you may be coming in cold, so to speak. So this section is intended as a refresher course and a general outline of some of the most commonly used rules of composition.

Photography, like any artistic discipline, has general rules. Although we call them rules, they are really nothing more than guidelines. Some photographers – notably, Ansel Adams, who was quoted as saying "The

5.5 An image with a deep depth of field has most of the image in focus.

Chapter 5 + Essential Photography Concepts 117

so-called rules of photographic composition are, in my opinion, invalid, irrelevant and immaterial" – claim to have eschewed the rules of composition. However, when you look at Adams' photographs, they follow the rules perfectly in most cases.

Another famous photographer, Edward Weston, said "Consulting the rules of composition before taking a photograph is like consulting the laws of gravity before going for a walk." Again, as with Adams, when you look at his photographs, they tend to follow these very rules.

This isn't to say you need to follow all of the rules every time you take a photograph. As I said, these are really just general guidelines that when followed, can make your images more powerful and interesting.

However, when you're starting out in photography, you should pay attention to the rules of composition. Eventually you become accustomed to following the guidelines, it becomes second nature. That is the point you no longer need to consult the rules of composition; you just inherently follow them.

Keep it simple

Simplicity is arguably the most important rule in creating a good image. You want the subject of your photograph to be immediately recognizable. When you have too many competing elements in your image, it can be hard for the viewer to decide what to focus on.

Sometimes changing your perspective to the subject is all you need to do to remove a distracting element from your image. Try walking around and shooting the same subject from different angles.

5.6 There's no question as to what the subject is in this photograph.

5.7 Shooting this little bird from down low removed the distracting elements of the racetrack that was behind it.

The Rule of Thirds

Most of the time you are probably tempted to take the main subject of your photograph and stick it right in the middle of the frame. This makes sense, and it usually works pretty well for snapshots. However, to create more interesting and dynamic images, it often works better to put the main subject of the image a little off-center.

The Rule of Thirds is a compositional rule that has been in use for hundreds of years, and most famous artists throughout the centuries have followed it. With the Rule of Thirds, you divide the image into nine equal parts using two equally spaced horizontal and vertical lines, kind of like a tic-tac-toe pattern. You want to center the main subject of the image at an intersection, as illustrated in figure 5.8. The subject doesn't necessarily

5.8 The seagull, which is the main subject of this photograph, is placed near the bottom of the frame according to the Rule of Thirds.

Chapter 5 + Essential Photography Concepts 119

have to be right on the intersection of the line, but merely close enough to it to take advantage of the Rule of Thirds.

Another way to use the Rule of Thirds is to place the subject in the center of the frame, but at the bottom or top third of the frame as illustrated in figure 5.9. This part of the rule is especially useful when photographing landscapes. You can place the horizon on or near the top or bottom line; you almost never want to place it in the middle. Notice in figure 5.10 the mountain range is covering the bottom third of the entire frame.

When using the Rule of Thirds, keep in mind the movement of the subject. If the subject is moving, you want to be sure to keep most of the frame in front of the subject. to keep the illusion that the subject has someplace

5.9 In this image, the subject is in the center of the frame, but in the bottom third.

5.10 Using the Rule of Thirds in a landscape

to go within the frame. You can see the difference the framing makes in figures 5-11 and 5-12.

The Rule of Thirds is a very simple guideline, but it can work wonders in making your images more interesting and visually appealing. To make the Rule of Thirds even easier to apply to your photography, the D300 has the option of showing a grid in the viewfinder. After you get used to visualizing the grid, you will be able to start composing to the Rule of Thirds without even realizing it.

5.11 Placing the spider directly in the middle of the frame results in a pretty good picture.

5.12 Recomposing to place the spider in the left part of the frame results in a much more dramatic image.

Chapter 5 + Essential Photography Concepts 121

Leading lines and S-curves

Another good way to add drama to an image is to use a *leading line* to draw the viewer's eye through the picture. A leading line is an element in a composition that leads the eye toward the subject. A leading line can be a lot of different things, a road, a sidewalk, railroad tracks, buildings, or columns, to name a few.

In general, you want your leading line to go in a specific direction. Most commonly, a leading line leads the eye from one corner of the picture to another. A good rule of thumb to follow is to have your line go from the bottom left corner leading toward the top right. You can also use leading lines that go from the bottom of the image to the top, and vice versa. For the most part, leading lines heading in this direction lead to a *vanishing point*. A vanishing point is the point at which parallel lines appear to converge and disappear. Figure 5.13 shows a leading line ending in a vanishing point. Depending on the subject matter, a variety of directions for leading lines can work equally well.

Another nice way to use a leading line is with an *S*-curve. An S-curve is exactly what it sounds like: it resembles the letter S. An Scurve can go from left to right or right to left. The S-curve draws the viewer's eye up through the image, from the subject to background of the image in an S, through the middle, over to the corner, and back to the other side again.

5.13 A leading line ending in a vanishing point

5.14 In this image, the racetrack and the barrier together form an S-curve that draws the eye through the whole image.

Helpful hints

Along with the major rules of composition, there are all sorts of other helpful guidelines. Here are just a few that I've found most helpful.

- Frame the subject. Use elements of the foreground to make a frame around the subject to keep the viewer's eye from wandering.
- Avoid having the subject looking directly out of the frame. Having the subject looking out of the photograph can be distracting to the viewer. For example, if you're subject is on the left side of the composition having them facing the right is better, and vice-versa.

- Avoid mergers. A merger is when an element from the background appears to be a part of the subject, like the snapshot of Granny at the park that looks like she has a tree growing out of the top of her head.
- Try not to cut through the joint of a limb. When composing or cropping your picture, it's best not to end the frame on a joint, such as an elbow or a knee. This can be unsettling to the viewer.
- Avoid having bright spots or unnecessary details near the edge. Having anything bright or detailed near the edge of the frame will draw the viewer's eye away from the subject and out of the image.

- Avoid placing the horizon or strong horizontal or vertical lines in the center of the composition. This cuts the image in half and makes it hard for the viewer to decide which half of the image is important.
- Separate the subject from the background. Make sure the background doesn't have colors or textures similar to the subject. If necessary, try shooting from different angles, or use a shallow depth of field to achieve separation.
- Fill the frame. Try to make the subject the most dominant part of the image. Avoid having lots of empty space around the subject unless it's essential to making the photograph work.
- Use odd numbers. When photographing multiple subjects, odd numbers seem to work best.

These are just a few of the hundreds of guidelines out there. Remember, these are not hard and fast rules, just simple pointers that can help you create interesting and amazing images.

Lighting Essentials

To get your images to appear exactly as you want them, you need to know a few things about light – how it reacts, its specific properties, and even how to control it to make it suit your needs. This section touches on some of the basic properties of light.

For more information on working with light see Chapter 6.

Quality of light

Lighting is the essence of photography. Not only does it create the image, it sets the tone and the mood of the photograph. It can accentuate features and enhance the detail, or it can soften the subject, creating a serene mood. Quality of light can be a misleading term; it not only means good quality light, but it can also describe some of the unwanted attributes. In the broad scope of things, there are two basic qualities of light: hard light and soft light.

Hard light

Hard light comes from a single bright source and is very directional, for example photographing in midday open sunlight – the sun is your single, bright source. The shadows are very distinct, and the image has high contrast and a wide tonal range. Using hard light can be effective when you want to highlight textures in your subject. Hard light is also very good at creating a dramatic portrait and is especially effective in black and white.

Because hard light is directional and there is high contrast associated with its use, you want to be very careful with the position of the light source. The placement of the light affects where the shadows fall, and in highcontrast images, shadow placement can make or break an image.

5.15 I used hard light in this image to create a dramatic mood.

Soft light

Soft light is very diffuse and comes from a broad source or is reflected onto the subject. The resulting images are very soft with less noticeable differences between the shadows and the highlights. With a soft light image, the lighting seems to be coming from more than one direction, and it is often hard to pinpoint from which directions the light is coming. With soft light, the texture of objects is less apparent and some of the detail is lost.

Soft light is very good for portraits and most everyday subjects. Soft light is flattering to most subjects, but it can sometimes lack the depth and drama that you may need for your image.

5.16 This soft-light portrait of Kim at the Joshua Tree Inn was taken using the morning sun filtering in from a window.

Chapter 5 + Essential Photography Concepts 125

Metering light

The first thing you need to know before you actually press the Shutter Release button and take the picture is the camera setting necessary to get the proper exposure. Although there are ways to figure the proper exposure in your head, such as using the Sunny 16 Rule, when using the D300 you don't need to figure it out yourself. Fortunately, your D300 is equipped with a very accurate, state-of-the-art light meter built right in.

The D300 metering system is what is known as a *TTL* system. TTL is short for through the lens, meaning the light measured is actually coming through the lens. The reason this system works so well is the sensor that measures the light is measuring the *exact* amount of light reaching the sensor. This takes into account the amount of light lost traveling down the barrel of the lens and through the glass of the lens, unlike a handheld meter, which only reads the amount of light reflected off of the object.

Cross-Reference

For more information on the D300 metering system and the different options see Chapter 2.

Sunny 16 Rule

The Sunny 16 Rule is a guide to achieving proper exposure outdoors without the aid of a light meter. The name of the rule is derived from the aperture you should use when photographing outdoors on a sunny day, which is f/16. The shutter speed is equal to the nearest reciprocal of the ISO speed. For example, if you are using ISO 100, your shutter speed should be about 1/125 second at f/16. For ISO 200, you change your shutter speed to 1/250 at f/16.

So, what if the day isn't bright and sunny? In that case, you just open up the aperture. The following is a table showing the settings to use for different outside lighting conditions.

Aperture	Lighting	Shadows
f/16	Sunny	Hard, well-defined shadows
f/11	Slightly overcast	Distinct shadows with soft edges
f/8	Overcast	Very soft, diffused shadows
f/5.6	Dark clouds / heavy overcast	No shadows
f/4	Sunrise / sunset	N/A

In addition to these settings, you can also use equivalent exposures. For example, you can use f/11 on a sunny day by raising your shutter speed by one full stop (from 1/125 second to 1/250 second, for example). You can even use f/2.8 at 1/4000 second.

Working with Light

he word photography stems from two Greek words: photos, meaning light, and graphos, meaning to write or draw, literally light-drawing. The most important factor in photography is light; without it, your camera is rendered useless. You need light to make the exposure that results in an image. Whether the light is recorded to silver halide emulsion on a piece of film or to the CMOS sensor on your D300, you can't make a photograph without light.

Not only is light necessary to make an exposure, it also has different qualities that can impact the outcome of your image. Light can be soft and diffuse, or it can be hard and directional. Light can also have an impact on the color of your images; different light sources emit light at different temperatures, which changes the color cast of the image.

When there is not enough light to capture the image you're after, or if the available light isn't suitable for your needs, you can employ alternative sources of light, such as flash, to achieve the effect you're after.

The ability to control light is a crucial step toward being able to make images that look exactly how you want them to. In this chapter, I explain some of the different types of light and how to modify them to suit your needs.

Natural Light

By far the easiest type of light to find, natural light is sometimes the most difficult to work with. Natural light, because it comes from the sun, is often unpredictable and can change from minute to minute. A lot of times I hear people say, "Wow, it's such a nice, sunny day; what a perfect day to take pictures", but unfortunately this is not often the case. A bright day when the sun is high in the sky presents many obstacles. Natural light D300 flash basics Nikon Creative Lighting

In This Chapter

Using the built-in Speedlight

Studio strobes

System basics

Continuous lighting

Light modifiers

First, you have serious contrast issues on a sun-drenched day. Oftentimes, the digital sensor doesn't have the latitude to capture the whole scene effectively. For example, it is nearly impossible to capture detail in the shadows of your subject while keeping the highlights from blowing out or going completely white.

Fortunately, if you want to use natural light, it isn't necessary to stand in direct sunlight at noon. You can get desirable lighting effects when working with natural light in many ways. Here are a few examples.

- Use fill flash. You can use the flash as a secondary light source (not as your main light) to fill in the shadows and reduce contrast.
- Try window lighting. Believe it or not, one of the best ways to use natural light is to go indoors.
 Seating your model next to a window provides a beautiful soft light

that is very flattering. A lot of professional food photographers also use window light. It can be used to light almost any subject softly and evenly.

- Find some shade. The shade of a tree or the overhang of an awning or porch can block the bright sunlight while giving you plenty of diffuse light with which to light your subject.
- Take advantage of the clouds. A cloudy day softens the light allowing you to take portraits outside without worrying about harsh shadows and too much contrast. Even if it's only partly cloudy, you can wait for a cloud to pass over the sun before taking your shot.
- Use a modifier. Use a reflector to reduce the shadows or a diffusion panel to block the direct sun from your subject.

6.1 A portrait using natural light from a window

D300 Flash Basics

A major advantage of the Nikon D300 is the fact that it has a built-in flash for quick use in low-light situations. Even better is the fact that Nikon has additional flashes called Speedlights. These Speedlights are much more powerful and versatile than the smaller built-in flash.

Nikon Speedlights are *dedicated* flash units, meaning they are built specifically for use with the Nikon camera system and offer much more functionality than a non-dedicated flash. A non-dedicated flash is a flash made by a third party manufacturer, the flashes usually don't offer fully automated flash features. There are, however, some non-Nikon flashes that make use of Nikon's i-TTL flash metering system. The i-TTL system allows the flash to operate automatically, resulting in a perfect exposure without the user having to do any calculations.

Achieving proper exposures

If you are new to using an external Speedlight flash, exposure can seem confusing when you first attempt to use it. There are a lot of settings you need to know, and there are different formulas to use to get the right exposure. Once you understand the numbers and where to plug them in, using the Speedlight becomes quite easy.

If you are using your Speedlight in the i-TTL mode, all of the calculations you would otherwise do manually are done for you, but it's always good to know how to achieve the same results if you didn't have the technology to rely on and so you understand how to work with the numbers. When you know these calculations, you can use any flash and get excellent results. There are three main elements that go into making a properly exposed flash photograph; Guide Number, Aperture, and Distance. If one of these elements is changed another one must be changed proportionally to keep the exposure consistent. In the following sections they are covered one by one and then an explanation on how to put them together is given.

Guide Number

The first element in the equation for determining proper flash exposure is the Guide Number, which is a numeric value that represents the amount of light emitted by the flash. You can find the Guide Number (GN) for your specific Speedlight in the owner's manual. The GN changes with the ISO sensitivity to which your camera is set, so the GN at ISO 400 is greater than the GN of the same Speedlight when set to ISO 100 (because of the increased sensitivity of the sensor). The GN also differs depending on the zoom setting of the Speedlight. The owner's manual has a table that breaks down the Guide Numbers according to the flash output setting and the zoom range selected on the Speedlight.

Tip If you are planning on doing a lot of manual flash exposures, I suggest you make a copy of the GN table from the owner's manual and keep it in your camera bag with the flash.

Note If you have access to a flash meter, you can determine the GN of your Speedlight at any setting by placing the meter 10 feet away and firing the flash. Next, take the aperture reading from the flash meter and multiply by ten. This is the correct GN for your flash.

Aperture

The second component to the formula to determine the proper flash exposure is the aperture setting. As you already know, the wider the aperture is, the more light that falls on the sensor. Using a wider aperture allows you to use a lower power setting (such as 1/4 when in Manual mode) on your flash, or if you're using the automatic i-TTL mode, the camera fires the flash using less power.

Distance

The third element in the flash exposure equation is the distance from the light source to the subject. The closer the light is to your subject, the more light falls on it. Conversely, the farther away the light source is, the less illumination your subject receives. This is important because if you set your Speedlight to a certain output, you can still achieve a proper exposure by moving the Speedlight closer or farther away as needed.

GN / Distance = Aperture

Here's where the GN, aperture, and distance all come together! The basic formula allows you to take the Guide Number and divide it by the distance to determine the aperture at which you need to shoot. You can change this equation to find out what you want to know specifically:

- GN / D = A. If you know the GN of the flash and the distance of the flash from the subject, you can determine the aperture to use to achieve the proper exposure.
- A / GN = D. If you know the aperture you want to use and the GN of the flash, you can determine the distance to place your flash from the subject.

A × D = GN. If you already have the right exposure, you can take your aperture setting and multiply it by the distance of the flash from the subject to determine the approximate GN of the flash.

Flash exposure modes

Flashes have different modes in which they can operate. These modes determine how the flash receives the information on how to set the exposure. Be aware that, depending on the Speedlight or flash you are using, some flash modes may not be available.

i-TTL

The D300 determines the proper flash exposure automatically by using Nikon's proprietary i-TTL system. The camera gets most of the metering information from monitor preflashes emitted from the Speedlight. These preflashes are emitted almost simultaneously with the main flash so it looks as if the flash has only fired once. The camera also uses data from the lens, such as distance information and f-stop values, to help determine the proper flash exposure.

Additionally, there are two separate types of i-TTL flash metering available when using the D300: Standard i-TTL flash and i-TTL Balanced Fill-Flash (BL). With Standard i-TTL flash the camera determines the exposure for the subject only, not taking the background lighting into account. When using the i-TTL Balanced Fill-Flash mode, the camera attempts to *balance* the light from the flash with the ambient light to produce a more natural looking image.

When using the D300's built-in flash, the default mode is the i-TTL Balanced Fill-Flash mode. To switch the flash to Standard i-TTL, the camera must be switched to Spot metering.

The i-TTL and i-TTL BL flash modes are available with Nikon's current Speedlight lineup, including the SB-800, SB-600, SB-400, and the R1-C1 Macro ring lighting kit.

Manual

Setting your Speedlight (either the built-in or accessory) to full Manual mode requires you to adjust the settings yourself. The best way to figure out the settings is by using a handheld light meter or by using the GN / D = A formula discussed previously.

Auto

With Speedlights such as the SB-800 that offer the Auto mode, sometimes referred to as Non-TTL Auto Flash, you decide the exposure setting. These flashes usually have a sensor built into the front that detects the light reflected back from the subject. When the flash determines there has been enough light produced to make the exposure, it automatically stops the flash tube from emitting any more light.

When using this mode, you need to be aware of the limitations of the flash you are using. If the flash doesn't have a high GN or the subject is too far away, you may need to open the aperture. Conversely, if the flash is too powerful or the subject is very close, you may need to stop the aperture down a bit.

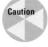

When using Auto mode with a non-Nikon flash, be sure not to set the D300's shutter speed above the rated sync speed, which is 1/250 second. If you do, you will have an incompletely exposed image.

Auto Aperture

Some flashes such as the SB-800, also offer what is called an Auto Aperture flash mode. In this mode you decide what aperture you want to use to best suit the subject you are photographing, and the flash determines how much light to add to the exposure.

Guide Number distance priority

In the Guide Number distance priority mode available with the SB-800, the flash controls the output according to aperture and subject distance. You manually enter the distance and f-stop value into the flash unit, and then select the f-stop with the camera. The flash output remains the same if you change the aperture. You can use this mode when you know the distance from the camera to the subject.

Changing the aperture or the distance of the subject after entering the setting on the flash can cause improper exposures.

Repeating flash

When in Repeating flash mode, the flash fires repeatedly like a strobe light during a single exposure. You must manually determine the proper flash output using the formula to get the correct aperture (GN / D = A), and then you decide the frequency and the number of times you want the flash to fire. The slower the shutter speed, the more flashes you are able to capture. For this reason, I recommend only using this mode in low-light situations because the ambient light tends to create a multiple exposure-type image.

Flash sync modes

Flash sync modes control how the flash operates in conjunction with your D300. These modes work with both the built-in Speedlight and accessory Speedlights such as the SB-800, SB-600, etc. These modes allow you to choose when the flash fires, either at the beginning of the exposure or at the end, and they also allow you to keep the shutter open for longer periods enabling you to capture more ambient light in lowlight situations.

Sync speed

Before getting into the different sync modes, you need to understand sync speed. The sync speed is the fastest shutter speed that can be used while achieving a full flash exposure. This means if you set your shutter speed at a speed faster than the rated sync speed of the camera, you don't get a full exposure and you end up with a partially underexposed image. With the D300, you can't actually set the shutter speed above the rated sync speed of 1/250 when using a dedicated flash because the camera won't let you; so no need to worry about having partially black images when using a Speedlight, but if you're using a studio strobe or a third party flash this is a concern you should think about.

The reason for limited sync speeds is due to the way the shutters in modern cameras work. As you already know, the shutter controls the amount of time the light is allowed to reach the imaging sensor. All dSLR cameras have what is called a *focal plane shutter*. This term stems from the fact that the shutter is located directly in front of the focal plane which is essentially on the sensor. The focal plane shutter has two shutter curtains that travel vertically in front of the sensor to control the time the light can enter through the lens. At slower shutter speeds, the front curtain covering the sensor moves away, exposing the sensor to light for a set amount of time. When the exposure has been made, the second curtain then moves in to block the light, thus ending the exposure.

To achieve a faster shutter speed, the second curtain of the shutter starts closing before the first curtain has exposed the sensor completely. This means the sensor is actually exposed by a slit that travels the length of the sensor. This allows your camera to have extremely fast shutter speeds, but limits the flash sync speed because the whole sensor must be exposed to the flash all at once to achieve a full exposure.

Front-curtain sync

Front-curtain sync is the default sync mode for your camera whether you are using the built-in flash, one of Nikon's dedicated Speedlights, or a third-party accessory flash. With Front-curtain sync the flash is fired as soon as the shutter's front curtain has fully opened. This mode works well with most general flash applications.

One thing that needs mentioning about front curtain sync is that although it works well when using relatively fast shutter speeds, when the shutter is slowed down (also known as *dragging the shutter* when doing flash photography), especially when photographing moving subjects, it causes you're images to have an unnatural looking blur in front of them caused by the ambient light recording the moving subject.

When doing flash photography at slow speeds your camera is actually recording two exposures, the flash exposure and the

Chapter 6 + Working with Light 133

ambient light. When using a fast shutter speed the ambient light usually isn't bright enough to have an effect on the image. When the shutter speed is slowed down substantially this allows the ambient light to be recorded to the sensor causing what is known as *ghosting*. Ghosting is a partial exposure that is usually fairly transparent looking on the image.

6.2 Shot using front curtain sync with a shutter speed of 1 second. The flash freezes the dropping ball at the top of the frame at the beginning of the exposure, and the trail caused by the ambient exposure appears in the front causing the ball to look like it's moving up.

This ghosting causes a trail to appear in front of the subject because the flash freezes the initial movement of the subject. So, because the subject is still moving, the ambient light records it as a blur which shows in front of the subject creating the illusion that it's moving backward. To counteract this problem there is a setting called Rear curtain sync which is explained later in this section.

Red-eye reduction

We've all seen red-eye in a picture at one time or another-that unholy red glare emanating from the subject's eyes, which is caused by light reflecting off the retina. Fortunately, the D300 offers a Red-eye reduction flash mode. When this mode is activated, the camera fires some preflashes (when using an accessory Speedlight) or turns on the AF-assist illuminator (when using the built-in flash), which cause the pupils of the subject's eyes to contract. This stops the light from the flash from reflecting off of the retina and reduces or eliminates the red-eve effect. This mode is for use when taking portraits or snapshots of people or pets when there is little light available.

Slow sync

Sometimes when using a flash at night especially when the background is very dark, the subject is lit but appears as if he or she is in a black hole. Slow sync helps take care of this problem. When used in Slow sync mode, the camera allows you to set a longer shutter speed (up to 30 seconds) to capture the ambient light of the background. This allows your subject to be lit as well as the background, so you can achieve a more natural-looking photograph.

6.3 A picture taken with standard flash at night. Notice the dark background and the bright subject.

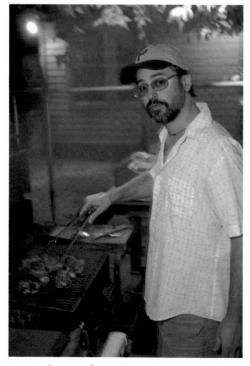

6.4 A picture taken using slow sync flash. Notice how the subject and background are more evenly exposed.

When using Slow sync, be sure the subject stays still for the whole exposure to avoid ghosting. Ghosting is a blurring of the image caused by motion during long exposures. Of course, ghosting can also be used creatively.

Note

Caution

Slow sync can be used in conjunction with Red-eye reduction for night portraits.

Rear-curtain sync

When using Rear-curtain sync the camera fires the flash just before the rear curtain of the shutter starts moving. This mode is useful when taking flash photographs of moving subjects. Rear-curtain sync allows you to more accurately portray the motion of the subject by causing a motion blur trail behind the subject rather than out in front as is the case with Front-curtain sync. Rear curtain sync is used in conjunction with slow sync.

6.5 A picture taken using Rear-curtain sync flash looks natural because the flash fires at the end of the exposure.

Chapter 6 + Working with Light 135

the subject needs more or less light than it actually does. This can happen when the background is very bright or very dark, or when the subject is off in the distance or very small in the frame.

6.6 A series of images using FEC

Flash Exposure Compensation

When photographing subjects using flash, whether it's an external Speedlight or your D300's built-in flash, there may be times when the flash causes your principal subject to appear too light or too dark. This usually occurs in difficult lighting situations, especially when using TTL metering, where your camera's meter can get fooled into thinking

Flash Exposure Compensation (FEC) allows you to manually adjust the flash output while still retaining TTL readings so your flash exposure is at least in the ballpark. With the D300 you can vary the output of your built-in flash's TTL setting (or your own manual setting) from -3 EV to +1 EV. This means if your flash exposure is too bright, then you can adjust it down to 3 full stops under the original setting. Or, if the image seems underexposed or too dark, you can adjust it to be brighter by 1 full stop. Additionally, the D300 allows you to fine-tune how much exposure compensation is applied by letting you set the FEC incrementally in either 1/3, 1/2, or 1 stop of light.

Fill flash

Fill flash is a handy flash technique that allows you to use your Speedlight as a secondary light source to fill in the shadows rather than as the main light source, hence the term fill flash. Fill flash is used mainly in outdoor photography when the sun is very bright creating deep shadows and bright highlights that result in an image with very high contrast and a wide tonal range. Using fill flash allows you to reduce the contrast of the image by filling in the dark shadows, thus allowing you to see more detail in the image.

You also may want to use fill flash when your subject is backlit (lit from behind). When the subject is backlit, the camera's meter automatically tries to expose for the bright part of the image which is behind your subject. This results in a properly exposed background while your subject is underexposed and dark. On the other hand, if you use the spot meter to obtain the proper exposure on your subject, then the background will be overexposed and blown out. The ideal thing is to use fill flash to provide an amount of light on your subject that is equal to the ambient light of the background. This brings sufficient detail to both the subject and the background resulting in a properly and evenly exposed image.

All of Nikon's dSLR cameras offer i-TTL BL (Nikon calls this Balanced Fill Flash) or, in laymen's terms, automatic fill flash, with both the built-in flash and the detachable Speedlights, the SB-800, SB-600, and SB-400. When using a Speedlight, the camera automatically sets the flash to do fill flash (as long as you're not in Spot metering mode). This is a very handy feature because it allows you to concentrate on composition and not have to worry about your flash settings. If you decide that you don't want to use the i-TTL BL option you can set the cameras metering mode to Spot metering, or if you are using an SB-800 or SB-600 simply press the Speedlight's Mode button.

Of course, if you don't own an additional i-TTL dedicated Speedlight or you'd rather control your flash manually you can still do fill flash. It's actually a pretty simple process that can vastly improve your images when used in the right situations.

To execute a manual fill flash:

- Use the camera's light meter to determine the proper exposure for the background or ambient light. A typical exposure for a sunny day is 1/250 at f/16 with an ISO of 200. Be sure not to set the shutter speed higher than the rated sync speed of 1/250.
- Determine the flash exposure. Using the GN / D = A formula, find the setting that you need to properly expose the subject with the flash.

Chapter 6 + Working with Light 137

3. Use FEC to reduce the flash output. Setting the flash exposure compensation down 1/3 to 2/3 stops allows the flash exposure to be less noticeable while filling in the shadows or lighting your backlit subject. This makes your images look more natural as if a flash didn't light them, which is the ultimate goal when attempting fill flash.

The actual amount of FEC needed will vary with the intensity of the ambient light source. Use your LCD to preview the image and adjust the amount of FEC as needed.

Bounce flash

One of the easiest ways to improve your flash pictures, especially snapshots, is to employ the use of *bounce flash*. Bounce flash is a technique in which the light from the flash unit is bounced off of the ceiling or off of a wall onto the subject in order to diffuse the light, resulting in a more diffused and evenly lit image. To do this your flash must have a swiveling / tilting head. Most flashes made within the last 10 years do have this feature, but some may not.

When you attempt bounce flash you want to get as much light from the flash onto your subject as you can. To do this you need to first look at the placement of the subject and adjust the angle of the flash head appropriately. Consider the height of the ceiling or distance from the surface you intend to bounce the light from to the subject.

Unfortunately, not all ceilings are useful for bouncing flash. For example, the ceiling in my studio is corrugated metal with iron crossbeams. If I attempted to bounce flash from a ceiling like that, it would make little or no difference to the image because the

6.7 A picture taken without fill flash

6.8 A picture taken with fill flash

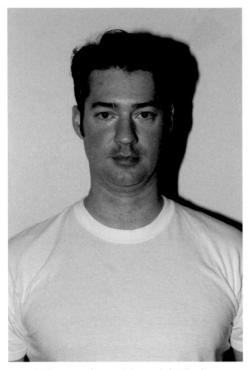

6.9 A picture taken with straight flash

light won't reflect evenly and will scatter in all different directions. In a situation where the ceiling is not usable, you can position the subject next to a wall and swivel the flash head in the direction of the wall and bounce it from there. To bounce the flash at the correct angle, remember the angle of incidence equals the angle of reflection.

You want to aim the flash-head at such an angle that the flash isn't going to bounce in behind the subject resulting in a poorly lit subject. You want to be sure that the light is bounced so that it falls onto your subject. When the subject is very close to you, you need to have your flash head positioned at a more obtuse angle than when the subject is farther away. I recommend positioning the subject at least 10 feet away and setting the angle of the flash head at 45 degrees for a typical height ceiling of about 8 to 10 feet.

6.10 A picture taken with bounced flash

An important pitfall to be aware of when bouncing flash is that the reflected light picks up and transmits the color of the surface from which it is bounced. This means if you bounce light off of a red surface your subject will have a reddish tint to it. The best way to deal with this is to avoid bouncing light off of surfaces that are brightly colored; your best bet is to stick with bouncing light from a neutral colored surface. White surfaces tend to work the best because they reflect more light and don't add any color. Neutral gray surfaces also work well although you can lose a little light due to lessened reflectivity and the darker color.

Unfortunately, you can't do bounce flash with the D300's built-in flash; you need an external Speedlight such as an SB-800, 600, or 400.

Nikon Creative Lighting System Basics

Nikon introduced the Creative Lighting System (CLS) in 2004. It is, simply explained, a system designed to enable the photographer to take Nikon Speedlights off of the camera and attach them to stands. This allows you to position the Speedlights wherever you want and control the direction of light to make the subject appear exactly how you want. The Nikon CLS enables you to achieve more creative lighting scenarios similar to what a typical photographer would do with expensive and much larger studio strobes. All of this can be done wirelessly with the benefit of full i-TTL metering. To take advantage of the Nikon CLS, all you need is the D300 and at least one SB-800 or SB-600. With the CLS, there is no more mucking about with huge power packs and heavy strobe heads on heavyduty stands with cables and wires running all over the place.

The Nikon Creative Lighting System is not a lighting system in and of itself, but it's comprised of many different pieces that can be added to your system as you see fit (or your budget allows). The first and foremost piece of the equation is your camera.

Understanding the CLS

The Nikon CLS is basically a communication system that allows the camera, the commander, and the slaves to share information regarding exposure.

A commander, which is also called a master, is the flash that controls external Speedlights. *Slaves*, which are sometimes referred to as

remote units, are the external flash units controlled remotely by a commander. Communications between the commander and the slaves are accomplished by using pulse modulation. Pulse modulation is a term that means the commanding Speedlight fires rapid bursts of light in a specific order. The pulses of light are used to convey information to the remote groups of slaves, which interpret the bursts of light as coded information.

Triggering the commander tells the other Speedlights in the system when and at what power to fire. The D300's built-in flash can act as a commander. However, for full functionality of the Nikon CLS, an SB-800 Speedlight or an SU-800 Commander must be used as a master because when using the built-in Speedlight as a commander you can only control two groups of external Speedlights, and you have a limited range on how far the camera can be from the slave flashes.

This is how CLS happens in a nutshell:

- The commander unit sends out instructions to the slave groups to fire a series of monitor preflashes to determine the exposure level. The camera's i-TTL metering sensor reads the preflashes from all of the remote groups and also takes a reading of the ambient light.
- The camera tells the commander unit the proper exposure readings for each group of remote Speedlights. When the shutter is released, the commander, via pulse modulation, relays the information to each group of slave Speedlights.
- The slaves then fire at the output specified by the cameras i-TTL meter, and the shutter closes.

All of these calculations are done in a fraction of a second as soon as you press the Shutter Release button. It appears to the naked eye as if the flash just fires once. There is no waiting for the camera and the Speedlights to do the calculations.

Given the ease of use and the portability of the Nikon CLS, I highly recommend purchasing at least one (if not two) SB-800 or SB-600 Speedlights to add to your setup. With this system you can produce almost any type of lighting pattern you want. It can definitely get you on the road to creating more professional-looking images.

Speedlights

Speedlights are Nikon's line of flashes. These flashes are amazing accessories to add to your kit. Most of the new Nikon Speedlights allow full wireless control of the flashes. Currently, Nikon offers three shoemounted flashes – the SB-800, SB-600, SB-400 – along with two macro lighting ring flash setups – the R1 or R1C1. You can also purchase SBR-200s for the R1 kits and the SU-800 Wireless Commander unit. All current Nikon Speedlights are part of the Nikon Creative Lighting system (CLS).

This is not meant to be a definitive guide to the Nikon Speedlight system, but a quick overview of some of the flashes Nikon has to offer and their major features.

SB-800 Speedlight

The SB-800 is the top-of-the-line Nikon Speedlight. The SB-800 can be used not only as a flash but also as a commander to control up to three groups of external Speedlights on four channels. You can also set the SB-800 to work as a remote flash for off-camera applications. The SB-800 has a built-in AF-Illuminator to assist in achieving focus in low light. The SB-800 has a powerful Guide Number (GN) of 174 at ISO 200 and can be used to photograph subjects up to 66 feet away.

The SB-800 offers a wide variety of flash modes:

- i-TTL and i-TTL Balanced Fill Flash (i-TTL BL)
- Auto Aperture Flash
- Non-TTL Auto Flash
- Distance Priority Manual Flash
- Manual Flash
- Repeating Flash

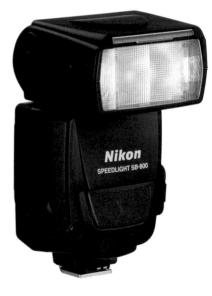

Image courtesy Nikon 6.11 The SB-800

SB-600 Speedlight

The SB-600 is the SB-800's little brother. This flash has fewer features than its bigger sibling but has everything you need. This Speedlight can be used on the camera as well as off-camera by setting it up for use as a remote. Like the SB-800, the SB-600 also has a built-in AF Illuminator. The SB-600 cannot, however, be used as a commander to control off-camera flash units. The SB-600 has an impressive GN of 138 at ISO 200, which, although it gives about 1 stop less light than the SB-800, is more than enough for most subjects.

The SB-600 only has the two most important flash modes:

- i-TTL / i-TTL BL
- Manual

SB-400 Speedlight

The SB-400 is Nikon's entry-level Speedlight. It can only be used in the i-TTL/i-TTL BL mode. One nice feature that it does have is a horizontally tilting flash head that allows you to bounce flash. This only works when the camera is in the horizontal position, unless you bounce off a wall when holding the camera vertically. For such a small flash the SB-400 has a decent GN of 98 at ISO 200.

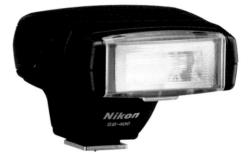

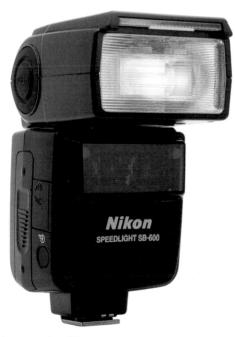

Image courtesy Nikon 6.12 The SB-600

Image courtesy Nikon 6.13 The SB-400

The SB-400 doesn't work wirelessly with the CLS. It only works when connected to the camera hot shoe or an off-camera hotshoe cord.

SU-800 Speedlight commander

The SU-800 is a wireless Speedlight commander that uses infrared technology to communicate with off-camera Speedlights. It can control up to three groups of Speedlights on four different channels. Because the built-in flash on the D300 can control two groups on four channels, you may not need to use one of these unless you have to have an extra group of flashes or you want to take advantage of the invisible infrared preflashes.

Image courtesy Nikon 6.14 The SU-800

R1 / R1C1 Macro flash

The R1C1 kit comes with an SU-800 wireless commander, which is the only difference between it and the R1.

The R1 set consists of a ring that attaches to the lens and SBR-200 Speedlights that attach to the ring. Ring lights are used in close-up and macro photography to provide a light that is direct or on-axis to the subject. This is to achieve a nice, even lighting, which can be difficult to do when the lens is close to the subject. Unlike a regular ring flash, the SBR-200 Speedlights can be moved around the ring to provide different lighting patterns.

For a definitive and in-depth look into the Nikon CLS read the Nikon Creative Lighting System Digital Field Guide, also published by Wiley.

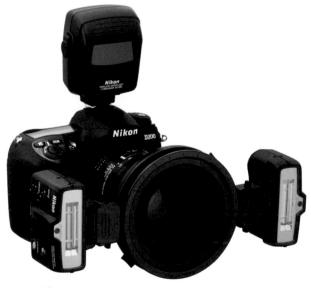

Image courtesy Nikon 6.15 The R1C1 as set up on a D200

Image courtesy Nikon 6.16 An SBR-200

Using the Built-In Speedlight

The D300's built-in Speedlight is a handy little flash that's great for taking casual snapshots. Although it lacks the versatility of the bigger external flashes, the built-in Speedlight is always there when you need it and requires no extra batteries because it is powered by the camera's battery. Activate it by pressing the flash pop-up button on the top left of the camera (as you would hold it for shooting) near the built-in Speedlight.

The built-in Speedlight is set to be used in i-TTL mode by default (i-TTL appears as TTL in the menu), although you can choose to set it to be used in Manual mode (you set the output). You can also set it to repeating flash (RPT) or Commander mode which allows you to use it to control up to two separate groups of remote Speedlights.

It can also be used with all of the different sync modes your camera offers: front curtain sync, rear curtain sync, slow sync, and red-eye reduction. To change the sync mode press the Flash mode button located just below the flash pop-up button. Rotating the Main Command dial while pressing the Flash mode button changes the mode. The selected mode can be seen in the LCD control panel.

You can also apply exposure compensation by pressing the Flash mode button and rotating the Sub-command dial.

One of the best features of the built-in Speedlight is that you can use it to wirelessly control remote slaves using the CLS. To take advantage of this feature you need at least one SB-600, SB-800, or SBR-200. To use the built-in Speedlight in commander mode:

- 1. Press the Menu button and use the multi-selector to navigate to the Custom Settings Menu.
- 2. Use the multi-selector to highlight CSM e Bracketing/flash, and then press the multi-selector right to enter the CSM e menu.
- 3. Use the multi-selector to highlight CSM e3 Flash cntrl for built-in flash, and then press the multi-selector right to view flash control options.
- Press the multi-selector up or down to choose Commander mode, and then press the multiselector right to view settings.
- 5. Press the multi-selector up or down to choose a flash mode for the built-in flash. You can choose M, TTL or --. The last option (--) allows the flash to control the remotes without adding additional exposure.
- 6. Press the multi-selector right to highlight the exposure compensation setting. Use the multiselector up/down to apply exposure compensation if desired. If the built-in flash is set to -- this option is not available.

- 7. Use the multi-selector to set the mode for Group A. You can choose TTL, AA, M or --. Press the multi-selector right to highlight exposure compensation. Press the multi-selector up or down to apply exposure compensation if desired. Repeat this process for Group B.
- 8. Use the multi-selector to highlight the Channel setting. You can choose from channels 1-4. These channels can be changed if you are shooting in the same area as another photographer using CLS. If you are both on the same channel you will trigger each other's Speedlights. If you use CLS alone it makes no difference as to what channel you choose.
- Press the OK button. If this button is not pressed no changes are applied.

When attempting to use wireless CLS be sure that your remote Speedlights are set to the proper Groups and Channel. If the remotes aren't properly set they will not fire.

Studio Strobes

Although the Nikon CLS allows you complete wireless control over lighting, it can be somewhat limited. The Speedlights are small, versatile, and portable, but they are limited in range, power, and options for accessories. Sometimes, there is no other option than to use a studio strobe, especially when lighting large subjects or when you need specific accessories to modify the light in a certain way. A studio strobe has a much higher GN than a shoe-mounted Speedlight, which means more power. Studio strobes run on AC power instead of batteries, which means faster recycle times between flashes Also, many different accessories and light modifiers are available for studio strobes.

There are two different types of studio strobes: standard pack and mono-lights. Standard pack and head strobes have a separate power pack and flash heads that are controlled centrally from the power pack. Mono-lights, which are flash heads that have a power pack built in and are adjusted individually at each head. Mono-lights tend to be lower in power than standard strobes, but they are also more portable and less expensive.

One of the downsides to using studio strobes is that you lose the advantage of i-TTL flash metering. Studio strobes are fired from the PC sync from the camera (or another triggering device), which only tells the flash *when* to fire, not at what output level. All of the strobe settings have to be calculated by you, the photographer. Of course, there are flash meters, which are designed to read the output of the strobe to give you a reading of the proper exposure. And you can always use the handy GN / D = A formula to determine the proper exposure.

One of the plus sides of using studio strobes is the continuous modeling light. Because the strobes are only lit for a fraction of a second, studio strobes are equipped with a constant light source (called a modeling light) that allows you to see what effect the strobe is going to have on the subject, although the modeling light isn't necessarily consistent with the actual light output of the flash tube.

Firing Your Studio Strobes Wirelessly

You can't use studio lighting setups completely wirelessly because you have to plug the lights in for power, and in the case of standard studio strobes, you have to not only plug in the power pack, but the flash heads have to be connected to the power pack also. For the most part studio strobes are fired via a sync cord, which connects to the PC sync port on the D300, or via a hot-shoe sync device such as the Wein Safe-Sync. This is the easiest and most affordable way of firing your studio flashes. Most mono-lights also have a built-in optical slave that allows the flash to be triggered by another flash or even a near invisible infrared triggering device. Most standard studio strobe power packs can also be fitted with an optical slave. This allows you some freedom from the wires that connect your camera to the main flash unit.

More and more photographers these days are using radio slaves. Radio slaves use a radio signal to trigger the strobes to flash when the shutter is released. Unlike the optical slave, the radio slave is not limited to "seeing" another flash to trigger it to fire. Radio slaves can also fire from a longer distance away and can even work from behind walls and around corners. Radio slave units have two parts: the transmitter and the receiver. The transmitter is attached to the camera and tells the receiver. which is connected to the strobe, to fire when the Shutter button is pressed. Some newer radio units are transceivers, being able to function as a transmitter or a receiver (not at the same time of course) but you still need at least two of them to operate. Radio slaves work very well and free you up from being directly attached to your lights, but they can be very high priced. There are a few different manufacturers of radio slaves but the most well known is Pocket Wizard. They are fairly pricey, but they are built well and are extremely reliable. Recently, there has been a proliferation of radio slave transmitters and receivers on eBay that are priced very low. I can't attest to how well they work, but a lot of folks on the Internet seem to like them. At around \$30 for a kit with one receiver and one transmitter, you won't be losing much if they don't work well. Currently, I use the Smith Victor RTK4 radio triggers that I bought from Smith Victor for around \$80. I bought this set because I am familiar with the Smith Victor product line, and I own a few Smith Victor mono-lights. They work well, and I feel confident recommending them.

When looking for a studio lighting setup there are thousands of different options you can go with. There are a lot of reputable manufacturers and a lot of different types of lights available from each of them. Your only limit really is the amount of money you want to spend.

Standard studio strobes are going to be the most powerful and most expensive option. With the standard strobes you can usually attach up to six flash heads to the power pack allowing you a lot of lighting options. Of course, to buy one power pack and two lights is going to cost you about \$1000 to start, not including stands, lighting modifiers (which are covered later in this chapter), and other accessories. There are quite a few reputable manufacturers of studio strobes; Speedotron, Dyna-lite, and Pro-foto being the most well known.

A more economical approach is to use mono-lights. Most of the manufacturers that make standard strobes also make monolights. Although they are lower in power than strobes that are powered by a power pack, they are also far more portable because they are lighter and smaller in size. They can also be outfitted with all of the same light modifiers as the bigger strobe units. I recommend going this route when purchasing lights for a small or home studio setup. You can get a complete setup with two 200-watt-second (ws) mono-lights (that's 400ws of combined power) with stands, umbrellas, and a carrying case for around \$500; that's only a little more than you would pay for a 400ws power pack alone.

When equipping your home or small studio with studio lighting, I recommend starting out with at least two strobes. With this setup you can pretty easily light almost any subject. A three-light setup is ideal for most small home studios, with two lights being used to light the subject and one light to illuminate the background.

Flash Alternatives

There is a growing movement of amateur photographers who are using nondedicated hot-shoe flashes to light their subjects. This movement is based on getting the flash off of the camera in order to create more professional-looking images (such as you get when using studio lights), but is also centered on not spending a lot of money to achieve these results.

Basically, what these folks, called *Strobists*, are saying is that you don't need big expensive studio lights or expensive dedicated flashes to achieve great images that look like they were lit by a professional.

Small hot-shoe flashes are extremely portable and are powered by inexpensive AA batteries. You can find older-model flashes that don't have all of the bells and whistles of the newer models at reasonable prices.

All you need to get started with off-camera flash is a flash that has two things; a PC sync terminal and the ability to set the output power manually. If your flash doesn't have a PC sync terminal you can buy a hot-shoe adapter that has one on it. This adapter slides onto the shoe of your flash and has a PC terminal on it that syncs with your flash.

The best flashes to use for this are the older Nikon Speedlights from the mid-1980s to the mid-90s. These are the SB-24, SB-25, SB-26, and SB-28 Speedlights. These flashes are available at a fraction of the cost of the newer i-TTL SB-800 or SB-600. Unfortunately, due to the increased number of people who have come into contact with the Strobist technique, the prices have increased a bit. This is good news if you happen to have one of these things lying around. I've had my SB-24, SB-26, and SB-28 collecting dust, and now I can sell them for almost three times what they were worth just two years ago.

With all of the people who are now using small hot-shoe flashes, off-camera manufacturers are making accessories to attach these flashes to stands and other accessories to allow light modifiers to be added to them.

If you want to learn more about the Strobist technique and find many tricks and tips, go to http://strobist.blogspot.com/.

For those with a more limited budget, you can still achieve some excellent results using a single strobe head, especially when going for moody low-key lighting. The late Dean Collins was a skilled photographer and a master at lighting who could light some amazing scenes with just one strobe. I highly encourage anyone who is interested in photographic lighting to view some of his instructional videos.

Continuous Lighting

Continuous lighting is just what it sounds like: a light source that is constant. It is by far the easiest type of lighting to work with. Unlike natural lighting, continuous lighting is consistent and predictable. Even when using a strobe with modeling lights, you sometimes have to estimate what the final lighting will look like. Continuous lighting is "what you see is what you get." With continuous lighting, you can see the actual effects the lighting has on your subjects, and you can modify and change the lighting before you even press the Shutter Release button.

Continuous lights, also known as *hot lights* because of the heat they can emit, are an affordable alternative to using studio strobes. Because the light is constant and consistent, the learning curve is also less steep. With strobes, you need to experiment with the exposure or use a flash meter. With continuous lights, the D300's Matrix meter can be used to yield good results.

As with other lighting systems, continuous lights have a lot of different options. Here are a few of the more common types:

- Incandescent. Incandescent or tungsten lights are the most common type of lights. This is the type of lamp that was invented by Thomas Edison. Your typical light bulb is a tungsten lamp. With tungsten lamps, an electrical current is run through a tungsten filament, heating it and causing it to emit light. This type of continuous lighting is the source of the name "hot lights."
- Halogen. Halogen lights, which are much brighter than typical tungsten lights, are actually very similar. Halogen lights are considered a type of incandescent light. Halogen lights also employ a tungsten filament, but have a halogen vapor added to the gas inside the lamp. The color temperature of halogen lamps is higher than the color temperature of standard tungsten lamps.
- Fluorescent. Fluorescent lighting. which most of us are familiar with. is everywhere these days. You find it in most office buildings, stores, and even in your own house. In a fluorescent lamp, electrical energy is used to change a small amount of mercury into a gas. The electrons collide with the mercury gas atoms causing them to release photons, which in turn causes the phosphor coating inside the lamp to glow. Because this reaction doesn't create much heat, fluorescent lamps are much cooler and energy efficient than tungsten and halogen lamps. These lights are commonly used in TV lighting.

HMI. HMI or Hydrargyrum Medium-Arc lodide lamps are probably the most expensive type of continuous lighting. This is the type of lamp used by the motion picture industry because of its consistent color temperature and the fact that it runs cooler than a tungsten lamp with the same power rating. These lamps operate by releasing an arc of electricity in an atmosphere of mercury vapor and halogenides.

Incandescent and halogen

Although incandescent and halogen lights have the advantages of making it easier to see what you're dealing with and costing less, there are quite a few drawbacks to using these lights for serious photography work. First, they are hot. When a model has to sit under lamps for any length of time, he will get hot and start to sweat. This is also a problem with food photography. It can cause your food to change consistency or even to sweat; for example, cheese that has been refrigerated. On the other hand, it can help keep hot food looking fresh and hot.

The second drawback to using incandescent lights is that although they appear to be very bright to you and your subject, they actually produce *less* light than a standard flash unit. For example, a 200-watt tungsten light and a 200-watt-second strobe use the same amount of electricity per second, so they should be equally bright, right? Wrong. Because the flash discharges all 200 watts of energy in a fraction of a second, the flash is actually much, much brighter. Why does this matter? Because when you need a fast shutter speed or a small aperture, the strobe can give it to you much easier. An SB-600 gives you about 30 watt-seconds of light at full power. To get an equivalent amount of light at the maximum sync speed of 1/250 of a second from a tungsten light, you would need a 7500-watt lamp! Of course, if you don't need to use a fast shutter speed, then you can use one 30-watt light bulb for a 1-second exposure or a 60-watt lamp for a 1/2-second exposure.

Some other disadvantages of using incandescent lights include the following:

- Color temperature inconsistency. The color temperature of the lamps changes as your household current varies and as the lamps get more and more use. The color temperature may be inconsistent from manufacturer to manufacturer and may even vary within the same types of bulbs.
- Light modifiers are more expensive. Because continuous lights are hot, modifiers such as softboxes need to be made to withstand the heat, which makes them more expensive than the standard equipment that is meant to be used for strobes.
- Short lamp life. Incandescent lights tend to have a shorter life than flash tubes, so you'll have to replace them more often.

Although incandescent lights have quite a few disadvantages, they are by far the most affordable type of lights you can buy. Many photographers who are starting out use inexpensive work lights that can be bought at any hardware store for less than \$10. These lights use a standard light bulb and often have a reflector to direct the light; they also come with a clamp you can use to attach them to a stand or anything else you have handy that might be stable.

Chapter 6 + Working with Light 149

Halogen work lamps, also readily available at any hardware store, have the advantage of a higher light output than a standard light, generally speaking. The downside is they are very hot, and the larger lights can be a bit unwieldy. You also may have to come up with some creative ways to get the lights in the position you want them. Some halogen work lamps come complete with a tripod stand. If you can afford it, I'd recommend buying these; they're easier to set up and less of an aggravation in the long run. The single halogen work lamps that are usually designed to sit on a table or some other support are easily available for less than \$20; the double halogen work lamps with two 500-watt lights and a 6-foot tripod stand are usually available for less than \$40.

If you're really serious about lighting with hot lights, you may want to invest in a photographic hot light kit. These kits are widely available from any photography or video store. They usually come with lights, light stands, and sometimes with light modifiers such as umbrellas or softboxes for diffusing the light for a softer look. The kits can be relatively inexpensive, with two lights, two stands, and two umbrellas for around \$100. Or you can buy much more elaborate setups ranging in price up to \$2000. I've searched all over the Internet for these kits and have found the best deals are on eBay.

Fluorescent

Fluorescent lights have a lot of advantages over incandescent lights; they run at much lower temperatures and use much less electricity than standard incandescent lights. Fluorescent lights are also a much softer light source than incandescent lights.

In the past, fluorescent lights weren't considered viable for photographic applications because they cast a sickly green light on the subject. Today, most fluorescent lamps that are made for use in photography are color corrected to match both daylight and incandescent lights. Also, with the white balance being adjustable in the camera or in Photoshop with RAW files, using fluorescents has become much easier because you don't have to worry about color-correcting filters and special films.

These days, because more people are using fluorescent lights, light modifiers are more readily available. They allow you to control the light to make it softer or harder and directional or diffused.

Fluorescent light kits are easily available through most photography stores and online. These kits are a little more expensive than the incandescent light kits — an average kit with two light stands, reflectors, and bulbs costs about \$160. Fluorescent kits aren't usually equipped with umbrellas or softboxes because the light is already fairly soft. You can buy these kinds of accessories and there are kits available that come with softboxes and umbrellas, although the kits are significantly higher in price.

Unfortunately there aren't many low-cost alternatives to buying a fluorescent light kit. The only real option is to use the clamp light mentioned in the section about incandescent light and fit it with a fluorescent bulb that has a standard bulb base on it. These types of fluorescent bulbs are easily available at any store that sells light bulbs.

HMI

This type of continuous light is mainly used in the motion picture industry. HMI lamps burn extremely bright and are much more efficient than standard incandescent, halogen, or fluorescent lights. The light emitted is equal in color temperature to that of daylight.

Although I include them here for general information, these kits are usually too costprohibitive for use in most average still-photography applications. A one-light kit with a 24-watt light can start at over \$1000. An 18,000-watt kit can cost more than \$30,000!

Light Modifiers

Light modifiers do exactly what their name says they do: they modify light. When you set up a photographic shot, in essence, you are building a scene using light. For some images you may want a hard light that is very directional; for others a soft, diffused light works better. Light modifiers allow you to control the light so you can direct it where you need it, give it the quality the image calls for, and even add color or texture to the image.

Umbrellas

The most common type of light modifier is the umbrella. Photographic umbrellas are coated with a material to maximize reflectivity. They are used to diffuse and soften the light emitted from the light source, whether it's continuous or strobe lighting. There are three types of umbrellas to choose from:

Standard. The most common type of umbrella has a black outside with the inside coated with a reflective material that is usually silver or gold in color. Standard umbrellas are designed so you point the light source into the umbrella and bounce the light onto the subject, resulting in a non-directional soft light source.

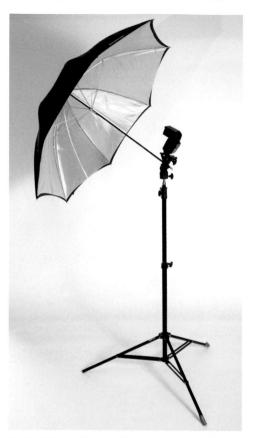

6.17 A Speedlight with a standard umbrella

- Shoot-through. Some umbrellas are manufactured out of a onepiece translucent silvery nylon that enables you to shoot through the umbrella like a softbox. You can also use shoot-through umbrellas to bounce the light as previously mentioned.
- Convertible. This umbrella has a silver or gold lining on the inside and a removable black cover on the outside. Convertible umbrellas can be used to bounce light or as a shoot-through when the outside covering is removed.

Chapter 6 + Working with Light 151

Photographic umbrellas come in various sizes, usually ranging from 27 inches all the way up to 12½ feet. The size you use is dependent on the size of the subject and the degree of coverage you want. For standard headshots, portraits, and small to medium products, umbrellas ranging from 27 inches to about 40 inches supply plenty of coverage. For full-length portraits and larger products, a 60- to 72-inch umbrella is generally recommended. If you're photographing groups of people or especially large products, you need to go beyond the 72-inch umbrella.

The larger the umbrella is, the softer the light falling on the subject from the light source. It is also the case that the larger the umbrella is, the less light you have falling on your subject. Generally, the small to medium umbrellas lose about a stop and a half to 2 stops of light. Larger umbrellas generally lose 2 or more stops of light because the light is being spread out over a larger area.

Smaller umbrellas tend to have a much more directional light than larger umbrellas. With all umbrellas, the closer your umbrella is to the subject, the more diffuse the light is.

Choosing the right umbrella is a matter of personal preference. Some items to keep in mind when choosing your umbrella include the type, size, and portability. You also want to consider how they work with your light source. For example, regular and convertible umbrellas return more light to the subject when light is bounced from them, which can be advantageous, especially if you are using a Speedlight, which has less power than a studio strobe. Also, the less energy the Speedlight has to output, the more battery power you save. On the other hand, shoot-through umbrellas lose more light through the back when bouncing, but they are generally more affordable than convertible umbrellas.

Softboxes

Softboxes, as with umbrellas, are used to diffuse and soften the light of a strobe or continuous light to create a more pleasing light source. Softboxes range in size from small, 6-inch boxes that you mount directly onto the flash head, to large boxes that usually mount directly to a studio strobe.

The reason you may want to invest in a softbox rather than an umbrella for your studio is that softboxes provide a more consistent and controllable light than umbrellas do. Softboxes are closed around the light source, thereby preventing unwanted light from bouncing back on to your subject. The diffusion material makes it so there is less of a chance of creating *hotspots* on your subject. A hotspot is an overly bright spot usually caused by bright or uneven lighting.

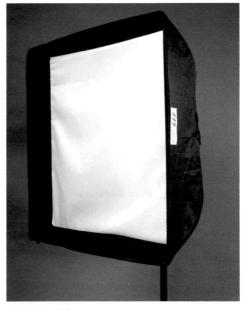

6.18 A softbox

Softboxes are generally made for use with studio strobes and mono-lights, although special heat-resistant softboxes are made for use with hot lights. Softboxes attach to the light source with a device called a speedring. Speedrings are specific to the type of lights to which they are meant to attach. If you are using a standard hot-shoe flash as your light source, some companies, such as Chimera (www.chimeralighting. com), manufacture a type of speedring that mounts directly to the light stand and allows you to attach one or more Speedlights to the light stand as well. You mount the speedring to the stand, attach the softbox to the speedring, attach the Speedlight with the flash head pointed into the softbox, and you're ready to go.

Softboxes are available in a multitude of shapes and sizes ranging from squares and rectangles to ovals and octagons. Most photographers use the standard square or rectangular softboxes. However, some photographers prefer to use oval or octagonal softboxes for the way they mimic umbrellas and give a more pleasing round shape to the catchlights in the subject's eyes. This is mostly a matter of personal preference. I usually use a medium-sized, rectangular softbox.

As with umbrellas, the size of the softbox you need to use depends on the subject you are photographing. Softboxes can be taken apart and folded up conveniently, and most of them come with a storage bag that can be used to transport them.

Diffusion panels

A diffusion panel is basically a frame made out of PVC pipe with reflective nylon stretched over it. Diffusion panels function

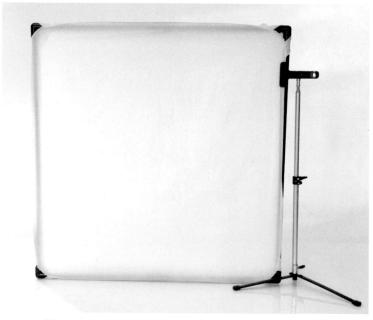

6.19 A diffusion panel

in much the same way as a softbox, but you have a little more control over the quality of the light when you use a diffusion panel.

Diffusion panels are usually about 6 feet tall and have a base that allows it to stand up without the need of a light stand. The diffusion panel is placed in front of the subject. Your light source is then placed behind the diffusion panel. You can move the light closer to the diffusion panel for more directional light or farther away for a softer and more even light. For a full-length portrait or a larger subject, you can place two or more lights behind the panel allowing you to achieve greater coverage with your lights.

You can use a diffusion panel as a reflector, bouncing the light from your light source on to the subject. Diffusion panels can be purchased at most major camera stores at a fraction of the price of a good softbox. The PVC frame can be disassembled easily and packed away into a small bag for storage or for transport to and from location.

Tip If you're feeling crafty, a diffusion panel can be made from items easily found in your local hardware and fabric store. There are numerous sites on the Internet that offer advice on how to construct one.

Other light modifiers

There are many different types of light modifiers. The main types – umbrellas, softboxes, and diffusion panels – serve to diffuse the light by effectively increasing the size of the light source, thereby reducing contrast. In addition to softboxes and such, other types of light modifiers are worth your consideration, such as barn doors and snoots. These are also used to control the direction of the light to make it appear stronger or to focus it on a specific area of the subject. The following list includes some of the more common tools photographers use to direct the light from the light source.

- Parabolic reflectors. Most light sources come equipped with a parabolic reflector. These reflectors usually range in size from 6 to 10 inches in circumference although you can buy larger ones. Without a reflector, the light from the bare bulb, whether it's a flash tube or an incandescent, would scatter and lack direction resulting in the loss of usable light. The reflector focuses the light into a more specific area actually increasing the amount of usable light by 1 or 2 stops. Parabolic reflectors are commonly used in conjunction with other light modifiers including umbrellas, barn doors, and grids. When using an umbrella, a reflector is always used to direct the light into the umbrella, which diffuses the light. Using only a reflector gives the light a very hard quality that results in a lot of contrast.
- Barn doors. Barn doors are used to control the direction of light and to block stray light from entering the lens, which can result in lens flare. Blocking the light is also known as *flagging*. Barn doors are normally attached to the reflector and come in two types-4-leaf and 2-leaf. Barn doors consist of panels that are attached to hinges. These hinges allow you to open and close the doors to let light out or keep it in. Typically, barn doors are used when you want a hard light source to shine on a specific area of the subject but you don't want any stray light striking other parts of the subject or the camera lens.

- Grids. Grids, also known as grid spots or honeycombs, are used to create a light similar to a spotlight. A grid is a round disc with a honeycomb-shaped screen inside of it. When the light shines through it, it is focused to a particular degree, giving you a tight circle of light with a distinct fall-off at the edges. There are different types of grids that control the spread of light. They run from a 5-degree grid to a 60-degree grid. The 5-degree grid has very small holes and is deep so the light is focused down to a small bright spot. The higher the degree of the grid spot, the more spread out the spot becomes. Grid spots fit inside of the reflector just in front of the lamp or flash tube. Grids are great to use as hair lights and to add a spot of light on the background to help the subject stand out.
- Snoots. A snoot is another device that creates a spotlight-like effect similar to the grid spot. A snoot is shaped like a funnel and it kind of works that way, too, funneling light into a specific area of the scene. The snoot usually has a brighter spot effect than a grid does. The snoot fits directly over the flash head.

- Reflector. This type of reflector doesn't directly modify the light coming from the light source, but it is used to reflect light onto the subject. Reflectors are usually white or silver although some can be gold. Professional reflectors are usually round or oval disks with a wire frame that can be easily folded up to a smaller size. You can make your own reflector by using white foam board available at any art supply store and at some photography stores. You can use the board white or cover it with silver or gold foil. In a pinch, almost anything white or silver, such as a lid from a styrofoam cooler or even a white t-shirt, will work.
- Gobos. A gobo can be anything that "goes between" the light source and the subject or background, often to create a pattern or simulate a specific light source, such as a window. They are usually attached to a stand and placed a few feet in front of the light source. A common technique in film noirtype photography is to place Venetian blinds between a light and the background to simulate sunlight shining through the blinds of the office window of a private eye. Gobos can be made or purchased from a photographic supply house.

Real-World Applications

n this chapter I cover just a few of the many different types and styles of photography. Each different subject you photograph has certain caveats that you must be aware of.

In each section I provide different samples of the photographic technique along with some helpful pointers and examples of the types of aperture, shutter speed, ISO settings, and lenses that could be used with the specific subject matter.

For those of you who are not new to photography, this section can offer you some different insights to old subjects, perhaps inspiring you to create new and more exciting images.

Abstract Photography

For the most part, when you photograph something you are concerned with showing the subject clearly. When photographing a portrait, you try to represent the face or some revealing aspect of the person; when shooting a landscape, you try to show what's in the environment, be it trees, mountains, or a skyline. However, when shooting abstract photography, you are working with the idea of the subject, rather than an absolute subject.

In abstract photography, the subject is less important than the actual composition. When attempting abstract photography, you want to try to bring out the essence of what you're photographing.

There are no hard and fast rules to photography, and this is even truer in abstract photography. With this type of photography, you may be attempting to show the texture or color of something. What the actual object is isn't necessarily important. In This Chapter

Abstract photography

Action and sports photography

Architectural photography

Art photography

Child photography

Concert photography

Flower and plant photography

Landscape photography

Light trail and fireworks photography

Macro photography

Night photography

Pet photography

Portrait photography

Still-life and product photography

Travel photography

Wildlife photography

An abstract photograph should give the viewer a different perspective of the subject than a normal photograph would. There are a few hardliners who say that if you can recognize the subject then it's not truly abstract. To that, I say: Abstract photography (or any abstract art) can be broken down into two types – *objective* and *nonobjective*. Objective abstract art presents something that can be recognized, but it presents it in an unusual way. Nonobjective abstract art takes the subject and breaks it down to a base element such as lines, forms, colors, and texture.

7.1 Bones. This is a photo of an art installation where there were thousands of cow bones suspended from the ceiling. I used a very large aperture to capture the ambient light and to create a shallow depth of field. Shot with a Nikkor 50mm f/1.8 lens, ISO 400 at f/1.8 for 1/80 second.

Inspiration

Almost anything can be used to create an abstract photograph. It can be a close-up of the texture of tree bark or the skin of an orange. Look for objects with bright colors or interesting textures.

Many structures have interesting lines and shapes. Cars can have interesting lines. Keep an eye out for patterns. Patterns can be anywhere – on the side of a building, or the surface of a rock. Evening shadows often create dynamic patterns with the added benefit of the rich colors of the sunset.

7.2 Gateway in Blue. This is a photo of the Gateway Arch in St Louis, Missouri. I specifically stood underneath the arch and shot up at it using the sky as a backdrop to give it an abstract quality. I used a wide-angle setting to maximize perspective distortion. Shot with a Tokina 19-35 f/3.5-4.5 lens zoomed to 19mm, ISO 200 at f/8 for 1/200 second.

Abstract photography practice

7.3 White Sands photographed at White Sands National Monument in New Mexico

Table 7.1 Taking Abstract Pictures

Setup Practice Picture: Figure 7.3 is a study of a sand dune taken at White Sands National Monument in New Mexico. What caught my eye in this scene was the leading line at the crest of the dune that separated the smooth side of the dune from the side with all of the randomly textured patterns.

On Your Own: Abstract photo opportunities can exist in even the most mundane subjects; take a closer look at things to find some interesting aspects.

Lighting Practice Picture: I chose to shoot at an angle where the sun was side lighting the windblown sand dune so that there was a distinct contrast from one side of the ridge to the other.

On Your Own: Try to find ways to use the lighting to your advantage. Finding the delicate interplay between shadows and highlights can give your images the added dynamic you need.

Continued

Table 7.1 (continued)

Lens Practice Picture: Tamron 17-50mm f/2.8 zoomed to 50mm.

On Your Own: You can use any type of lens to make an abstract image. Using wide angles can add strange distortions, or coming in close can focus on a minute detail.

Camera Practice Picture: I chose Aperture Priority to control the depth of field. I used Spot metering to be sure that some shadow detail was retained. I captured the image in RAW to be able to adjust the white balance in post-processing.

On Your Own: Controlling your aperture is key in focusing on the details in the image. You may want to use a wide aperture to blur unwanted elements from the background or a small aperture to be sure that the whole scene is in sharp focus.

Exposure Practice Picture: ISO 250 at f/10 for 1.6 seconds. I chose a small aperture to ensure that all of the details were in focus from the front of the frame to the back.

On Your Own: Your settings can vary widely depending on your subject matter and lighting. With a relatively still subject you can use longer shutter speeds; when your subject is moving, be sure to use a faster shutter speed to freeze any motion.

Accessories I used a tripod to achieve a sharp focus during the rather long exposure.

Abstract photography tips

 Keep your eyes open. Always be on the lookout for interesting patterns, repeating lines, or strange textures.

Action and Sports Photography

Action and sports photography is just what it sounds like, although it doesn't necessarily mean your subject is engaging in some type of sport. It can be any activity that involves fast movement, such as your child **Don't be afraid to experiment.** Sometimes something as minor as changing the white balance setting can change the whole image. Sometimes the wrong setting may be the right one for the image.

riding his bike down the street or running across the beach. Shooting any type of action can be tricky to even seasoned pros because you need to be sure to shoot at a fast enough shutter speed to freeze the movement of your subject.

Although the high frame rate of 6 fps (8 with the optional battery grip) of the D300 comes in handy when shooting action and

sports, often the best approach with shooting action is to get familiar with the movement of the subject, learn when the action is at its peak, and then take your shot.

You can employ a number of different techniques to decrease motion blur on your subject. The most commonly used technique is panning. Panning is following the moving subject with your camera lens. With this method, it is as if the subject is not moving at all because your camera is moving with it. When done correctly, the subject should be in sharp focus while the motion blurs the background. This effect is great for showing the illusion of motion in a still photograph. While panning you can sometimes use a slower shutter speed to exaggerate the effect of the background blur. Panning can be a very difficult technique to master and requires a lot of practice.

Tip

Consider using a monopod, which is a one-legged support, when trying the panning technique. Monopods help keep the camera steady while allowing the photographer more freedom of movement than a tripod.

Using flash for action/sports photography is not always necessary or advisable. Sometimes you are so far away from the action your flash won't be effective or you may be in a situation where flash is not allowed. In these cases, just make sure you have a fast enough shutter speed to freeze the motion. You can either use a wider aperture or higher ISO setting to be sure you get the proper shutter speed.

7.4 I used Shutter Priority mode to be sure to have a fast enough shutter speed to freeze the motion of this motorcycle that was racing by on this straightaway at over 130 mph, at Texas World Speedway in College Station, Texas. I also used panning to retain sharpness as well as to show some motion blur in the background. Shot on a monopod with a Nikkor 80-200mm f/2.8 lens with a 2X teleconverter to extend the range to 340mm, ISO 400 at f/5.6 for 1/400 second.

Inspiration

When looking for action scenes to shoot, I tend to gravitate toward the more exciting and edgy events. You may find you favor more low key action events, but regardless of what appeals to you, just keep your eyes open. Nearly everywhere you look there is some kind of action taking place. Go to the local parks and sporting events. Almost every weekend there is a soccer tournament at the school across the street from my studio. I often go there just to practice getting action shots. Check your local newspapers for sporting events. Often the local skateboard shops and bike shops have contests. I try to take pictures of people having fun doing what they love to do.

7.5 In this shot skateboarder Casey Miller pulls a rock 'n roll at the Bastrop Pool in Texas. I used a fast shutter speed to freeze the action. Shot with a Tamron 17-50mm f/2.8 lens, ISO 200 at f/2.8 for 1/250 second.

Action and sports photography practice

7.6 Watching the ponies run at Del Mar Racetrack

	Table 7.2 Taking Action and Sports Pictures
Setup	Practice Picture: Figure 7.6 was taken when I was attending the horse races at Del Mar Racetrack near San Diego. I was always fascinated by the speed and agility of the horses and jockeys so I decided to snap a few shots.
	On Your Own: Sporting events are a great place to find exciting action shots. Securing an unobstructed view of the action is one of the hardest parts when photographing sporting events. Try to show up early to stake out the best spot.
Lighting	Practice Picture: The sun provided all of the lighting for this shot. It was coming in from the side of the frame, which normally isn't considered ideal because it can create too much contrast causing shadows that can obscure important parts of the image. In this case, the contrast created by the sidelighting helped the muscle definition of these amazing horses to really stand out.
	On Your Own: When photographing a sporting event, if at all possible, try to keep the sun at your back so that your subject is lit from the front.
Lens	Practice Picture: I used a Nikkor 80-200mm f/2.8 zoomed to 120mm.
	On Your Own: Depending on how close you can get to your subject, you may want to use a telephoto lens in order to get closer to the action. If you can get right up to the action, using a wide-angle lens can also work.
	Continued

Table 7.2 (continued)

Camera Settings	Practice Picture: My camera was set to Shutter Priority mode. When setting out to take this picture I knew I wanted a shutter speed that was slow enough to show some motion blur to create a feeling of speed. I also panned along with the horses to keep most of the image in reasonable focus.
	On Your Own: When photographing action, setting your shutter speed is the key to capturing the image properly. Whether you want to stop motion by using a fast shutter speed or blur the background using a slower shutter speed and panning with your subject, you want to be able to control the shutter speed in Shutter Priority mode.
Exposure	Practice Picture: 1/160 at f/2.8, ISO 100 (L1.0).
	On Your Own: Try to use the fastest shutter speed you can to stop motion. If the light is dim, you may need to bump up your ISO in order to achieve a fast shutter speed.
Accessories	I used a monopod to help keep the camera steady while panning with the subjects.

Action and sports photography tips

- Practice panning. Panning can be a difficult technique to master, but practice makes perfect. The more time you spend practicing this, the better you (and your images) will get.
- Pay attention to your surroundings. Often when concentrating on getting the shot, you can forget that there are things going on around you. When photographing

sporting events, be sure to remember that there may be balls flying around or athletes on the move. It's better to miss a shot than to get hurt in the process of trying to get the shot.

Know the sport. In order to be able to effectively capture a definitive shot, you need to be familiar with the sport, it's rules, and the ebb and flow of the action. Being able to predict where the action will peak will get you better shots than hoping that you will luck into a shot.

Architectural Photography

Buildings and structures surround us, and many architects pour their hearts and souls into designing buildings that are interesting to the casual observer. This may be why architectural photography is so popular. Despite the fact that buildings are such familiar, everyday sights, photographing them can be technically challenging and difficult – especially when you're taking pictures of large or extremely tall buildings. A number of different problems can arise, the main one being *perspective distortion*. Perspective distortion is when the closest

7.7 Fayette County Courthouse, La Grange, Texas. When photographing this courthouse, which was built in the 1890s, I tried to stand as far away from the structure as I could to avoid perspective distortion. I used a Tamron 17-50mm f/2.8 lens zoomed to 17mm to capture the whole structure. ISO 200 at f/8 for 1/250 second.

part of the subject appears irregularly large and the farthest part of the subject appears abnormally small. Think about standing at the bottom of a skyscraper and looking straight up to the top.

Professional architectural photographers have special cameras that allow them to

correct for the distortion. Unfortunately, you can't make these types of adjustments in a dSLR camera. You have to either fix the image using software or work with the perspective distortion to make a dynamic and interesting image.

Copyright and Permission

In most places, you don't need permission to photograph a building as long as it's a place to which the public has free access. If you are on private property, you should definitely request permission to photograph before you start. If you are inside a building, it is generally a good idea to ask permission before photographing as well.

Due to recent tightening of security policies, a lot of photographers have been approached by security and/or police, so it's a good idea to check the local laws in the city where you are photographing to know what rights you have as a photographer.

For the most part, copyright laws allow photography of any building on "permanent public display." Although the architect of the structure may own the copyright of the design, it usually does not carry over to photographs of the building. There are exceptions to this, so again, check local laws, especially if you plan on selling your images.

Inspiration

Because buildings and architecture are all around us, there are limitless possibilities to shoot. Try looking for buildings with architectural features that you may enjoy, such as art deco, gothic, or modern. The building doesn't necessarily have to be in tip-top condition. Sometimes photographing a building in a state of disrepair can give you an excellent image.

7.8 Texas State Capitol, Austin, Texas. I specifically chose a wide-angle setting very close to the building to get drastic distortion. I used a Tamron 17-50mm f/2.8 lens set to 17mm, ISO 400 at f/8 for 1/125 second.

Architectural photography practice

7.9 The Palmer Event Center near downtown Austin, Texas, at night

Table 7.3	
	Taking Architectural Pictures
Setup	Practice Picture: For figure 7.9, I photographed the Palmer Event Center located near downtown Austin, Texas. I decided to photograph the building at night to take advantage of the lighting, which makes it vaguely resemble a UFO.
	On Your Own: Buildings are literally everywhere, but that doesn't mean you have to photograph a huge skyscraper or giant structure. Even a small bungalow can make an interesting architectural photograph.
Lighting	Practice Picture: Because this picture was shot at night, the only lighting came from the lights on the building and the surrounding area.
	On Your Own: Night is a fantastic time to take architectural shots. Architects and landscape designers often use lighting to create an entirely different look to a building at night. When shooting during the day, be sure the sun is facing the side of the building you're photographing to ensure a good exposure. Shooting a backlit building can cause the sky to blow out when the building is properly exposed, or when the sky is properly exposed the building will appear too dark.
Lens	Practice Picture: For this photo, I used a 17-50mm Tamron f/2.8 zoomed to 50mm. Because I was a good distance from the structure I was able to zoom in a bit to fill the frame.
	On Your Own: Generally, a wide-angle lens setting is used for close-up architectural shots, when you can put some distance between you and the structure you can zoom in a bit. A good wide to short telephoto lens like the 17-50mm is a good choice to cover most architectural shots.
Camera Settings	Practice Picture: My camera was set to Manual exposure with Spot metering. I chose these settings because I knew the dark sky would fool the meter into overexposing the bright lights on the building. I set the white balance to fluorescent's subsetting for Sodium Vapor lamps to match the light source.
	On Your Own: Oftentimes when shooting static objects like buildings you can set up your camera and use the built-in light meter to determine your settings and adjust them as you see fit. Be sure to take into consideration the light source, especially when photographing at night.
Exposure	Practice Picture: ISO 160 at f/11 for 15 seconds.
	On Your Own: Achieving a good depth of field is important in architectural photography so using a rather small aperture is usually advisable. Keep your ISO low for the best image quality.
Accessories	A tripod is one of the best tools you can use for architectural photography. Even in fairly bright sunlight, using a small aperture can make for slow shutter speeds. A tripod will keep your images sharp.

Architectural photography tips

- Shoot from a distance. When taking pictures of tall buildings and skyscrapers try not to take your photograph too close to the base of the building. The perspective distortion can make the structure look abnormal.
- Avoid backlighting. If the building you are photographing is backlit you will lose detail in the structure and the background will appear

too bright. Try to take your picture when the sun is shining on the part of the building you want to photograph.

Be aware of lens distortion. Different lenses can introduce distortion. Wide-angle lenses often suffer from barrel distortion that can cause the straight lines of the structure that are near the edge of the frame to appear bowed out. Either avoid placing straight lines near the edge of the frame or be sure to correct for the distortion in post processing.

Art Photography

Art photography is a touchy subject that often brings up the question, "What is art?" Simply put, art is an expression of the artist's own idea of what is beautiful or aesthetically appealing. This doesn't mean that art has to be beautiful; sometimes art is meant to evoke a feeling or reaction. And, not everyone finds the same things appealing, which is why art can spark controversy.

When I think of photographic art, I think of something that is beyond the normal scope of pointing a camera at something strange and just snapping a picture. Artistic photographs should have a modicum of thought behind them and careful consideration should be given to composition, color, and perspective.

One of the main tools in taking artistic photographs is using your lens aperture to create selective focus. Using a wide aperture often softens a lot of the elements of the image and can give it a surreal look. Conversely, having everything in the image hyper-sharp can also create a feeling of ultrarealism. One fun thing about doing artistic photography is stepping out of the box and trying new things and techniques that you wouldn't normally apply to your standard everyday photograph. There are a lot of fun techniques and accessories that you can use to make your camera take very interesting images.

Lensbabies

One of the most popular and readily available accessories is the *Lensbaby*. A Lensbaby is a selective focus lens that fits on your D300 just like any regular lens would. Lensbabies are flexible and allow you to bend, move, and compress the lens element until you reach focus in a desired area of the composition while the other areas are out of focus and slightly distorted.

The Lensbaby features a single element glass lens in the front (most lenses have multiple elements to reduce distortion and increase sharpness), which gives the image a soft focus effect. Using your fingers to move the flexible housing you get an area of sharpness (the sweet spot) surrounded by an area of increasing blur.

7.10 Tuff-dart. This image was shot with a Lensbaby 2.0. ISO 400, f/2.0 for 1/15 second.

Although this lens may not be for everyone, I find it a lot of fun to use. It compels you to really take a look at what you're photographing and concentrate on the different elements of composition.

TtV

TtV, which stands for through the viewfinder, is a technique that involves using your dSLR to take photos through the viewfinder of a second camera. The second camera is usually an old twin-lens reflex film camera such as a Kodak Duaflex. Because film isn't available for many of these old cameras or they simply don't work anymore, they can often be found for next to nothing on sites such as eBay.

The TtV technique gives your images a decidedly vintage flavor, reminiscent of viewing old slides. Most of these old cam-

eras have lenses that are scratched and coated with dust and these aberrations show up in the image. Although these cameras can usually be disassembled and cleaned out fairly easily, I prefer to keep mine somewhat dirty as it adds to the overall old feel of the photos I take through it. As with the Lensbabies, some people say "why take an expensive, high-resolution dSLR and put an inexpensive lens on it to degrade the image?" My replay to that is, "Because it's fun!" After all, one of the main reasons people do photography is to have fun.

Getting involved in TtV photography does require a little work and a macro lens. You need the macro lens to be able to get the lens close enough to focus on the image that appears in the second camera's viewfinder. You can also use close-up filters on an existing lens to achieve the same effect.

In order to get a usable image you first need to build something to block extraneous light from the outside, allowing only the light coming through the viewfinder lens to reach the lens of your D300. For the most part, this light-blocking contraption can easily be made from black poster board or mat board and some tape. Gaffer's tape, a cloth tape similar to duct tape, works best for this application because the adhesive doesn't leave a sticky residue behind like duct tape does.

There is an excellent tutorial written by photographer Russ Morris that details how to build a light-blocking contraption and a list of some of the different types of cameras that can be used with this technique. The tutorial can be found at www.russmorris. com/ttv/.

7.11 TtV in use.

7.12 Tyrant Lizard King. This image was shot using a 50mm macro lens shooting into the viewfinder of a Kodak Duaflex II from the late 1940s. Some additional color adjustments also were done in post processing.

Other techniques

There are many techniques that are used to create different types of artistic photographs. Some involve using image-editing software to emulate the effects of different film cameras such as Holga or Lomo. Both are fairly inexpensive cameras with cheap lenses that give sometimes unpredictable results. The Holga is a clunky plastic camera with a plastic lens that is prone to light leaks and soft focus. To some people this sounds like a nightmare scenario, but to others this unpredictability adds to the character of the photograph. The Lomo is a Russian camera; it gets its name from Leningradskoye Optiko-Mechanichesckoye Obyedinenie (Leningrad Optical Mechanical Amalgamation). This camera is known for its overly saturated colors, blurry lenses, and uneven exposures.

7.13 Clementine and the Pigeons. This photo is a simulated Holga shot. The image was cropped to a square because Holgas are a square-format camera. I also added a C-41 to E-6 cross-processing technique by adjusting the curves in Photoshop CS3.

7.14 In Homage to Bukowski. This is a simulated Lomo photograph. To achieve this effect I simply ran a Photoshop action that I found online.

Another technique that involves image manipulation is simulating *cross-processing*, also known as X-pro. Cross-processing is a film technique that involves developing negative film in chemicals that are normally used to process slide film (C-41 to E-6), or vice versa (E-6 to C-41). Doing this shifts the colors so that they appear different than normal, usually overly cyan and green. Cross-processing also increases the saturation and contrast of the image.

This is by no means a complete list of artistic photographic techniques. There are literally thousands of different techniques already out there waiting for you to discover them.

7.15 An Evening at the Laundromat. This photo is meant to simulate Agfa Optima film cross-processed C-41 to E-6. Cross-processing different types of film leads to different color shifts.

Art photography practice

7.16 Still-life with fish head

Table 7.4 Taking Art Pictures

Setup
 Practice Picture: For figure 7.16, I was walking down the Ocean Beach pier in San Diego when I noticed this fish head sitting on a gutting table. For some reason this struck me as interesting so I photographed it, purposely placing the fish head off center to add some interest to the shot.
 On Your Own: Keep your eyes open; art can be anywhere. Look for odd scenes or things that seem to be out of place in their environments.
 Lighting
 Practice Picture: The subject was lit by the natural light of an overcast sky.
 On Your Own: Lighting can vary. It depends upon the scope of your vision. You can use natural lighting or you can choose to create your own lighting using a flash or a continuous light. You can make your lighting hard or soft. There are no hard and fast rules, the only limits are in your mind.

Continued

Table 7.4 (Continued)	Tab	le 7.4	(continued	1)
-----------------------	-----	--------	------------	----

Lens Practice Picture: Tamron 17-50mm f/2.8 lens zoomed to 50mm. I had the aperture wide open to achieve a shallow depth of field.

On Your Own: Any type of lens can be used to take an artistic photo, including nonstandard lenses like the Lensbaby. Use a wide-angle lens to give your image some perspective distortion, which can give your subject an odd look.

Camera Practice Picture: As I often do when I'm out walking around with my camera with no idea of what I'll discover, my camera was set to Aperture Priority mode. I set the white balance to Shade because the Auto setting was making the image look bluish.

On Your Own: Aperture Priority is a good setting to use because it allows you to control your depth of field for selective focus. Don't be afraid to adjust your white balance to the "wrong" setting. This often adds interest to your image.

Exposure Practice Picture: ISO 100 at f/2.8 for 1/80 second. Minimal post-processing was done to this image; just a saturation boost and a vignette around the corners.

On Your Own: The recommended setting for taking an artistic photo is the one that works. Experimentation can be fun and yield great results. Sometimes overexposing or underexposing an image can give it that extra bit of flair.

Art photography tips

- Experiment. Try different techniques and accessories. Sometimes a small amount of post processing can turn a boring image into a work of art. Using the aperture creatively or using selective focus can add some interest to your image.
- Think outside of the box. Shoot odd subjects from strange angles, set your white balance deliberately wrong. Try a different lens if you're not getting the desired results.
- Don't get discouraged. Often some people won't understand your artistic vision. This is to be expected. This doesn't mean your image isn't any good, it may be just beyond the scope of the observers normal thought processes.

Child Photography

Kids grow up fast, and having a photographic chronicle of them doing that growing up is great. For a number of people this is one of the main reasons they buy a camera. Most first-time parents buy a compact digital camera, then realizing the limitations, they upgrade to a dSLR, then before they know it they're hooked not only on photographing their children but on photography in general.

One of the greatest challenges when photographing children is that they seem to never stop moving, and you have to be on your

toes to catch those fleeting moments when they are at their best. Child photography is one-third action photography, one-third portrait photography, and one-third luck!

When trying to set up a shot with children as the subjects, one of the first things you want to consider is the environment. This is very important, as you want the child to be comfortable, and you want to have a nice background that doesn't compete with the subject for attention. Often the child's bedroom can be the perfect place. The child is in his or her own environment, and there are likely to be toys he can play with and that

7.17 For this shot of my niece, I used a little backlighting from the sun to highlight the hair; I also used some fill-flash to bring the face out of the shadows caused by the backlighting. I used a Nikkor 50mm f/1.8 lens, ISO 400 at f/1.8 for 1/6400 second.

you can use as props. Another great place is outside, either in the child's own backyard or, even better, at a scenic park where there is playground equipment to play on.

One of the most important things to remember when photographing children is that they are amazingly perceptive to moods and emotions. They can easily tell when you are getting frustrated, so if things aren't exactly working out the way you planned and you're getting a bit irritable, it may be a good time to take a break. The best way to get great pictures is to make sure everyone involved is having fun.

Inspiration

7.18 For this image of my nephew Seamus, I placed him next to a window to take advantage of the soft morning light shining through. I used a Nikkor 50mm f/1.8 lens. Shot at ISO 200 at f/1.8 for 1/30 second.

Having children or grandchildren of your own is inspiration enough to want to take a million photographs of them. However, if you don't have children of your own, maybe

you have a niece or nephew or perhaps you just enjoy capturing children's youthful enthusiasm.

Child photography practice

7.19 Aurora

Table 7.5			
	Taking Children's Pictures		
Setup	Practice Picture: My friend Katie and her daughter Aurora stopped by my studio one afternoon and we decided to do an impromptu photo shoot at the railroad tracks nearby as shown in figure 7.19.		
	On Your Own: Try to find an interesting location to add a fun element to your photo. Playgrounds or places where the child can interact with the surroundings can be fun.		
Lighting	Practice Picture: The late-afternoon sun provided the lighting for this shot. I positioned Aurora so that the sun was lighting her from the side so that the sun wasn't shining directly in her eyes.		
	On Your Own: Shooting outdoors in the late afternoon or early morning can give your images a nice, golden light. Shooting during the afternoon when the sun is full bright is not recommended because it can cause images with a lot of contrast and deep shadows. Also try to avoid posing your subject directly facing the sun as this can cause them to squint.		
Lens	Practice Picture: Tamron 17-50mm f/2.8 lens zoomed to 50mm.		
	On Your Own: Using a longer focal length can help compress the features of the person you're shooting. Shooting with a wide angle lens can cause the features of your subject to appear distorted especially when used close up.		
Camera Settings	Practice Picture: My camera was set to Aperture Priority, Matrix metering, Auto white balance.		
	On Your Own: As with most portraits you'll want to set your camera to Aperture Priority so you can control how much depth of field you have. Matrix or Center-weighted metering usually works well for children's portraits.		
Exposure	Practice Picture: ISO 200, f/2.8, 1/1250 second.		
	On Your Own: Expect pretty fast shutter speeds when shooting outdoors while using a wide aperture. You definitely want to use the lowest ISO possible.		

Child photography tips

- Have patience. Sometimes it may take quite a bit of photographing to get the image you're after. Don't get discouraged if it doesn't turn out right away.
- Have some props handy. A favorite toy or stuffed animal can add a personal touch to the photograph as well as keep the child occupied.
- Bring along some sweets.
 Sometimes a little bit of a treat can dry up tears or just keep kids from getting bored.

Concert Photography

Concert photography can be a particularly difficult endeavor, but it's also extremely rewarding, especially if you're a music fan. Getting that quintessential shot of your favorite performer is the reason why many photographers do this type of photography. Unfortunately to get "the" shot, sometimes you have to fight a crowd and risk getting drinks spilled on your camera. Of course, if you're like me, the type of person who likes to get into the fray, this is great fun.

Tip I strongly suggest that you invest in good earplugs if you plan to do much concert photography.

7.20 Mr. Lewis and the Funeral 5, the Longbranch Inn, Austin, Texas. This picture was shot using an SB-600 Speedlight. The flash was set to slow sync to capture some of the ambient light. Shot using a Tamron 17-50mm f/2.8 lens zoomed to 24mm, ISO 400 at f/2.8 for 0.6 second, FEC –1.

Some photographers are staunchly against using flash at concerts, preferring to shoot with the available light. I like to use some flash at times, as I find that the stage lights can oversaturate the performer, resulting in loss of detail. Another downside to shooting with available light is you need to use high ISO settings to get a shutter speed fast enough to stop action. Typically you need to shoot anywhere from ISO 800 to 3200, which can result in noisy images and the loss of image detail. Fortunately, the D300 excels in high ISO performance so this is not as much of an issue as it was in the past with earlier dSLR cameras.

Note

Some venues or performers do not allow flash photography at all. In this situation, just try to use the lowest ISO you can while still maintaining a fast enough shutter speed.

Inspiration

A good way to get started with concert photography is to find out when a favorite band or performer is playing and bring your camera. Smaller clubs are usually better places to take good close-up photos simply because you are more likely to have closer access to the performers. Most local bands, performers, and regional touring acts don't mind having their photos taken. You can also offer to e-mail the performers some images to use on their Web site. This is beneficial for both them and you, as lots of people will see your photos.

7.21 Professional skateboarder and lead singer of the U.S. Bombs, Duane Peters. For this shot, I didn't want to use on-camera flash because I was down in the front with about 100 people. I opted for a wide aperture and high ISO to get a fast enough shutter speed to freeze the action and counteract against the camera shake caused by being jostled by the crowd. Shot with a Tamron 17-50mm f/2.8 lens zoomed to 50mm. ISO 6400 at f/2.8 for 1/320 second. Spot metered to expose for the singer.

Concert photography practice

7.22 The Angry Samoans at Beerland in Austin, Texas

Table 7.6 Taking Concert Pictures

Setup Practice Picture: For figure 7.22, I was photographing the seminal early-1980s California punk band Angry Samoans playing at a local Austin club, Beerland.

On Your Own: Smaller venues can offer the most intimate or in-your-face photo ops. Often you can get closer to the stage and the band giving your images an up-close and personal feel.

Lighting Practice Picture: Because the stage lighting at the venue was dim at best, I used an SB-600 Speedlight to provide most of the lighting for the exposure. I used the built-in flash to wirelessly trigger the SB-600 while I held it in my hand over my head directing the light on to the singer who was writhing on the floor. The built-in flash was set to Commander mode while the SB-600, set to Group A, was fired in TTL mode with an FEC of -2 EV Rear-curtain sync.

> **On Your Own:** Concert lighting can be very tricky depending on the venue. Some venues have bright stage lights, while some can be very dim. Make a few test shots to determine if the lighting is bright enough. Sometimes I like to mix it up, taking shots with and without flash.

Lens

Practice Picture: Tamron 17-50mm f/2.8 lens zoomed to 17mm. This is my go-to lens for almost everything. It works well for smaller venues allowing you a wide-angle view for close-up shots as well as a small amount of zoom for when you're farther away. The fast, constant f/2.8 aperture allows you to work with available light even when the lighting is quite dim.

On Your Own: For small venues a good wide-angle to medium telephoto works well. For larger venues or concerts where you're farther away from the stage you may need to use a longer telephoto lens, but your flash will be of little use. When photographing large concert events I bring both a 17-50mm and an 80-200mm lens with a 2X teleconverter just in case I need some extra reach.

Camera Settings **Practice Picture:** I used Aperture Priority mode to ensure that my lens was wide open to capture enough light. I also had the camera set to record the images in JPEG Fine and the camera Picture Control was set to Monochrome Black & White. I chose to use this setting to emulate the early concert photography work of Glen E. Friedman. Friedman covered the burgeoning California skateboarding and punk rock scene in the late 1970s and early '80s. He shot mainly black and white, and he captured the frenetic energy and reckless abandon of the musicians of that era.

On Your Own: Aperture Priority mode is a good place to start to be sure that you have as much light reaching the sensor as possible. Using Spot metering is often a good choice especially if the performers are on a dark stage with spotlights shining on them. This prevents the camera from trying to expose for the mostly dark areas behind the performers, which can cause your shutter speed to be too slow.

Exposure Practice Picture: ISO 3200 at f/2.8 for 1/8 second.

On Your Own: Because the lighting is often dark at concert events more often than not you'll have to crank up the ISO. Before using the D300, I tried not to go up past 800 unless absolutely necessary. Now even at 3200 the images are pretty noise free. When shooting above 3200, choosing the Black & White option can help your images because much of the noise is chrominance noise (color). Most of the time you'll find yourself shooting wide-open apertures. Using a fast shutter speed is recommended although when using flash you can bring the shutter speed down a bit, allowing the bright flash to freeze your subject while allowing some of the ambient light to fill in the shadow areas.

Accessories An off-shoe camera cord such as Nikon's SC-27 can help to get your flash off of your camera.

Concert photography tips

- Experiment. Don't be afraid to try different settings and long exposures. Slow Sync flash enables you to capture much of the ambient light while freezing the subject with the short, bright flash.
- Call the venue before you go. Be sure to call the venue to ensure that you are able to bring your camera in.
- Bring earplugs. Protect your hearing. After spending countless hours in clubs without hearing protection, my hearing is less than perfect. You don't want to lose your hearing. Trust me.
- Take your Speedlight off of your camera. If you're using one of the Nikon accessory flashes, such as the SB-800 or SB-600, invest in an off-camera through-the-lens (TTL) hot-shoe sync cord such as the Nikon SC-29 TTL cord. You can also try using the built-in flash as a commander and take advantage of the wireless flash capabilities of your D300. When you're down in the crowd, your Speedlight is very vulnerable. The shoe mount is not the sturdiest part of the flash. Not only is using the Speedlight offcamera safer, but you also gain more control of the light direction by holding it in your hand. This reinforces my suggestion to experiment-move the Speedlight around; hold it high; hold it low; or bounce it. This is digital, and it doesn't cost a thing to experiment.

Flower and Plant Photography

One of the great things about photographing plants and flowers, as opposed to other living things, is that you have almost unlimited control with them. If they are potted or cut, you can place them wherever you want, trim off any excess foliage, sit them under a hot lighting setup, and you never hear them complain.

Some other great things about photographing plants and flowers are the almost unlimited variety of colors and textures you can find them in. From reds and blues to purples and yellows, the color combinations are almost infinite. Plants and flowers are abundant, whether purchased or wild, so there is no shortage of subjects. Even in the dead of winter, you can find plants to take photos of. They don't have to be in bloom to have an interesting texture or tone. Sometimes the best images of trees are taken after they have shed all of their foliage.

Flower and plant photography also offers a great way to show off your macro skills. Flowers especially seem to look great when photographed close-up.

You don't have to limit flower and plant photography to the outdoors. You can easily go to the local florist and pick up a bouquet of flowers, set them up, and take photos of them. After you're done, you can give them to someone special for an added bonus!

7.23 Cactus, Saguaro National Park, Arizona. I used a shallow depth of field to draw attention to the sharp needles. Shot with a Tamron 17-50mm f/2.8 lens zoomed to 48mm, ISO 100 at f/2.8 for 1/320 second.

Infrared Photography

Infrared photography, commonly known as IR photography, uses invisible (to the naked eye) near infrared light to create the image. Although you can't see infrared light, CMOS sensors are very sensitive to this type of light. IR light can have a detrimental effect on the standard images you create using visible light. For that reason Nikon installs an IR blocking filter in front of the sensor. Unfortunately, this means that IR photography with the D300 can be quite difficult. This isn't to say that it's impossible, but it takes very long exposure times, and for this reason it's absolutely necessary to use a tripod when attempting IR photography with the D300.

In order to capture an IR image you first need to block visible light from reaching the sensor. To do this an IR filter is used. The most commonly used filter is the Hoya R72, which blocks out all wavelengths of visible light that fall below 720 nanometers (nm). The *nanometer* is the measurement used to determine the wavelength of light. The wavelengths of visible light fall somewhere between 400 and 700nm, so at 720nm the light is just about beyond the reach of our eyes. There are a couple of important things to remember when taking IR photos with your D300:

Compose the shot with the filter off of the lens. Once you compose the shot you then must focus before placing the filter on the lens. Focusing can be a little tricky. Because IR light doesn't focus at the same point as visible light, you must make some adjustments. The best way to do this is to focus the camera, take a shot, adjust the focus a little, take another shot, and repeat, using the preview to check focus.

Continued

 Use the Manual exposure mode. When using one of the Auto exposure modes (P, S, or A), the camera's meter will underexpose, so using manual exposure is necessary. This is another area in which you need to experiment to find the right setting.

Your infrared image will appear mostly red or deep magenta, so there are some steps that may need to be taken to get your image to appear the way you want it. Traditionally most infrared photography has been done in black and white, but you can also do some post-processing to produce what is known as a false-color infrared image. You can also use the Black and White Picture Control setting with decent results.

Typically, when IR photography is done in black and white the resulting image has vegetation that turns white (living plants reflect a lot of IR) while the sky is usually darkened, sometimes almost black. With false-color infrared you can get a myriad of different colors depending on your post-processing technique.

The bottom line is the D300 is not the ideal camera for attempting IR photography, but it can be done. More information and many tutorials can be found online. If you want to get serious about IR photography your best bet is to purchase a camera that is known to have a relatively weak IR blocking filter such as the D70, or there are companies that will modify a camera by removing the IR blocking filter, However, removing the filter will void the warranty of the camera.

Inspiration

Just take a walk around and look at the interesting colors of the local flora. Pay close attention to the way the light interacts with different plants. A lot of the time, it is undesirable to have a backlit subject, but the light coming through a transparent flower petal can add a different quality of beauty to an already beautiful flower.

It can also be fun to make your own floral arrangements, experimenting with different color combinations and compositions. Taking a trip and talking to a florist can give you some ideas of which plants and flowers work best together.

7.24 The sun lit this shot from behind giving it a bit of a glow. I zoomed in to 50mm and used a wide aperture to blur out the distracting elements of the background. Shot with a Tamron 17-50mm f/2.8 lens zoomed to 50mm. ISO 200 at f/2.8 for 1/50 second.

Flower and plant photography practice

7.25 Wildflowers and grasses in winter

	Table 7.7 Taking Flower and Plant Pictures
Setup	Practice Picture: While taking a hike to Goat Cave in South Austin, Texas, one winter afternoon, I noticed this patch of golden sun shining on some tall grasses and wildflower seed heads, which I thought would make a nice composition as shown in figure 7.25.
	On Your Own: Keep an open mind; pictures of plants and flowers don't necessarily have to be blooming with colors. For example, figure 7.25 is almost monochromatic with its bright gold tones.
Lighting	Practice Picture: This picture was lit entirely by the sun. The sun was coming in at such an angle that the image is almost backlit giving a bit of contrast to the seed heads.
	On Your Own: Oftentimes, natural sunlight is the best thing for lighting plants and flowers. Even if it's a house plant, you can take it outside and sit it in the sun.

Lens Practice Picture: Tamron 17-50mm f/2.8 lens zoomed to 50mm. I zoomed into 50mm so I could be sure to get a very shallow depth of field drawing attention to the seed head.

On Your Own: A lens with a wide zoom range can offer you quite a bit of compositional leeway, allowing you a wide-angle view or zoomed in to isolate a specific detail.

Camera Practice Picture: I set the camera to Aperture Priority so that I could choose a wide aperture to blur out the background, which was full of details that would draw attention away from the main subject of the photo. I also chose to use Matrix metering to keep detail in both the shadows and the highlights. Spot metering would have caused the seed head to be exposed a little brighter, and the background would then have been overexposed and blown out.

On Your Own: Be sure to pay attention to the differences between the shadows and the highlights and expose the image so that everything retains detail. Use Aperture Priority to be able to control your depth of field.

Exposure Practice Picture: ISO 100 at f/2.8 for 1/1000 second. The sun was extremely bright that day and shooting at f/2.8 was giving me a very high shutter speed. Sometimes the shutter speed needed was over 1/8000, higher than the maximum speed of the camera. For this reason I dropped the ISO to L 1.0 (ISO 100) to keep the shutter speeds in a usable range.

On Your Own: Keep an eye on your camera exposure settings when shooting wide open in bright light and adjust your ISO accordingly if the shutter speed isn't fast enough to get the right exposure.

Accessories You may not always be shooting in bright sunlight so a tripod can come in handy if the lighting is dim and your shutter speed drops below an acceptable limit for handheld shooting.

Flower and plant photography tips

- Shoot from different angles. Shooting straight down on a flower seems like the obvious thing to do, but sometimes shooting from the side or even from below can add a compelling perspective to the image.
- Try different backgrounds.
 Photographing a flower with a dark background can give you an image with a completely different feel than photographing that same flower with a light background.
- Try using complimentary colors. Adding different flowers with complimentary colors to your composition can add a little interest to your image. Adding a splash of yellow into a primarily purple composition can make the image pop.

Landscape Photography

With landscape photography, the intent is to represent a specific scene from a certain viewpoint. For the most part, animals and people aren't included in the composition so the focus is solely on the view.

Landscape photography can incorporate any type of environment—desert scenes, mountains, lakes, forests, sky lines, or just about any terrain. You can take landscape photos just about anywhere, and one nice thing about them is that you can return to the same spot, even as little as a couple of hours later, and the scene will look different according to the position of the sun and the quality of the light. You can also return to the same scene months later and find a completely different scene due to the change in seasons. There are three distinct styles of landscape photography:

- Representational. This is a straight landscape; the "what you see is what you get" approach. This is not to say that this is a simple snapshot; it requires great attention to details such as composition, lighting, and weather.
- Impressionistic. With this type of landscape photo, the image looks less real due to filters or special photographic techniques such as long exposures. These techniques can give the image a mysterious or otherworldly quality.
- Abstract. With this type of landscape photo, the image may or may not resemble the actual subject. The compositional elements of shape and form are more important than an actual representation of the scene.

7.26 Cascade Mountains, Washington. For this shot, I used a small f-stop to get a deep depth of field. I spot metered a bright spot in the clouds to avoid a blown-out sky. Shot with a Nikkor 18-70 f/3.5-4.5 lens zoomed to 18mm, ISO 100 at f/10 for 1/1000 second.

One of the most important parts of capturing a good landscape image is knowing about *quality of light*. Simply defined, quality of light is the way the light interacts with the subject. There are many different terms to define the various qualities of light, such as soft or diffused light, hard light, and so on, but for the purposes of landscape photography, the most important part is knowing how the light interacts with the landscape at certain times of day.

For the most part, the best time to photograph a landscape is just after the sun rises and right before the sun sets. The sunlight at those times of day is refracted by the atmosphere and bounces off of low-lying clouds, resulting in a sunlight color that is different, and more pleasing to the eye, than it is at high noon. This time of day is often referred to as the *golden hour* by photographers due to the color and quality of the light at this time. This isn't to say you can't take a good landscape photo at high noon; you absolutely can. Sometimes, especially when you're on vacation, you don't have a choice about when to take the photo, so by all means take one. If there is a particularly beautiful location that you have easy access to, spend some time and watch how the light reacts with the terrain.

Inspiration

There are many breathtaking vistas everywhere you look. Even in the middle of a large city, you can go to a park and find a suitable subject for a landscape. Remember that a landscape doesn't have to be a spectacular scene with awesome natural forces like mountains; it can be a pond, or a small waterfall. Even a simple wheat field can make a great landscape photo.

7.27 The Rio Grande at the Santa Elena Canyon, Big Bend National Park, Texas. I used a small aperture to get a good depth of field. I spot metered on the sky behind the canyon to avoid a blown-out sky. Active D-Lighting was also used to prevent loss of detail of the canyon in the foreground. Shot with a Tamron 17-50mm f/2.8 lens zoomed to 17mm, ISO 200 at f/16 for 1/250 second.

Landscape photography practice

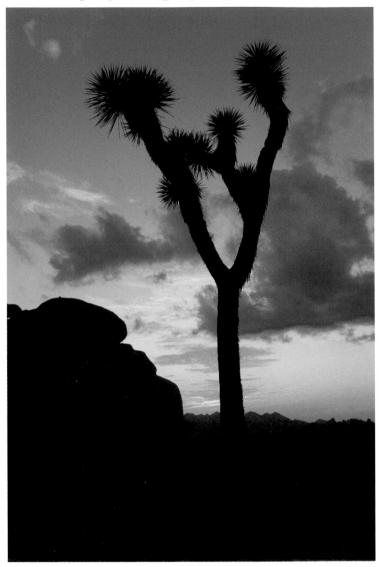

7.28 Joshua Tree at Sunset

Table 7.8			
	Taking Landscape Pictures		
Setup	Practice Picture: For figure 7.28, I was photographing the Joshua trees at sunset in Joshua Tree National Park in California.		
	On Your Own: Landscapes are all around you. You can find some fantastic scenery at a nearby park or nature preserve. Find a compelling sight and shoot it!		
Lighting	Practice Picture: This photo was shot just as the sun was setting. There was still enough light to capture detail in this Joshua tree even though it was backlit. The setting sun brought out some amazing colors including some pink, which contrasts nicely with the blue sky.		
	On Your Own: Lighting can make or break a landscape photograph. If the lighting is flat it can make the photo seem uninteresting and without character. Often, the best time to shoot a landscape is early morning or evening. When not shooting sunset or sunrise landscapes keep your back to the sun to avoid overexposed skies and underexposed land areas.		
Lens	Practice Picture: Tamron 17-50mm f/2.8 lens zoomed to 17mm.		
	On Your Own: The rule of thumb when shooting landscapes is the wider the better. More often than not you want to catch a large area in your photograph.		
Camera Settings	Practice Picture: My camera was set to Aperture Priority because I wanted to use as small an aperture as I could to ensure everything in both the background and foreground was in focus. I chose spot metering and I metered on the brightest part of the sky to ensure I would capture all of the colors of the sky without blowing out the highlights.		
	On Your Own: For landscapes, you want to be in control of the aperture to keep a deep focus so Aperture Priority works great. When photographing directly into the sun like this, spot metering is preferable, but when the lighting is more even, Matrix metering works great.		
Exposure	Practice Picture: ISO 100 at f/5 for 1/125 second. Exposure compensation set to $+0.3$ to capture detail in the tree.		
	On Your Own: As usual, use a low ISO for better resolution. Use smaller apertures to increase depth of field (here I was shooting at a relatively wide setting due to the decreasing light). Often, shutter spee ds will be longer due to the smaller f-stops.		
Accessories	A tripod can be a great help when those shutter speeds get really long.		

Landscape photography tips

- Bring a tripod. When you're photographing landscapes, especially early in the morning or at sunset, the exposure time may be quite long. A tripod can help keep your landscapes in sharp focus.
- Scout out locations. Keep your eyes open; even when you're driving around, you may see something interesting.
- Be prepared. If you're out hiking looking for landscape shots don't forget to bring the essentials such as water and a couple of snacks. It's also a good idea to be familiar with the area you're in or at the very least bring a map.

Light Trail and Fireworks Photography

One of the most fun types of photography is capturing light trails. You can capture some amazing and surreal images. Fireworks photography is exciting, and while it is simple in theory, getting the timing right can be a big challenge. You need a sharp eye to know when the fireworks have been launched so you can be sure to have the camera shutter open before the fireworks explode with a burst of color.

Light trail photography, while different than fireworks photography, shares the same type of camera settings. You need a very slow shutter speed and usually a fairly small aperture. I find that shooting in Aperture Priority mode usually gives long enough shutter speeds to capture a light trail as long as the scene is fairly dark.

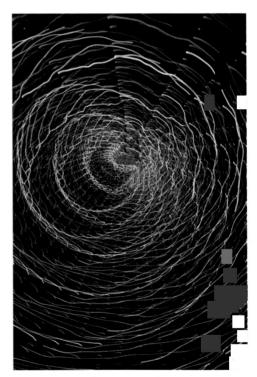

7.29 For this shot I snapped a long exposure shot while twisting the camera around in my hand. Shot with a Tamron 17-50mm f/2.8 lens zoomed to 17mm, ISO 200 at f/6.3 for 1 second.

Inspiration

A tripod is the one thing that is almost essential when you're doing any photography using long shutter speeds. If you try to handhold your camera with an 8-second exposure, your image will be nothing but a blurry mess. Of course, sometimes a handheld blur is exactly the effect you're looking for.

When photographing fireworks I find that using the *Bulb* setting in Manual mode works the best. The Bulb setting opens the shutter when the button is pressed. The shutter remains open as long as the Shutter button remains pressed. When the button is released the shutter closes. The first thing you want to do is figure out where the fireworks are going to "bloom." Set your camera on the tripod and aim it in the right direction. For the most part, you're going to need a wide-angle lens to be sure to get everything in the frame; unless you are very far away, you shouldn't need to zoom in. When the firework is launched, press the Shutter Release button and hold it down until the firework explodes. When the bloom is over, release the Shutter Release button to close the shutter and end the exposure.

When using the Bulb mode, your best bet is to get some sort of remote shutter release. These gadgets plug into the ten-pin remote terminal on the front of your D300. This allows you to release the shutter without jiggling the camera, which can cause motion blur in your images, especially when using long shutter speeds. Nikon offers a few versions of these remote cords that offer different options. There are also thirdparty manufacturers that offer remote release cords that work with the D300.

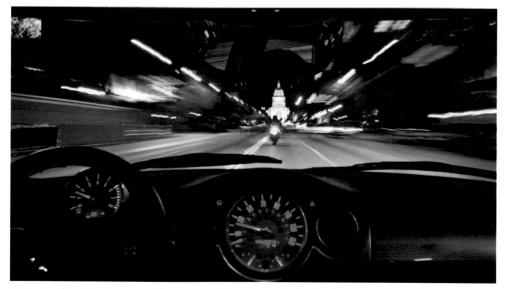

7.30 For this shot I secured the camera to a tripod in the back of a car. I used a remote shutter release to fire the camera while driving down South Congress Ave. in Austin, Texas. The tripod keeps the interior of the car in relatively sharp focus while allowing the motion of the car to give the lights outside a nice motion blur. Shot with a Tamron 17-50mm f/2.8 lens zoomed to 26mm. ISO 200 at f.8 for 2 seconds.

Light trail and fireworks photography practice

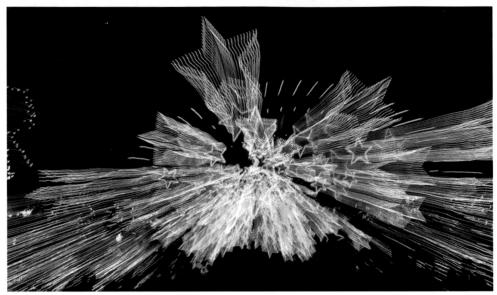

7.31 Starlight at Austin's Trail of Lights

	Table 7.9 Taking Light Trail and Fireworks Pictures
Setup	Practice Picture: For figure 7.31, I was taking pictures at Austin's Trail of Lights display at Christmas. I liked the blue color of the stars, and I thought it would be an interesting effect to zoom in the lens while making a long exposure.
	On Your Own: The holidays are a great time to find displays of lights. You can also find many types of lights in any downtown area or places that have lots of neon signage, such as Las Vegas or Times Square.
Lighting	Practice Picture: The lights on display provided the lighting. At a Christmas display like this one there are many different styles and lighting setups.
	On Your Own: You want to rely on the lights you are photographing; using an outside light source such as flash will diminish the impact and saturation of the lights.

Lens	Practice Picture: Tamron 17-50mm f/2.8 lens. For this shot I started with the zoom set to 17mm and zoomed in while the exposure was being made. This gives the illusion of the stars zooming right at you.
	On Your Own: Almost any type of lens will do, but a nice wide-angle zoom is best. With light trail photography, the blur is the essence of the shot. Moving the camera around and zooming the lens in and out can give you interesting effects.
Camera Settings	Practice Picture: I shot this in Aperture Priority mode. I chose this mode because the light levels were varying and when choosing one set shutter speed I reviewed some of my photos in the camera and discovered that some of my photos were underexposed. Using Aperture Priority mode, I adjusted the aperture until I got the desired shutter speed. This way I was assured to have a good exposure. Using Matrix metering allowed the camera to meter for both the light and dark areas of the image. Spot or center-weighted doesn't generally work well for this type of photo because the lights are very bright and the dark areas are very dark. This causes the camera to severely overexpose or underexpose the lights depending on where the spot is.
	On Your Own: Any one of the modes can work depending on the situation. Programmed Auto can work pretty reliably for this type of photo.
Exposure	Practice Picture: ISO 200 at f/5.6 for 3 seconds.

On Your Own: Low ISO settings and long exposure times are crucial for this type of photography.

Light trail and fireworks photography tips

- Be patient. Sometimes you will have to take many photos before you get one you like. It can be a trial-and-error process to find the exposure that works.
- Look for multicolored lights.
 Bright lights of different colors can add more interest to your images.

- Get there early. To get a good spot for the fireworks, show up a little early to stake out a spot.
- Use a remote shutter release cord. Using a remote release can reduce camera shake when the camera is mounted on the tripod for long exposures.

Macro Photography

Macro photography is easily my favorite type of photography. Sometimes you can take the most mundane object and give it a completely different perspective just by moving in close. Ordinary objects can become alien landscapes. Insects take on a new personality when you can see the strange details of their faces, especially their multifaceted eyes.

Technically, macro photography can be difficult. The closer you get to an object, the less depth of field you get, and it can be difficult to maintain focus. When your lens is less than an inch from the face of a bug, just breathing in is sometimes enough to lose focus on the area that you want to capture (or scare the bug off). For this reason, you usually want to use the smallest aperture you can (depending on the lighting situation) and still maintain focus. I say "usually" because a shallow depth of field can also be very useful in bringing attention to a specific detail.

Caution

When shooting extremely closeup, the lens may obscure the light from the built-in flash, resulting in a dark area on the bottom of the images.

One of the best things about macro photography is that you aren't limited to shooting in one type of location. You can do this type of photography indoors or out. Even on a rainy day, you can find something in your house to photograph. It can be a piece of fruit, a trinket, a coin, or even your dog's nose (if the dog sits still for you). Macro photography requires special lenses or filters to allow you to get closer to your subject. Most lens manufacturers offer lenses that are designed specifically for this purpose. These macro lenses give you a reproduction ratio of 1:1, which means that the image projected onto the sensor is exactly the same size as the physical subject. Some other lenses that can be used to do macro photography are actually telephoto lenses. Although you can't actually get close to the subject with a telephoto the extra zoom gives you a close-up perspective. Telephoto lenses usually have a reproduction ratio of 1:4, or one guarter size.

There are alternatives to dedicated macro lenses. One of the cheaper routes is to use an *extension tube*. An extension tube attaches between the lens and the camera body and gives your lens a closer focusing distance, allowing you to reduce the distance between the lens and your subject. Extension tubes are widely available and easy to use. They make both autofocus tubes and those that require you to focus manually. A drawback to using extension tubes is that they effectively reduce the aperture of the lens they are attached to causing you to lose a bit of light.

Another inexpensive alternative to macro lenses are *close-up filters*. A close-up filter is like a magnifying glass for your lens. It screws onto the end of your lens and allows you to get closer to your subject. There are a variety of different magnifications, and they can be *stacked* or screwed together to increase the magnification even more. Using close-up filters can reduce the sharpness of your images because the quality of the glass isn't quite as good as the glass of the lens elements. This reduction in sharpness becomes more obvious when stacking filters.

Reversing rings are adapters that have a lens mount on one side and filter threads on the other. The filter threads are screwed into the front of a normal lens like a filter, and you attach the lens mount to the camera body. The lens is then mounted to the camera backwards. This allows you to closely focus on your subject. One thing to be careful of when using reversing rings is damaging the rear element of your lens; special care should be taken when using one of these. Not all lenses work well with reversing rings. The best lenses to use are fixed focal-length lenses that have aperture rings for adjusting the f-stop. Zoom lenses simply do not work well, nor do lenses that have no aperture control.

A very good alternative to expensive autofocus macro lenses is to find an older manualfocus macro lens. These lenses can be found for much less money than AF lenses. You can also check into lenses from other camera companies. The lens I use for macro photography most often was actually made for older Pentax screw-mount (M42) camera bodies. I found an adapter on eBay that allows you to attach M42 lenses to Nikon Fmount cameras. The lens and adapter together cost me less than \$50. The lens allows me to get a 4:1 magnification, which is 4X life size.

7.32 Bzzzt! When taking this macro shot of a fly I used as small an aperture as I could to try to get as much of the fly in focus as possible. Shot with a Macro-Takumar 50mm f/2.8 lens, ISO 640 at f/11 for 1/80 second.

Inspiration

My favorite subjects for macro photography are insects. I go to parks and wander around, keeping my eyes open for strange bugs. Parks are also a great place to take macro pictures of flowers. Although flowers are easily the most common subjects for macro photography enthusiasts, by no means are they the only subjects you can take pictures of. Many normal, everyday objects can become interesting when viewed up close.

7.33 Leptotyphlops dulcis, Texas blind snake. I used the built-in flash to trigger an offcamera SB-600 to add light and depth to the shot. Shot with Macro-Takumar 50mm f/2.8 lens, ISO 200 at f/8 for 1/250 second.

Macro photography practice

^{7.34} Giant spider with flash

Table 7.10 Taking Macro Pictures

Setup

Practice Picture: I found this monstrous spider shown in 7.34 hanging out on the side of my house one evening and I just knew I had to get out my macro lens and photograph it.

On Your Own: You can find plenty of interesting macro subjects; just look around. It's a good idea to always have your macro lens or close-up filters in your camera bag because you never know when you may run across interesting subject matter for a macro shot.

Continued

Table 7.10 (continued)

Lighting	Practice Picture: It was dark when this photo was taken so I used an SB-600 Speedlight to light the spider. The SB-600 was connected to the camera with an SC-27 off-camera hot-shoe cord. I held the flash in my left hand slightly above and to the left of the camera. The flash was set to Manual mode 1/16 power.
	On Your Own: When the lighting is dim it is sometimes necessary to use an external flash. Even in bright light, a flash can help give your subject a little more light to help you maintain a very small aperture. When photographing your subject at a very close distance the lens can obscure the built-in flash causing a dark area near the bottom of the frame. It's best to use off-camera flash or use a dedicated macro flash system such as the Nikon R1.
Lens	Practice Picture: Macro-Takumar 50mm f/4 lens.
	On Your Own: A good macro lens is invaluable to get nice, sharp images. Using close-up filters or extension tubes can also be a good option.
Camera Settings	Practice Picture: Because my lens is a non-CPU lens I used the Manual exposure setting. White balance was set to Auto.
	On Your Own: If you are using an AF lens, Aperture Priority works best to ensure that you can get the depth of field you desire. Using Auto white balance usually yields good results.
Exposure	Practice Picture: ISO 200 at f/8 for 1/60 second.
	On Your Own: Your exposure may vary depending on the lighting situation. Using a small f-stop is recommended for maximum depth of field although a wide aperture can draw attention to a specific feature by making it the only thing in focus.
Accessories	Close-up filters can be used instead of a dedicated macro lens. A tripod can be a good tool to have when photographing macro subjects because focusing close up to a subject tends to exaggerate camera shake.

Macro photography tips

- Use the self-timer. When using a tripod, use the self-timer to make sure the camera isn't shaking from pressing the Shutter Release button.
- Use a low ISO. Because macro and close-up photography focuses on details, use a low ISO to get the best resolution.
- Use a remote shutter release. If using a tripod, using a remote shutter release can also help reduce blur from camera shake.

Night Photography

Taking photographs at night brings a whole different set of challenges that are not present when you take pictures during the day. The exposures become significantly longer, making it difficult to handhold your camera and get sharp images. Your first instinct may be to use the flash to add light to the scene, but as soon as you do this, the image loses its nighttime charm. It ends up looking like a photograph taken with a flash in the dark. In other words, it looks like a snapshot.

When taking photos at night, you want to strive to capture the glowing lights and the delicate interplay between light and dark. The best way to achieve this is to use a tripod and a longer exposure. This allows you to capture the image keeping your subjects in sharp focus even with the long exposures that are often necessary.

Flash can be used effectively at night for portraits. You don't necessarily want to use it as your main light; as a matter of fact you almost never want to use it as your main light. Ideally, you want a good balance of flash and ambient light. To get this effect, set your flash to the Slow Sync or the Rear / Slow Sync setting. This allows longer exposures so the ambient light is sufficiently recorded while the flash adds a nice bright "pop" to freeze the subject for sharp focus.

7.35 Minneapolis skyline. I used an extra-long shutter speed to get a glass-like appearance from the water. Shot with a Tamron 17-50mm f/2.8 lens zoomed to 26mm, ISO 100 at f/10 for 28 seconds.

Inspiration

When I look for scenes to photograph at night, I try to think of subjects that have a lot of color that can be accented by the long exposures. City skylines, downtown areas, and other places with lots of neon or other brightly colored lights are very good subject matter for this type of photography.

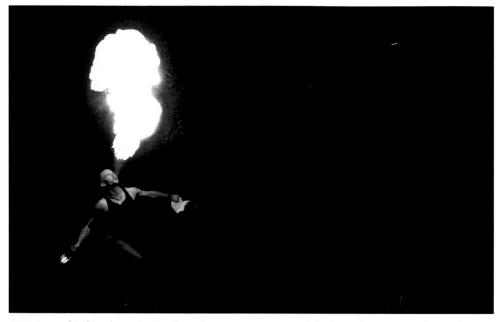

7.36 I caught this shot of a fire breather at a party one night. I used spot metering to be sure to capture some detail in the brightest area of the frame. Shot with a Nikkor 18-70mm f/3.5-4.5 lens zoomed to 40mm. ISO 3200 at f/4.2 for 1/320 second.

Painting with Light

When doing long exposures in low light situations you can often use a little bit of external light to add dimension, color, or to bring out some details in your subject. This technique is called painting with light. You can fire a hand held Speedlight or shine a flash light on dark areas that aren't receiving enough ambient light.

When using this technique you want to be sure to use a low power light so as not to over light your subject, thus causing it to look like a flash exposure.

For example when photographing figure 7.37, the statue was coming out too dark due to the fact there wasn't as much ambient light falling on the subject as there was being captured from the city skyline. To bring out some detail in the statue I brought out an SB-600 set to Manual. I dialed in a flash setting of 1/32. This added a little shine to the statue.

Night photography practice

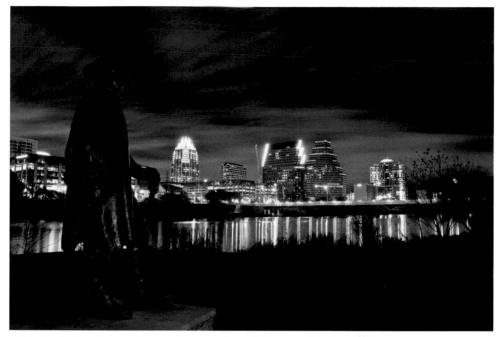

7.37 Stevie Ray Vaughn's statue is one of Austin's most visited attractions.

Table 7.11 Taking Night Pictures

Setup	Practice Picture: Figure 7.37 is a photo of the statue commemorating legendary Texas blues guitarist Stevie Ray Vaughn. The statue is located along the shores of Austin's Town Lake with the Austin skyline in the background. I wanted to capture this iconic statue in a photo that showed the beauty of the Austin skyline at night as well.
	On Your Own: Skylines make great night pictures. The lights at night are often brightly colored and long exposures can make them super-saturated.
Lighting	Practice Picture: For this shot most of the lighting is ambient. I used a small amount of flash on the statue to bring it out of the deep shadows to make it stand out. I set the flash to manual at 1/8 power. I held the flash in my hand, aimed it at the statue, and fired it using the test button.
	On Your Own: For the most part, ambient lighting is all you need. If there are some details in the foreground you want to bring out, you can use a low-powered flash pop to paint some light into the scene.

Continued

	Table 7.11 (continued)
Lens	Practice Picture: Tamron 17-50mm f/2.8 lens zoomed to 17mm.
	On Your Own: Any lens will do for night photography. It just depends on your subject matter. Sometimes a lens with a wider aperture can give a little bit more light allowing for a faster shutter in case it's necessary to hand-hold your camera.
Camera Settings	Practice Picture: To get this shot I used the Manual exposure mode. Because there are many different light sources in this shot I recorded the image in RAW mode so I could adjust the white balance manually in post- processing until I got the effect that I liked the most. The camera white balance was set to tungsten.
	On Your Own: When photographing a scene with multiple light sources it's best to shoot to RAW so you can adjust the white balance in post processing to suit your particular taste.
Exposure	Practice Picture: ISO 200 at f/11 for 30 seconds. For this particular image, I chose a small aperture to ensure that the whole scene was in focus. I also wanted a small aperture so I could get a long shutter speed to allow the flowing water to get a glass-like appearance. The motion of the clouds was also recorded, which was an added bonus.
	On Your Own: For night shots long exposures are the norm. Extremely long exposures can sometimes bring unexpected results (like the clouds in this shot). These results may not always be desired so open your f-stop to get a faster shutter speed if you need it.
Accessories	A tripod was absolutely necessary to achieve this shot. When photographing at night you should always have a tripod with you.

Night photography tips

- Bring a tripod. Without a tripod, the long exposure times will cause your photos to be blurry.
- Use the self-timer. Pressing the Shutter Release button when the camera is on the tripod often causes the camera to shake

enough to blur your image. Using the self-timer gives the camera and tripod enough time to steady so your images come out sharp.

 Try using Slow Sync flash. If using flash is an absolute must try using Slow Sync to capture some of the ambient light in the background.

Pet Photography

Photographing pets is something every pet owner likes to do (I've got hundreds of pictures of my dog on my hard drive). The most difficult aspect about pet photography is getting the animal to sit or stand still. Whether you're creating an animal portrait or just taking some snapshots of your pet playing, patience is a good trait to have.

If your pet is fairly calm and well trained, using a studio-type setting is entirely possible. If you have trained your pet to sit and wait for a treat it can be easy to snap a formal portrait. Some pets such as snakes or rodents may be more difficult to pose. In these types of situations it's good to have someone on hand to help you out.

Some of my most popular pictures are the ones I have taken of my dog just doing her normal dog things: sitting and waiting for a treat, yawning, or jumping around. The best photos of pets often are those that capture their personality, and this isn't necessarily achieved by sitting them in front of studio lights.

7.38 Chloe the basset hound. I used a wide-angle setting and I got very close to create a very dramatic distorted effect. Shot with a Tamron 17-50mm f/2.8 lens zoomed to 17mm, ISO 3200 at f/2.8 for 1/13 second.

Inspiration

Animals and pets are an inspiration in and of themselves. If you don't have a pet yourself, you likely have a friend or relative who has one they would be happy to let you photograph. Go to the park and find people playing with their dog. Lots of people have pets so it shouldn't be hard to find one.

7.39 Stray cat. This is a photo of a stray cat that hangs around my studio that we feed. I used a Lensbaby 2.0 to shoot this shot giving the image a soft-focus effect.

Pet photography practice

7.40 Henrietta at play

Table 7.12 Taking Pet Pictures

Setup Practice Picture: For figure 7.40, I was lying on the ground taking yet another photo of my playful Boston terrier, Henrietta. As I was snapping the shot she opened up with a big yawn.

On Your Own: Odd or unusual angles often make the most interesting shots. Don't be afraid to get dirty!

Lighting Practice Picture: The morning sun provided all the light I needed for this shot.

On Your Own: Using natural light is often the best for shooting pets. It allows you to concentrate on the composition without worrying about your lighting set up.

Lens Practice Picture: Tamron 17-50mm f/2.8 lens zoomed to 17mm.

On Your Own: A good wide-angle to medium zoom is invaluable for pet photography. This type of lens allows you the freedom to try many different compositions, from wide-angle shots to close-ups.

Camera Practice Picture: I chose Aperture Priority for this shot to try to throw the background out of focus a bit. I used the spot meter on Henrietta to be sure her dark fur wasn't underexposed.

On Your Own: Programmed Auto can work fine when photographing pets. It frees you from worrying about the exposure and allows you to concentrate on dealing with the animal.

Exposure Practice Picture: ISO 100 at f/2.8 for 1/1600 second.

On Your Own: Your exposures may vary depending on the setting that your subject is in. Using a wide aperture can help blur out distracting background details. A fast shutter speed can also help to keep your subject sharp in case of any movement.

Pet photography tips

- Be patient. Animals aren't always the best subjects; they can be unpredictable and uncooperative. Have patience and shoot plenty of pictures. You never know what you're going to get.
- Bring some treats. Sometimes animals can be coaxed to do things with a little bribe.
- Get low. Because we're used to looking down at most animals, we tend to shoot down at them. Get down low and shoot from the animal's perspective. This can make your picture much more interesting.
- Use Red-Eye Reduction. If you are going to use the flash, using Red-Eye Reduction is a must, although sometimes it doesn't completely remove the glare.

Portrait Photography

Portrait photography can be one of the easiest or one of the most challenging types of photography. Almost anyone with a camera can do it, yet it can be a complicated endeavor. Sometimes simply pointing a camera at someone and snapping a picture can create an interesting portrait; other times elaborate lighting setups may be needed to create a mood or to add drama to your subject.

A *portrait*, simply stated, is the likeness of a person – usually the subject's face – whether it is a drawing, a painting, or a photograph. A good portrait should go further than that. It should go beyond simply showing your subject's likeness and delve a bit deeper, hopefully revealing some of your subject's character or emotion, also.

You have lots of things to think about when you set out to do a portrait. The first thing to ponder (after you've found your subject, of course) is the setting. The setting is the background and surroundings, the place where you'll be shooting the photograph. You need to decide what kind of mood you want to evoke. For example, if you're looking to create a somber mood with a serious model, you may want to try a dark background. For something more festive, you may need a background with a bright color or multiple colors. Your subject may also have some ideas about how they want the image to turn out. Keep an open mind and be ready to try some other ideas that you may have not considered.

There are many different ways to evoke a certain mood or ambiance in a portrait image. Lighting and background are the principal ways to achieve an effect, but there are other ways. Shooting the image in black and white can give your portrait an

evocative feel to it. You can shoot your image so that the colors are more vivid giving your photo a live, vibrant feeling, or you can tone the colors down for a more ethereal look.

Studio considerations

Studio portraits are essentially indoor portraits, except that with studio portraits the lighting and background is controlled to a much greater extent. The studio portrait is entirely dependent on the lighting and background to set the tone of the image.

The most important part of a studio setting is the lighting setup. Directionality and tone are a big part of studio lighting, and close attention must be paid to both. There are quite a few things to keep in mind when setting up for a studio portrait. A few things to consider:

- What kind of tone are you looking for? Do you want the portrait to be bright and playful or somber and moody? These elements must be considered, and the appropriate lighting and backgrounds must be set up.
- Do you want to use props? Sometimes having a prop in the shot can add interest to an otherwise bland portrait.
- What kind of background is best for your shot? The background is crucial to the mood and/or setting of the shot. For example, when shooting a highkey portrait you must have a bright, colored background. You can also use props in the background to evoke a feeling or specific place. One photographer I know went so far as to build walls, complete with windows, inside his

studio. He then set up a couch, end tables, and lamps to create a 1970s-style motel room for a series of photographs he was shooting for assignment.

 What type of lighting will achieve your mood? Which lighting pattern are you going to use? Do you need to light the background?

Studio portraits require the most thought and planning of all the different types of portraits. This type of photography also requires the most equipment; lights, stands, reflectors, backgrounds, and props are just a

7.41 Angel. Shot with a Tamron 17-50mm f/2.8 lens zoomed to 50mm, ISO 100 at f/8 1/125 second. This image was kept low-key to draw attention to the bright colors of her tattoo which is meant to be the focus of the image.

few of the things you may need. For example for 7.41, I used a 200-watt second strobe set up at camera right, bounced from a 36-inch umbrella for the main light. A reflector was used to add a little fill on the left.

For more information on lighting and accessories, see Chapter 4.

Portrait lighting patterns

Professional photographers use different types of *lighting patterns*. These patterns are generally used to control where the shadow falls on the face of the subject. If the shadows aren't controlled while lighting your subject, your portrait can appear odd with strange shadows in unwanted places. In addition to the lighting patterns there are two main types of lighting – broad lighting and short lighting. *Broad lighting* occurs

7.42 Shadowless lighting

when your main light is illuminating the side of the subject that is facing towards you. *Short lighting* occurs when your main light is illuminating the side of the subject that is facing away from you. In portrait lighting there are five main types of lighting patterns:

- Shadowless. This is when your main light and your fill light are at equal ratios. Generally, you will set up a light at 45 degrees on both sides of your model. This type of light can be very flattering although it can lack moodiness and drama.
- Butterfly or Hollywood glamour. This type of lighting is mostly used in glamour photography. The name is derived from the butterfly shape

of the shadow that the nose casts on the upper lip. You achieve this type of lighting by positioning the main light directly above and in front of your model.

Loop or Paramount. This is the most commonly used lighting technique for portraits. Paramount Studios used this pattern so extensively in Hollywood's golden age that this lighting pattern became synonymous with the studio's name. This lighting pattern is achieved by placing the main light at a 15-degree angle to the face making sure to keep the light high enough so that the shadow cast by the nose is at a downward angle and not horizontal.

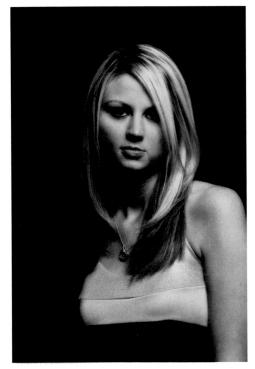

7.43 Butterfly lighting

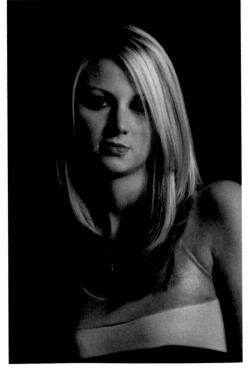

7.44 Loop or Paramount lighting

- Rembrandt. The famous painter Rembrandt van Rijn used this dramatic lighting pattern extensively. It's a moody dramatic pattern that benefits from using less fill light. The Rembrandt style is achieved by placing the light at a 45-degree angle, aimed a little bit down at the subject. Again, I emphasize using little or no fill light. This pattern is epitomized by a small triangle of light under one eye of the subject.
- Split. This is another dramatic pattern that benefits from little or no fill. You can do this by simply placing the main light at a 90-degree angle to the model.

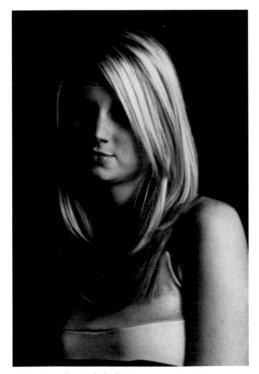

7.45 Rembrandt lighting

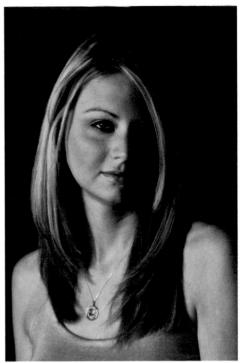

7.46 Split lighting

Indoor

When shooting portraits indoors, more often than not there isn't enough light to make a correct exposure without using flash or some sort of other additional lighting. Although the built-in flash on the D300 sometimes works very well, especially outdoors, I find that when I try to use it for an indoor portrait, the person ends up looking like a deer caught in headlights. This type of lighting is very unnatural looking and doesn't lend itself well for portraiture. It works fine for snapshots, but your goal here is to get beyond taking snapshots and move up to making quality images.

7.47 For this indoor shot of Mary, I wanted a very directional and hard light source, so I placed an SB-800 Speedlight off to camera right aimed directly at her with no diffuser. I used the D300's built-in flash as a commander unit. The SB-800 was set to TTL in Group A. Shot with a Nikkor 50mm f/1.8 lens, ISO 100 at f/1.8 for 1/60 second.

The easiest way to achieve a more naturallooking portrait indoors is to move your subject close to a window. This gives you more light to work with and the window acts as a diffuser, softening the light and giving your subject a nice glow. Another easy way to get nice portrait lighting indoors is to use an additional light source. A good source of additional lighting is one of the Nikon Speedlights. As with the built-in flash, photographing your subject with the Speedlight pointed straight at him or her is unadvisable. When using one of the

shoe-mounted Speedlights, the best bet is to bounce the flash off the ceiling or a nearby wall to soften the flash. Ideally, use the flash off-camera, utilizing the wireless capabilities of the D300's built-in flash and Nikon CLS.

Outdoor

When you shoot portraits outdoors, the problems that you encounter are usually the exact opposite of the problems you have when you shoot indoors. The light tends to be too bright, causing the shadows on your subject to be too dark. This results in an image with too much contrast.

In order to combat this contrast problem, you can use your flash. I know that this

sounds counterintuitive; you're probably thinking, "If I have too much light, why should I add more?" Using the flash in the bright sunlight fills in the dark shadows, resulting in a more evenly exposed image. This technique is known as *fill-flash*.

Cross-Reference

For more information on fillflash see Chapter 4. For more information on diffusion panels see Chapter 6.

Another way to combat images that have too much contrast when you're shooting outdoors is to have someone hold a diffusion panel over your model or move your model into a shaded area such as under a tree or a porch. This helps block the direct sunlight, providing you with a nice soft light for your portrait.

7.48 For this outdoor portrait, I place Julia under the shadow of a nearby bridge to block the harsh afternoon sun. The combination of wide aperture and long focal length makes the background a very soft indistinct blur of color. This shot was spot metered, and I used –0.3EV exposure compensation. Shot with a Nikkor 80-200mm f/2.8 lens zoomed to 125mm, ISO 100 at f/2.8 for 1/200 second.

Portrait photography practice

^{7.49} Inne as a pinup

Table 7.13 Taking Portrait Pictures

Setup Practice Picture: For figure 7.49, my model Inne and I wanted to do a shoot reminiscent of a 1950s pinup model featuring a plain background and what where considered, at the time, to be risqué poses.

On Your Own: You can find inspiration in many different areas; look into the past for some interesting ideas. Portraits can portray many different moods from somber to happy. Try to bring some of your subject's personality out.

Lighting	 Practice Picture: For this shot, I used two 200-watt-second studio strobes set up to the right of the camera. The strobes were bounced into 36-inch standard umbrellas to soften the light. To light the background, two 100-watt-second strobes were placed on each side of the camera just behind the model. These strobes were fired through a softbox to prevent hot spots. On Your Own: There are a lot of different studio lighting techniques. I find that using soft boxes and umbrellas give softer lighting causing the subjects' skin to appear smoother. This allows me to spend less time on post process retouching. The Internet has many different resources for learning about studio lighting.
Lens	Practice Picture: Tamron 17-50mm f/2.8 lens zoomed to 50mm.
	On Your Own: When shooting portraits, it's generally advisable to use a longer focal length to avoid the perspective distortion common with wide-angle lenses. Wide angle lenses, especially when used close-up can cause the subjects features to appear distorted. For example, the nose can appear too large while the ears will seem too small.
Camera Settings	Practice Picture: I used Manual exposure mode for this and most of the shots that I take using studio strobes. I preset the camera's white balance using the white background.
	On Your Own: When shooting portraits, using Aperture Priority mode is the preferred setting. This gives you the option to control the depth of field. Be sure to set your white balance to the proper light source. When using external studio strobes it is a good idea to set a custom white balance to match the strobes.
Exposure	Practice Picture: ISO 200 at f/5.6 for 1/125 second.
	On Your Own: When using studio strobes, shooting at or near the sync speed is recommended. Using a wide aperture is common to draw attention to the subject and blur out the background, but be sure that your aperture is small enough to get your whole subject's face in focus.
Accessories	Using a reflector can help bounce some light into shadow areas.

Portrait photography tips

- Plan some poses. Take a look at some photos on the Internet and find some poses that you like. Have these in mind when photographing your models.
- Use a tripod. Not only does the tripod help you get sharper images, but it also can make people feel

more comfortable when you're not aiming the camera directly at them. The camera can be less intimidating when it's mounted to a stationary object and you can make direct eye contact with them.

 Have some extra outfits. Ask your model to bring a variety of clothes. This way you can get some different looks during one shoot.

Still-life and Product Photography

In still-life and product photography, lighting is the key to making the image work. You can set a tone using creative lighting to convey the feeling of the subject. You can also use lighting to show texture, color, and form to turn a dull image into a great one. When practicing for product shots or experimenting with a still life, the first task you need to undertake is finding something to photograph. It can be one object or a collection of objects. Remember, if you are shooting a collection try to keep within a particular theme so the image has a feeling of continuity. Start by deciding which object you want to have as the main subject, and then place the other objects around it, paying close attention to the balance of the composition.

7.50 For this shot, I set up one of my favorite cameras, my vintage Rolleicord and my old light meter. I used one strobe placed camera right and shot through an umbrella to soften the light but still retain some directionality. This was a very simple yet effective setup. The image was converted to sepia tone in post-process to keep with the nostalgic feeling of the camera. Shot with a Tamron 17-50mm f/2.8 lens zoomed to 50mm, ISO 400 at f/14 for 1/200 second.

The background is another important consideration when photographing products or still-life scenes. Having an uncluttered background that showcases your subject is often best, although you may want to show the particular item in a scene, such as photographing a piece of fruit on a cutting board with a knife in a kitchen.

Diffused lighting is essential in this type of photography. You don't want harsh shadows to make your image look like you shot it with a flash. The idea is to light it so it doesn't look as if it was lit.

Even with diffusion, the shadow areas need some filling in. You can do this by using a second light as fill or by using a fill card. A *fill card* is a piece of white foam board or poster board used to bounce some light from the main light back into the shadows, lightening them a bit. When using two or more lights, be sure that your fill light isn't too bright, or it can cause you to have two shadows. Remember, the key to good lighting is to emulate the natural lighting of the sun.

Inspiration

When searching for subjects for a still-life shot, try using some personal items. Some ideas are objects such as jewelry or watches, a collection of trinkets you bought on vacation, or even seashells you brought home from the beach. If you're interested in cooking, try photographing some dishes you have prepared. Fruits and vegetables are always good subjects, especially when they have vivid colors or interesting textures.

7.51 I chose to include this shot because lighting clear glass can be very difficult. For this shot, I placed two strobes just behind the plane of the bottle. The strobes were fired at the white background and the light was reflected back through the glass. This allows you to avoid the harsh reflections you can get when shooting glass. Shot with a Tamron 17-50mm f/2.8 lens zoomed to 38mm, ISO 200 at f/10 for 1/200 second.

Still-life and product photography practice

7.52 Gibson Les Paul Special

Table 7.14 Taking Still-life Pictures

Setup Practice Picture: For figure 7.52, I set out to take a picture of my roadworn Gibson Les Paul. Its battle-scarred appearance makes it an interesting subject for a still life. I chose to photograph this on a black background in order to showcase the rich red/brown of the mahogany body.

> **On Your Own:** Simple arrangements work best for still-life photos. Cramming too many objects into the composition can leave it looking cluttered. Keep it simple.

left unlit. I fired the Speedlights by linking one of the flashes to the came with a PC sync cord; its built-in optical slave triggered the second flash.	
On Your Own: You don't need expensive studio strobes to achieve professional lighting results. These Speedlights are a fraction of the cost of studio strobes and work very well when photographing small to medium-sized setups.	
Lens Practice Picture: Tamron 17-50mm f/2.8 lens zoomed to 35mm.	
On Your Own: A normal to medium focal length is recommended to reduce the perspective distortion that can occur when shooting close up. This is a common problem when using wide-angle lenses. For smaller objects using a macro lens or a telephoto lens can work well.	
CameraPractice Picture: Once again, as with most of my studio shots, I usedSettingsManual exposure. When shooting with flash I find it easiest to set the shutter speed and aperture that I want and adjust the lights to fit my chosen settings.	
On Your Own: Be sure to adjust your white balance settings to match you light source. Shooting in RAW can also help you to fine tune your white balance and exposure in post-processing.	ur
Exposure Practice Picture: ISO 200 at f/8 for 1/250 second. For this shot, I first set the shutter speed to 1/250 (the sync speed). I then set aperture to f/8 so would be sure to carry enough depth of field.	
On Your Own: Manual exposure is the best choice if using studio strober but if you're taking advantage of the Nikon CLS you can just as easily sho in one of the auto modes such as Programmed Auto, Shutter Priority, or Aperture Priority.	
Accessories A reflector was used to bounce a little more light on to the left side of the guitar body.	9

Still-life and product photography tips

- Keep it simple. Don't try to pack too many objects in your composition. Having too many objects for the eye to focus on can lead to a confusing image.
- Use items with bold colors and dynamic shapes. Bright colors and shapes can be eye-catching and add interest to your composition.
- Vary your light output. When using more than one light on the subject, use one as a fill light with lower power to add a little depth to subject by creating subtle shadows and varied tones.

Travel Photography

7.53 Le Cimetière du Père-Lachaise, Paris, France. Shot with a Nikkor 18-70mm f/3.5-4.5 lens zoomed to 18mm, ISO 800 at f/9 for 1/80 second. Photo ©Julian Humphries http://flickr.com/photos/austintexas/

Uncommon architecture, people, and landscape features are just a few of the things you may find on your ventures. Most of the topics covered in this chapter can be related to your travel photography, from abstracts to landscapes to wildlife photos. The most important part about travel photography is to use your images to not only remember what the place looked like, but also to convey the feeling of the locale. For example, when in a foreign place a few shots of the local people can remind you of the cultural differences that exist in some areas of the world or even just regional differences.

7.54 On the Waterfront, Seattle, Washington. Shot with a Nikkor 18-70mm f/3.5-4.5 lens zoomed to 18mm, ISO 100 at f/14 for 1/100 second.

Travel photography practice

7.55 White Sands at dusk

	Table 7.15 Taking Travel Pictures
Setup	Practice Picture: Figure 7.55 is a landscape shot at White Sands National Monument in New Mexico. I chose this scene to show that the contrast of the white sand seemed to make the colors of the sunset especially vivid.
	On Your Own: Try to capture the natural beauty that exists in different places of the world. You can also take a series of images to tell a story about your travels.
Lighting	Practice Picture: This was shot just before sunset, using only the light that was provided by the fading sun. I planned my drive that day so that I would arrive at White Sands about an hour before the sunset, enough time to scope out some spots before nightfall.
	On Your Own: A lot of the time when traveling you don't have the time to wait for the ideal lighting conditions to come along so you may have to make do with what you have. You can also try to plan your trip so that you arrive at your destination when the lighting is likely to be ideal as I did for this shot.
Lens	Practice Picture: Tamron 17-50mm f/2.8 lens zoomed to 27mm. I used a fairly wide-angle setting in order to show the vast expanse of beautiful white sand of the desert landscape.
	On Your Own: Use a wide-angle setting to capture vistas or you can choose to zoom in to focus on smaller details. Having a zoom lens that goes from a wide-angle to a short telephoto is almost a necessity when traveling. This type of lens is very versatile and can be used to cover almost any type of scene you come across.
Camera Settings	Practice Picture: I used Aperture Priority mode to control the depth of field. The image was shot in RAW so I could be sure to adjust the white balance to my preference later in post processing.
	On Your Own: Shooting in RAW can give you a little insurance in case your camera doesn't record the white balance exactly as you want it.
Exposure	Practice Picture: ISO 100 at f/2.8 for 1/500 second. I also set the exposure compensation to +2EV in order keep the white sand looking white. The aperture was opened wider than I normally would use when photographing landscapes in order to give the sky in the background a softer appearance due to reduced depth of field.
	On Your Own: Often, when photographing areas with a lot of white such as sand or snow, the camera's meter underexposes causing the white areas to appear gray. Adding a bit of exposure compensation will help keep the whites bright.
Accessories	No accessories were used for this shot but having a small travel tripod on hand can be quite useful.

Travel photography tips

- Keep your gear close. When traveling, especially abroad, keep a close eye on your gear. Many thieves target camera gear since it's fairly expensive and small enough to grab and make a quick getaway.
- Bring plenty of memory. There's nothing worse than missing a once in a lifetime shot because you ran out of space on your flash card. It's also a good idea to bring along a few memory cards. It can be better

to have four 2GB cards as opposed to one 8GB card in case your card fails or malfunctions. It's best not to have all of your eggs in one basket.

Do some research on your destination. Knowing what type of scenery to expect can help you to decide what kind of equipment to pack. For example, if you know you'll be shooting mostly land-scapes a wide-angle lens will be needed. If you're going to be shooting a lot of indoor subjects you may need a fast lens or a tripod.

Wildlife Photography

Photographing wildlife is a fun and rewarding pastime that can also be intensely frustrating. If you know what you want to photograph, it can mean standing out in the freezing cold or blazing heat for hours on end, waiting for the right animal to show up. But when you get that one shot you've been waiting for, it's well worth it.

Wildlife can be found at many different places, zoos, wildlife preserves, and animal sanctuaries as well as out in the wild. One of the easiest ways to capture wildlife photos is to be where you know the animals are.

Wildlife photography is another one of those areas of photography where people's opinions differ on whether or not you should use flash. I tend not to use flash to avoid scaring off the animals. But, as with any type of photography, there are circumstances in which you might want to use a flash, such as if the animal is backlit and you want to bring out some detail.

7.56 Great horned owl, Terlingua, Texas. I spotted this owl after I had just finished shooting the sunrise in the west Texas desert. Luckily, I happened to have my telephoto zoom lens with me. Because the owl was backlit I chose Spot metering to be sure that the camera exposed for the owl and not the brighter background. Shot with a Nikkor 80-200mm f/2.8 lens zoomed to 200mm, ISO 320 at f/2.8 for 1/400 second.

Opportunities to take wildlife pictures can occur when you're hiking in the wilderness, or maybe when you're sitting out on your back porch enjoying the sunset. With a little perseverance and luck, you can get some great wildlife images, just like the ones you see in *National Geographic*.

Inspiration

You can go to wildlife reserves, a zoo, or even your backyard to find wildlife. I tend to go the easy route, focusing on places where I'm pretty sure to find what I'm looking for. For example, while driving through Louisiana, I saw a sign that advertised for an alligator swamp tour. I was pretty sure I'd see some alligators if I went. And even though I'd missed the last tour, there were still plenty of alligators there.

Even in the city or urban areas, you may be able to find wildlife, such as songbirds perched on a power line or hawks in trees near roadsides. A lot of cities have larger parks where you can find squirrels or other smaller animals as well. For example, I've photographed the animals at a park near my studio where you can see peacocks and armadillos running around.

7.57 Zebras, Dripping Springs, Texas. Driving back from an on-location portrait session one afternoon I noticed a herd of zebras running around (much to my surprise). I pulled over to take some shots. Once again the animals were backlit so I used Spot metering to keep the zebras from being underexposed. Regardless of the backlighting, the golden sunlight was perfect for this shot. Shot with a Nikkor 80-200mm f/2.8 lens zoomed to 200mm. ISO 400 at f/8 for 1/800 second.

Wildlife photography practice

7.58 Great Blue Heron

	Table 7.1	6
Taking	Wildlife	Pictures

Setup	Practice Picture: I took a day trip to Nails Creek State Park in Texas to see if I could find some wildlife lurking about. I came across the Great Blue Heron in figure 7.58 standing in a marshy area near a small lake.
	On Your Own: You can go to state parks or wildlife preserves to try your hand at photographing wildlife if you are interested in more than you might find in an urban backyard. If you aren't successful in your hunt, at least you can enjoy a hike.
Lighting	Practice Picture: The golden light that often occurs before sunset lit this magnificent bird giving it a nice golden glow.
	On Your Own: Wild animals aren't often inclined to cooperate with you by being in the perfect lighting at all times, so you should basically take what you can get. Don't miss out on a shot because the lighting is less than ideal.
Lens	Practice Picture: Nikkor 80-200mm f/2.8 lens zoomed to 200mm.
	On Your Own: A long telephoto lens is almost an absolute necessity when it comes to photographing wild animals. Every time I tried to get close to this bird it flew away causing me to have to hike back and forth through the marshy grass. Even with the long focal length a bit of cropping was necessary to get a close-up look to the picture.
Camera Settings	Practice Picture: This shot was taken using Aperture Priority. It was captured in RAW, and Spot metering was used.
	On Your Own: When shooting with a long lens it is often best to use Shutter Priority to be sure that you have a fast enough shutter speed to counteract any camera shake (remember that longer focal lengths suffer from camera shake due to the extreme magnification). You may want to choose Aperture Priority to control your depth of field. Spot metering is usually a good choice, allowing you to be sure that the subject is properly exposed. Shooting in RAW can give you a little latitude in post-processing if the lighting isn't exactly right.
Exposure	Practice Picture: ISO 400 at f/4 for 1/250 second.
	On Your Own: Because the sun was going down there wasn't quite enough light so I adjusted the ISO up and opened the aperture. A shutter speed of 1/250 second is just about the minimum you can get away with when handholding the camera at this focal length.
Accessories	No accessories were used for this shot, but I highly recommend using a monopod to ensure a sharp focus at long focal lengths.

Wildlife photography tips

- Use a telephoto lens. This allows you to remain inconspicuous to the animal, enabling you to catch it acting naturally.
- Seize an opportunity. Even if you don't have the lens zoomed to the right focal length for capturing wildlife, snap a few shots anyhow. You can always crop them later if they aren't perfect. It's better to get the shot than not.
- Be patient. It may take a few hours, or even a few trips, to the outdoors before you have the chance to see any wild animals. Keep the faith; it will happen eventually.
- Keep an eye on the background. When photographing animals at a zoo, keep an eye out for cages and other things that look man-made — and avoid them. It's best to try to make the animal look like it's in the wild by finding an angle that shows foliage and other natural features.

Viewing and In-Camera Editing

ith the D300's large 3-inch, 920,000-dot VGA LCD monitor, you can view your images with much more clarity than was possible with earlier Nikon dSLRs. Nikon also offers some different options on the D300 that weren't available on other cameras. One option is the ability to view and show your images on a high-definition device. The D300 also offers quite a few in-camera editing features that allow you to save some time in post-processing and give you the option to fine-tune your images for printing without ever having to download your images to a computer.

Viewing Your Images

In the past Nikon has always offered two different ways to view your images while the CF card is still inserted in the camera. You could view the images directly on the LCD monitor on the camera or you could hook your camera up to a standard TV using the EG-D100 video cable that's supplied with the camera. Both of these options are still available with the D300, but now there is also a third option; you can connect your camera to a high-definition television (HDTV) or monitor.

When viewing through an external device such as a TV or HDTV, the view is the same as would normally be displayed on the LCD monitor. The camera's buttons and dials function exactly the same.

Cross-Reference Chapter 3.

To connect your camera to a standard TV:

- Turn the camera off. This can prevent damage to your camera's electronics from static electricity.
- Open the connector cover. The connector cover is on the left side of the camera when the lens is facing away from you.
- Plug in the EG-D100 video cable. The cable is included with the camera in the box. Plug the cable into the Video out jack. This is the connection at the top.
- Connect the EG-D100 to the input jack of your television or VCR.
- Set your TV to the video channel. This may differ depending on your TV. See the owner's manual if you are unsure.
- 6. Turn on the camera and press the Playback button.

To connect your camera to an HDTV or monitor:

- 1. Turn off the camera.
- Open the connector cover. The connector cover is on the left side of the camera when the lens is facing away from you.
- Plug in a type A HDMI cable to your camera's HDMI out jack. These cables are available separately at most electronics stores. The connection is the second one down from the top.
- 4. Connect the HDMI cable to the HD device.

- Set the HD device to the proper input channel. See the owner's manual for your specific device.
- 6. Press the Playback button.

The camera default setting allows the camera to automatically choose the appropriate resolution for the HDMI device that it is connected to. To manually choose a resolution, go to the Setup menu, select the HDMI menu option, then choose Auto (default): 480p, 576p, 720p, or 1080i. See your HD devices owner's manual for more information.

When the camera is connected to an HD device and set to Live view shooting mode, the LCD monitor is disabled and the HD device displays through the lens view.

The Retouch Menu

For the first time, Nikon is offering in-camera editing features on a professional-level dSLR. Formerly, this type of option was only available on compact digital cameras and consumer-level dSLRs. These in-camera editing options make it simple for you to print straight from the camera without downloading it to your computer or using any image-editing software.

One great feature of using the Retouch menu is that the camera saves the retouched image as a copy so you don't lose the original image. This can be beneficial if you decide that you would rather edit the photo on your computer or if you simply aren't happy with the outcome. There are two ways to access the Retouch menu.

Chapter 8 + Viewing and In-Camera Editing 229

The first method:

- 1. Press the Play button to enter Playback mode. Your most recently taken image appears on the LCD screen.
- 2. Use the multi-selector to review your images.
- When you see an image you want to retouch press the OK button to display the Retouch menu.
- Use the multi-selector to highlight the Retouch option you want to use. Depending on the Retouch option you choose, you may have to select additional settings.
- 5. Make adjustments if necessary.
- 6. Press the OK button to save.

The second method:

- 1. Press the Menu button to view menu options.
- Use the multi-selector button to scroll down to the Retouch menu. It's the fifth menu down and appears as an icon with a paintbrush.
- 3. Press the multi-selector right then use the multi-selector up and down buttons to highlight the Retouch option you want to use. Depending on the Retouch option you select, you may have to select additional settings. Once you have selected your option(s) thumbnails appear.

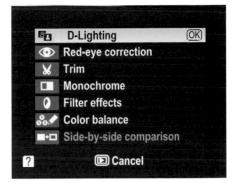

- 8.1 The Retouch menu options
 - 4. Use the multi-selector to select the image to retouch and then press the OK button.
 - 5. Make the necessary adjustments.
 - 6. Press the OK button to save.

Retouch Menu Options

There are a few options you can select when using the Retouch menu. The options vary from cropping your image to adjusting the color balance to taking red-eye out of your pictures.

D-Lighting

This allows you to adjust the image by brightening the shadows. This is not the same as Active D-Lighting. D-Lighting uses a curves adjustment to help to bring out details in the shadow areas of an image. This option is for use with backlit subjects or images that may be slightly underexposed.

When the D-Lighting option is chosen from the Retouch menu, you can use the multiselector to choose a thumbnail and the Zoom in button to get a closer look at the image. Press the OK button to choose the image to retouch, two thumbnails are displayed; one is the original image, and the other is the image with D-Lighting applied.

You can use the multi-selector up/down to select the amount of D-Lighting: Low, Normal, or High. The results can be viewed in real time and compared with the original before saving. Press the OK button to save, the Playback button to cancel and the zoomin button to view the full frame image.

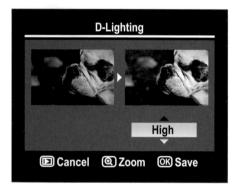

8.2 The D-Lighting option

Red-eye correction

This option enables the camera to automatically correct for the red-eye effect that can sometimes be caused by using the flash on pictures taken of people. This option is only available on photos taken with flash. When choosing images to retouch from the Playback menu by pressing the OK button during preview, this option is grayed out and cannot be selected if the camera detects that a flash was not used. When attempting to choose an image directly from the Retouch menu, a message is displayed stating that this image cannot be used. Once the image has been selected, press the OK button; the camera then automatically corrects the red-eye and saves a copy of the image to your CF card.

If an image is selected that flash was used on but there is no red-eye present, the camera displays a message stating that red-eye is not detected in the image and no retouching will be done.

Trim

This option allows you to crop your image to remove distracting elements or to allow you to crop closer to the subject.

You can choose different aspect ratios for your crop by rotating the Main Command dial. The choices are 3:2, 4:3, and 5:4. This changes the ratio between the height and width of your image.

You can also use the Zoom in and Zoom out buttons to adjust the size of the crop. This allows you to crop closer in or further out depending on your needs.

You can use the multi-selector to move the crop around the image so you can center the crop on the part of the image that you think is most important.

To preview your final cropped image, press and hold the button in the center of the multi-selector. If you are not pleased with the crop, release the button and use the multi-selector to move the crop to a more suitable area.

When you are happy with the crop you have selected, press the OK button to save a copy of your cropped image.

Chapter 8 + Viewing and In-Camera Editing 231

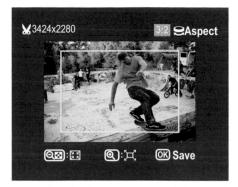

8.3 Using the in-camera crop (Trim) option

Monochrome

This option allows you to make a copy of your color image in a monochrome format. There are three options:

- Black-and-white. This changes your image to shades of black, white, and gray.
- Sepla. This gives your image the look of a black and white photo that has been sepia toned. Sepia toning is a traditional photographic process that gives the photo a reddish-brown tint.
- Cyanotype. This option gives your photos a blue or cyan tint. Cyanotypes are a form of processing film-based photographic images.

When using the Sepia or Cyanotype you can use the multi-selector up and down buttons to adjust the lightness or darkness of the effect. Press the OK button to save a copy of the image or press the Playback button to cancel without saving.

8.4 An image converted to black and white

Filter effects

Filter effects allow you to simulate the effects of using certain filters over your lens to subtly modify the colors of your image. There are two filter effects available:

 Skylight. A skylight filter is used to absorb some of the UV rays emitted by the sun. The UV rays can give your image a slightly bluish tint. Using the skylight filter effect causes your image to be less blue.

8.5 An image converted to sepia

Warm filter. A warming filter adds a little orange to your image to give it a warmer hue. This filter effect can sometimes be useful when using flash because flash can sometimes cause your images to feel a little too cool.

After choosing the desired filter effect, press the OK button to save a copy of your image with the effect added.

Color balance

You can use the color balance option to create a copy of an image on which you have adjusted the color balance. Using this

8.6 An image converted to cyanotype

option, you can use the multi-selector to add a color tint to your image. You can use this effect to neutralize an existing color tint or to add a color tint for artistic purposes.

Press the multi-selector up to increase the amount of green, down to increase the amount of magenta, left to add blue, and right to add amber.

A color chart and color histograms are displayed along with an image preview so you can see how the color balance affects your image. When you are satisfied with your image, press the OK button to save a copy.

Chapter 8 + Viewing and In-Camera Editing 233

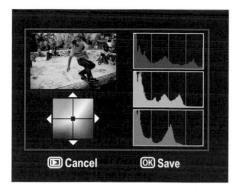

8.7 Color chart and histograms using the color balance option

Image overlay

This option allows you to combine two RAW images and save them as one. This menu option can only be accessed by entering the Retouch menu using the Menu button (the longer route); you cannot access this option by pressing the OK button when in Playback mode.

To use this option you must have at least two RAW images saved to your memory card. This option is not available for use with JPEG or TIFF images.

To use this option:

- 1. Press the Menu button to view the menu options.
- 2. Use the multi-selector to scroll down to the Retouch menu, and press the multi-selector right to enter the Retouch menu.
- 3. Use the multi-selector up/down to highlight Image overlay.

- Press the multi-selector right. This displays the Image overlay menu.
- Press the OK button to view RAW image thumbnails. Use the multi-selector to highlight the first RAW image to be used in the overlay. Press the OK button to select it.
- Adjust the exposure of Image 1 pressing the multi-selector up or down. Press the OK button when the image is adjusted to your liking.
- 7. Press the multi-selector right to switch to Image 2.
- Press the OK button to view RAW image thumbnails. Use the multi-selector to highlight the second RAW image to be used in the overlay. Press the OK button to select it.
- Adjust the exposure of Image 2 pressing the multi-selector up or down. Press the OK button when the image is adjusted to your liking.
- 10. Press the multi-selector right to highlight the Preview window.
- 11. Press the multi-selector up or down to highlight *Overlay* to preview the image, or use the multi-selector to highlight *Save* to save the image without previewing.

234 Part II + Creating Great Images with the Nikon D300

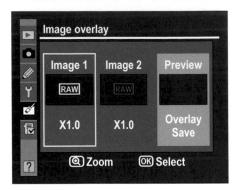

8.8 Image overlay screen

Side-by-side comparison

This option allows you to view a side-byside comparison of the retouched image and the original copy of the image.

To use this option:

- 1. Press the Play button and use the multi-selector to choose the image to view.
- 2. Press the OK button to display the Retouch menu.

- Use the multi-selector to highlight Side-by-side comparison, and then press the OK button.
- 4. Use the multi-selector to highlight either the original or retouched image. You can then use the Zoom in button to view closer.
- 5. Press the Play button to exit the Side-by-side comparison and return to Playback mode.

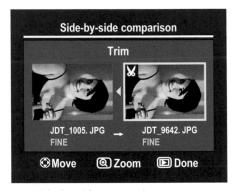

8.9 Side-by-side comparison screen

Appendixes

In This Part

÷

Appendix A Accessories

Appendix B D300 Specifications

Appendix C Online Resources

Glossary

Accessories

here are a number of accessories and additional equipment that are available for the Nikon D300. These accessories range from batteries and flashes to tripods and camera bags. These accessories can enhance your shooting experience by providing you with options that aren't immediately available with the purchase of the camera alone.

MB-D10 Battery Grip

The MB-D10 battery grip is an accessory available only from Nikon that attaches to the bottom of your D300. Not only does this grip offer you an extended shooting life by allowing you to fit additional batteries to your camera, it also offers the ease and convenience of a vertical shutter release, a Main and Sub-command dial, and an AF-On button. This means that if you hold your camera in the vertical position you can use the additional Shutter Release button on the MB-D10 to fire the camera and adjust settings without having to awkwardly hold your camera with your elbow up in the air to press the camera's Shutter Release button.

The MB-D10 grip has room for eight AA-sized batteries in addition to the EN-EL3e battery in the camera body itself. Instead of AA batteries, with the addition of a supplied adapter, you can also fit an EN-EL3e battery, which doubles the shooting life of the camera.

If you're willing to spend even more money you can also fit an EN-EL4 or EN-EL4a battery into the MB-D10. The EN-EL4 is the battery that comes standard with the D2X, D2H, and D3 professional-level cameras. EN-EL4 batteries are reported to have a very long life. If you do opt to go this route, be forewarned that this battery requires a separate charger and a BL-3 battery chamber cover that fits onto the end of the MB-D10 to hold the battery in place. All of these options can be expensive.

In addition to extra battery life and the vertical controls, the MB-D10 also allows you to shoot at a faster frame rate than with the camera body alone. The standard frame rate is up to 6 fps; you can shoot up to 8 fps with the MB-D10!

Unlike the MB-D200, the battery grip for the D200, the MB-D10 is made with a sturdy magnesium frame, which is the same material used for the D300 body.

Image courtesy Nikon A.1 The MB-D10 battery grip

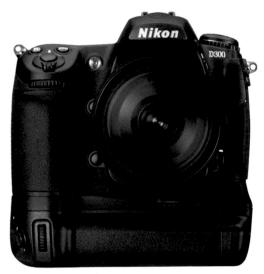

Image courtesy Nikon A.2 The D300 with the MB-D10

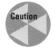

The MB-D10 only allows 8 fps shooting when using either AA or EN-EL4 batteries. Using a standard EN-EL3e battery results in only getting the standard 6 fps.

WT-4a Wireless Transmitter

The WT-4a transmitter allows you to control your camera wirelessly using Nikon Camera Control Pro software, or it allows you to transmit or transfer images to your computer through a wireless LAN connection. This can be handy when shooting in a controlled environment such as a studio. You can then preview your images on your computer monitor to be sure of the accuracy of the colors and focus.

Tripods

One of the most important accessories you can have for your camera, whether you're a professional or just a hobbyist, is a tripod. The tripod allows you to get sharper images by eliminating the shake caused by handholding the camera in low-light situations. A tripod can also allow you to use a lower ISO, thereby reducing the camera noise and resulting in an image with better resolution.

There are literally hundreds of types of tripods available, ranging in size from less than 6 inches to one that extends all the way up to 6 feet or more. In general, the heavier the tripod is, the better it is at keeping the camera steady. The D300 is a fairly heavy camera, so I definitely recommend purchasing a heavy-duty tripod; otherwise, the weight of the camera can cause the tripod to shake, leaving you right back where you started with a shaky camera. There are many different features available on tripods, but the standard features include:

- Height. This is an important feature. The tripod should be the right height for the specific application for which you are using it. If you are shooting landscapes most of the time and you are 6 feet tall, using a 4-foot-tall tripod will force you to bend over to look into the viewfinder to compose your image. This may not be the optimal size tripod for you.
- Head. Tripods have several different types of heads. The most common type of head is the pan/tilt head. This type of head allows you to rotate, or pan, with a moving subject and also allows you to tilt the camera for angled or vertical shots. The other common type of head on a tripod is the ball head. The ball head is the most versatile. It can tilt and rotate quickly into nearly any position.
- Plate. The plate attaches the camera to the tripod. The D300 has a threaded socket on the bottom. Tripods have a type of bolt that screws into these sockets, and this bolt is on the plate. Most decent tripods have what is called a *quick release* plate. You can remove a quick release plate from the tripod and attach it to the camera, and then reattach it to the tripod with a locking mechanism. If you're going to be taking the camera on and off

of the tripod frequently, this is the most time-efficient type of plate to use. The other type of plate, which is on some inexpensive tripods, is the standard type of plate. This plate is attached directly to the head of the tripod. It still has the screw bolt that attaches the camera to the plate, but it is much more time-consuming to use when you plan to take the camera on and off a lot. You must screw the camera to the plate every time you want to use the tripod, and you must unscrew it when you want to remove it from the tripod.

When to use a tripod

There are many situations when using a tripod is ideal, and the most obvious is when it's dark or lighting is poor. However, using a tripod even when there is ample light can help keep your image sharp. The following are just a few ideas of when you may want to use a tripod:

- When the light is low. Your camera needs a longer shutter speed to get the proper exposure if there isn't much available light. The problem is, when the shutter speed gets longer, you need steadier hands to get sharp exposures. Attaching your camera to a tripod eliminates camera shake.
- When the camera is zoomed in. When you are using a long focallength lens, the shaking of your hands is more exaggerated due to the higher magnification of the scene and can cause your images to be blurry, even in moderate light.

- When shooting landscapes. Landscape shots, especially when you're using the Landscape scene mode, require a smaller aperture to get maximum depth of field to ensure that the whole scene is in focus. When the camera is using a smaller aperture, the shutter speed can be long enough to suffer from camera shake, even when the day is bright.
- When shooting close up. When the camera is very close to a subject, camera shake can also be magnified. When you're shooting close-ups or macro shots, it may also be preferable to use a smaller aperture to increase depth of field, thus lengthening the shutter speed.

Which tripod is right for you?

Considering there are so many different types of tripods, choosing one can be a daunting experience. There are many different features and functions available in a tripod; here are some things to think about when you're looking into purchasing one:

- Price. Tripods can range in price from as little as \$5 to as much as \$500 or more. Obviously, the more a tripod costs, the more features and stability it's going to have. Look closely at your needs when deciding what price level to focus on.
- Features. There are dozens of different features available in any given tripod. Some tripods have a quick-release plate, some have a ball head, some are small, and some are large. Again, you need to decide what your specific needs are.

Appendix A + Accessories 241

Monopods

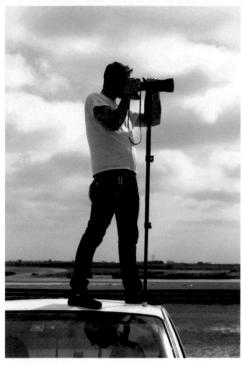

An option you may want to consider is a *monopod* instead of a tripod. A monopod connects to the camera the same way as a tripod, but it only has one leg. Monopods are excellent for shooting sports and action with long lenses, because they allow you the freedom to move along with support to keep your camera steady. The figure here shows a photographer using a monopod to photograph racecars.

©Destry Jaimes – nine2fivephotography.com

Weight. This can be a very important factor when deciding which tripod to purchase. If you are going to use the tripod mostly in your home, a heavy tripod may not be a problem. On the other hand, if you plan on hiking, a 7-pound tripod can be an encumbrance after awhile. Some manufacturers make tripods that are made out of carbon fiber. While these tripods are very stable, they are also extremely lightweight. On the downside, carbon fiber tripods are also very expensive.

Camera Bags and Cases

Another important accessory to consider is the bag or carrying case you choose for your camera. These can provide protection not only from the elements but also from impact. Camera bags and cases exist for any kind of use you can imagine, from simple cases to prevent scratches to elaborate camera bags that can hold everything you may need for a week's vacation. Some of the bag and case types available include:

- Pelican cases. These are some of the best cases you can get. The Pelican hard cases are watertight, crushproof, and dustproof. They are unconditionally guaranteed forever. If you are hard on your cameras or do a lot of outdoors activities, you can't go wrong with these cases. Recently, Pelican has started to offer soft camera bags, obviously they aren't waterproof and crushproof, but they are excellent bags, nonetheless.
- Shoulder bags. These are the standard camera bags you can find at any camera shop. They come in a multitude of sizes to fit almost any amount of equipment you can carry. Reputable makers include Tamrac, Domke, and Lowepro. Look them up on the Web to peruse the various styles and sizes.
- Backpacks. Some camera cases are made to be worn on your back just like a standard backpack. These also come in different sizes and styles, and some even offer laptop-carrying capabilities. The type of camera backpack I use when traveling is a Naneu Pro Alpha. It's designed to look like a military pack, so thieves don't

know you're carrying camera equipment. When traveling, I usually pack it with two Nikon dSLR camera bodies, two Coolpix cameras, a wide-angle zoom, a long telephoto, three or four prime lenses, two Speedlights, a reflector disk, a 12-inch Apple PowerBook, and all of the plugs, batteries, and other accessories that go along with my gear. And, with all that equipment packed away, there is space left over for a lunch. Lowepro and Tamrac also make some excellent backpacks.

Messenger bags. Recently more camera bag manufacturers have started to offer messenger bags, which resemble the types of bags that a bike messenger uses. They have one strap that goes over your shoulder and across your chest. The bag sits on your back like a backpack. The good thing about these bags is that you can just grab it and pull it around to the front for easy access to your gear. With a backpack, you have to take it off to get to your camera. I also have a messenger bag for when I'm traveling light. My messenger bag is the Echo made by NaneuPro.

D300 Specifications

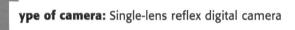

Effective pixels: 12.3 million

Image sensor: CMOS sensor, 23.6×15.8 mm; Total pixels: 13.1 million; Nikon DX-format

Image size (pixels): 4288 \times 2848 [L], 3216 \times 2136 [M], 2144 \times 1424 [S]

Dust-reduction system: Self-cleaning Sensor Unit, image dust-off data acquisition (Capture NX required)

Sensitivity: ISO 200 to 3200 in steps of 1/3, 1/2 or 1 EV with additional settings of approx. 0.3, 0.5, 0.7 and 1 EV (ISO 100 equivalent) under ISO 200 and approx. 0.3, 0.5, 0.7 and 1 EV (ISO 6400 equivalent) over ISO 3200

File system: Compliant with DCF 2.0, DPOF and Exif 2.21

Storage system: NEF 12-bit or 14-bit (uncompressed, lossless compressed, or compressed RAW), TIFF (RGB), JPEG: JPEG baseline-compliant

Media: CompactFlash (CF) Card (Type I and II, UDMA compliant), MicroDrive

Release modes:

- Single frame [S] mode
- Continuous low speed [CL] mode: 1 to 7 frames per second (7 frames per second with optional MB-D10 and batteries other than EN-EL3a or AC adapter)

- Continuous high-speed [CH] mode: 8 frames per second (7 frames per second with optional MB-D10 and batteries other than EN-EL3a or AC adapter), 6 frames per second (with EN-EL3a battery)
- LiveView [LV] mode
- Self-timer mode
- Mirror-up [Mup] mode

White balance: Auto (TTL white balance with 1,005-pixel RGB sensor), seven manual modes with fine-tuning, color temperature setting, white balance bracketing possible (2 to 9 frames in increments 1~3)

LiveView: Hand-held shooting mode: TTL Phase-difference AF with 51 focus areas (15 cross-type sensors); Tripod shooting mode: focal-plane contrast AF on a desired point within a specific area

LCD monitor: 3-in., approx. 920,000-dot (VGA), 170-degree wide viewing angle, 100% frame coverage, low-temperature polysilicon TFT LCD with brightness adjustment

Playback function:

- Full frame
- Thumbnail (4 or 9 segments)
- Zoom
- Slideshow
- RGB histogram indication
- Shooting data
- Highlight point display
- Auto image rotation

Delete function: Card format, All photographs delete, Selected photographs delete

Video output: NTSC or PAL; simultaneous playback from both the video output and on the LCD monitor available

HDMI output: Supports HDMI version 1.3a; Type A connector is provided as HDMI output terminal; simultaneous playback from both the HDMI output terminal and on the LCD monitor not available

Text input: Up to 36 characters of alphanumeric text input available with LCD monitor and multi-selector; stored in Exif header

Lens mount: Nikon F mount with AF coupling and AF contacts

Compatible lenses:

- DX AF Nikkor: All functions possible
- D-/G-type AF Nikkor (excluding IX Nikkor lenses): All functions possible (excluding PC Micro-Nikkor)
- AF Nikkor other than D-/G-type (excluding lenses for F3AF): All functions except 3D-Color Matrix Metering II possible
- AI-P Nikkor: All functions except Autofocus, 3D-Color Matrix Metering II possible
- Non-CPU AI Nikkor: Can be used in exposure modes A and M; electronic rangefinder can be used if maximum aperture is 5.6 or faster; Color Matrix Metering and aperture value display supported if user provides

Viewfinder: SLR-type with fixed eye-level pentaprism; built-in diopter adjustment (-2.0 to +1.0 m-1)

Eyepoint: 19.5mm (-1.0 m-1)

Focusing screen: Type-B BriteView Clear Matte screen Mark II with superimposed focus brackets and On-Demand grid lines

Viewfinder frame coverage: Approximately 100% (vertical and horizontal)

Viewfinder magnification: Approximately 0.94x with 50mm lens at infinity; -1.0 m-1

Autofocus: TTL phase detection, 51 focus points (15 cross-type sensors) by Nikon Multi-CAM 3500DX autofocus module; Detection -1 to +19 EV (ISO 100 at 20 degree C/68 degree F); AF fine adjustment possible. Focal-plane contrast [in LiveView (Tripod) mode]

Lens servo: Single-servo AF (S); continuous-servo AF (C); manual (M); predictive focus tracking automatically activated according to subject status in continuousservo AF

Focus point: Single AF point can be selected from 51 or 11 focus points LiveView (Tripod mode): Contrast AF on a desired point within entire frame

AF area mode:

- Single point AF
- Dynamic area AF [9 points, 21 points, 51 points, 51 points (3Dtracking)]
- Automatic area AF

Focus lock: Focus can be locked by pressing Shutter Release button halfway (singleservo AF) or by pressing AE-L/AF-L button

Exposure metering system: TTL fullaperture exposure metering using 1005pixel RGB sensor

- 3D Color Matrix Metering II: 3D Color Matrix Metering II (type G and D lenses); Color Matrix Metering II (other CPU lenses); Color Matrix Metering (non-CPU lenses if user provides lens data; metering performed)
- Center-weighted: Weight of 75% given to 6, 8, 10, or 13 mm dia. circle in center of frame or weighting based on average of entire frame (8mm circle when non-CPU lens is used)
- Spot: Meters approx. 3mm dia. circle (about 2.0% of frame) centered on selected focus point (on center focus point when non-CPU lens is used)

Exposure metering range:

- 0 to 20 EV (3D Color Matrix or center-weighted metering)
- 2 to 20 EV (spot metering) (ISO 100, f/1.4 lens, 20°C)

Exposure meter coupling: Combined CPU and AI

Exposure modes:

- Programmed Auto [P] with flexible program
- Shutter-Priority Auto [S]
- Aperture Priority Auto [A] 4) Manual [M]

Exposure compensation: Plus or minus 5 EV in increments of 1/3, 1/2 or 1 EV

Auto exposure lock: Detected exposure value locked by pressing AE-L/AF-L button

Auto exposure bracketing: Exposure and/or flash bracketing (2 to 9 exposures in increments of 1/3, 1/2, 2/3 or 1 EV)

Picture Control system: Four setting options: Standard, Neutral, Vivid, Monochrome; each option can be adjusted

Shutter: Electronically controlled verticaltravel focal plane shutter, 1/8,000 to 30 s in steps of 1/3, 1/2 or 1 EV, Bulb

Sync contact: X=1/250 s; flash synchronization at up to 1/320 s (FP) adjustable with built-in Speedlight or optional Speedlight (will reduce GN)

Flash control:

- i-TTL: TTL flash control by 1,005pixel RGB sensor, built-in flash, SB-800 or SB-600: i-TTL balanced fill-flash and standard i-TTL flash
- AA (Auto Aperture-type) flash: Available with SB-800 used with CPU lens
- Non-TTL Auto: Available with Speedlights such as SB-800, 28, 27, and 22S
- Range-priority manual flash; available with SB-800

Flash Sync mode:

- Front-Curtain Sync (normal)
- Red-Eye Reduction
- Red-Eye Reduction with slow sync

- Slow Sync
- Rear-Curtain Sync

Built-in Speedlight: Manual pop-up with button release

Guide number: (ISO 200, m): approx. 17 (manual 18) (ISO 100 equivalent, m): approx. 12 (manual 13)

Flash compensation: -3 to +1 EV in increments of 1/3, 1/2 or 1 EV

Accessory shoe: ISO 518 standard hotshoe contact with safety lock provided

Sync terminal: ISO 519 standard terminal

Creative Lighting System: With Speedlights such as SB-800, SB-600, SB-R200, supports Advanced Wireless Lighting, Auto FP High-Speed Sync, Flash Color Information Communication, modeling flash and FV lock

Self-timer: 2 to 20 seconds duration

Depth of field preview: When CPU lens is attached, lens aperture can be stopped down to value selected by user (A and M mode) or value selected by camera (P and S mode)

Remote control: Via 10-pin terminal or WT-4a Wireless Transmitter (optional)

GPS: NMEA 0183 (Ver. 2.01 and 3.01) interface standard supported with 9-pin D-sub cable (optional) and MC-35 GPS Cable (optional)

Supported languages: Chinese (Simplified and Traditional), Dutch, English, Finnish, French, German, Italian, Japanese, Korean, Polish, Portuguese, Russian, Spanish, Swedish

Appendix B + D300 Specifications 247

Power source: One EN-EL3e Rechargeable Li-ion Battery, MB-D10 Multi-Power Battery Pack (optional) with one EN-EL4a, EN-EL4 or EN-EL3e Rechargeable Li-ion Battery or eight R6/AA-size alkaline (LR6), Ni-MH (HR6), lithium (FR6) batteries, or nickelmanganese ZR6 batteries, EH-5a AC Adapter (optional)

Tripod socket: 1/4 in. (ISO 1222)

Custom settings: 48 settings available

Operating environment: Temperature 0-40 degrees C/32-104 degrees F: under 85 percent (no condensation)

Dimensions (W \times H \times D): Approx. 5.8 \times 4.5 \times 2.9 in. (147 \times 114 \times 74 mm)

Weight: Approx. 1.82 lbs. (825 g) without battery, memory card, body cap, or monitor cover

Supplied accessories (differ by area and country): EN-EL3e Rechargeable Li-ion Battery, MH-18a Quick Charger, UC-E4 USB Cable, EG-D100 Video Cable, AN-D300 Strap, BM-8 LCD monitor cover, Body cap, DK-5 Eyepiece Cap, DK-23 Rubber Eyecup, Software Suite CD-ROM

Optional accessories: MB-D10 Multi-Power Battery Pack, WT-4a Wireless Transmitter, DK-21M Magnifying Eyepiece, EH-5a AC Adapter, Capture NX Software, Camera Control Pro 2

Online Resources

Internet and the information is available on the Internet for photographers. This appendix serves as a guide to some of the resources on the Internet that can help you learn more about the Nikon D300 and photography in general as well as help you discover online photo sharing sites and online photography magazines.

Informational Web Sites

With the amount of information on the Web, sometimes it is difficult to know where to look or where to begin. The following are a few sites I suggest you start with when you want to find reliable information about your Nikon D300 or about photography in general.

Nikonusa.com

Nikonusa.com gives you access to the technical specifications for Nikon Speedlights, cameras, lenses, and accessories. You can also find firmware updates here should they become available. You can find the Web site at http://nikonusa.com.

Nikonions.org

Nikonions.org is a forum where you can post questions and discussion topics for other Nikon users on a range of photography-related topics. You can find the Web site at www.nikon ions.org.

Photo.net

Photo.net is a large site containing resources like equipment reviews, forums on a variety of topics, tutorials, and more. If you are looking for specific photography-related information and aren't sure where to look, this is a great place to start. You can find the Web site at http://photo.net.

Informational Web sites

Photo sharing and critiquing sites

Online photography magazines

Photo Sharing and Critiquing Sites

Flickr.com

Flickr.com is a site for posting your photos for others to see. The users range from amateurs to professionals and there are groups dedicated to specific areas, including the Nikon D300. You can find the Web site at http://flickr.com.

Photoworkshop.com

Photoworkshop.com is an interactive community that allows you to participate in competitions with other photographers by providing assignments as well as giving you a forum to receive feedback on your images. You can find the Web site at http://photo workshop.com.

ShotAddict.com

ShotAddict.com is a photography site that provides photo galleries, product reviews, contests, and discussion forums. You can find the Web site at http://shot addict.com.

Online Photography Magazines

Some photography magazines also have Web sites that offer photography articles, and they often post information that isn't found in the pages of the magazine. The following is a list of a few photography magazines' Web sites.

Communication Arts

http://commarts.com/CA/

Digital Photographer

http://digiphotomag.com

Digital Photo Pro

http://digitalphotopro.com

Outdoor Photographer

http://outdoorphotographer.com

Photo District News

http://pdnonline.com

Popular Photography & Imaging

http://popphoto.com

Shutterbug

http://shutterbug.net

Glossary

E (Auto-Exposure) A general-purpose shooting mode where the camera selects the aperture and/or shutter speed according to the camera's built-in light meter. See also *Shutter Priority* and *Aperture Priority*.

AE/AF lock A camera setting that lets you lock the current metered exposure and/or autofocus setting prior to taking a photo. This allows you to meter an off center subject, and then recompose the shot while retaining the proper exposure for the subject.

AF assist illuminator An LED light that is emitted in low-light or low-contrast situations. The AF assist illuminator provides enough light for the camera's AF to work in low light.

ambient lighting Lighting that naturally exists in a scene.

angle of view The area of a scene that a lens can capture, determined by the focal length of the lens. Lenses with a shorter focal length have a wider angle of view than lenses with a longer focal length.

aperture The designation for each step in the aperture is called the f-stop. The smaller the f-stop (or f/number), the larger the actual opening of the aperture, and the higher numbered f-stops designate smaller apertures, letting in less light. The f/number is the ratio of focal length to effective aperture diameter.

Aperture Priority A camera setting where you choose the aperture, and the camera automatically adjusts the shutter speed according to the camera's metered readings. Aperture Priority is often used for the photographer to control depth of field.

aspect ratio The proportions of an image as printed, displayed on a monitor, or captured by a digital camera.

autofocus The ability of a camera to determine the proper focus of the subject automatically.

backlighting A lighting effect produced when the main light source is located behind the subject. Backlighting can be used to create a silhouette effect or to illuminate translucent objects. See also *frontlighting* and *sidelighting*.

bounce flash Pointing the flash head in an upward position or toward a wall so that it bounces off another surface before reaching the subject. This softens the light illuminated off the subject. Bouncing the light often eliminates shadows and provides a smoother light for portraits.

bracketing Photographic technique in which you vary the exposure of your subject over three or more frames. By doing this you can ensure a proper exposure in difficult lighting situations where your camera's meter can be fooled.

broad lighting When your main light is illuminating the side of the subject that is facing toward you.

camera shake The movement of the camera, usually at slower shutter speeds, which produces a blurred image.

catchlight Highlights that appear in the subject's eyes.

center-weighted meter A light-measuring device that emphasizes the area in the middle of the frame when you're calculating the correct exposure for an image.

colored gel filters Colored translucent filters that are placed over a flash head or light to change the color of the light emitted on the subject. Colored gels can be used to create a colored hue of an image. Gels are often used to change the color of a white background when shooting portraits or still lifes, by placing the gel over the flash head and firing the flash at the background.

compression Reducing the size of a file by digital encoding, using fewer bits of information to represent the original. Some compression schemes, such as JPEG, operate by discarding some image information, while others, such as RAW with lossless compression, preserve all the detail in the original.

Continuous Auto-focus (AF-C) Camera setting that allows the camera to maintain focus on a moving subject.

contrast The range between the lightest and darkest tones in an image. A high-contrast image is one in which the shades fall at the extremes of the range between white and black. In a low-contrast image, the tones are closer together.

dedicated flash An electronic flash unit, such as the Nikon SB-600, SB-800, or SB-400, designed to work with the automatic exposure features of a specific camera.

default settings Factory settings of the camera.

depth of field (DOF) A distance range in a photograph in which all included portions of an image are at least acceptably sharp.

diffuse lighting Soft, low-contrast lighting.

digital SLR (dSLR) Single-lens reflex camera with interchangeable lenses and a digital image sensor.

D-Lighting Function within the camera that can fix the underexposure that can often happen to images that are backlit or in deep shadow.

equivalent focal length A digital camera's focal length, which is translated into the corresponding values for a 35mm film.

exposure The amount of light allowed to reach the film or sensor, determined by the intensity of the light, the amount admitted by the aperture of the lens, and the length of time determined by the shutter speed.

exposure compensation The ability to take correctly exposed images by letting you adjust the exposure, typically in 1/3 stops from the metered reading of the camera. Enables the photographer to make manual adjustments to achieve desired results. Exposure compensation is usually used in conjunction with auto-exposure settings.

exposure mode Camera settings that let the photographer take photos in Automatic mode, Shutter Priority mode, Aperture Priority mode, and Manual mode. When set to Aperture Priority, the shutter speed is automatically set according to the chosen aperture (f-stop) setting. In Shutter Priority mode, the aperture is automatically set according to the chosen shutter speed. When using Manual mode, both aperture and shutter speeds are set by the photographer, bypassing the camera's metered reading. When using Automatic mode, the camera selects the aperture and shutter speed. Some cameras also offer Scene modes. which are automatic modes that adjust the settings to predetermined parameters, such as a wide aperture for the Portrait scene mode and high shutter speed for Sports scene mode.

fill flash A lighting technique where the Speedlight provides enough light to illuminate the subject in order to eliminate shadows. Using a flash for outdoor portraits

often brightens the subject in conditions where the camera's meters light from a broader scene.

fill lighting In photography, the lighting used to illuminate shadows. Reflectors or additional incandescent lighting or electronic flash can be used to brighten shadows. One common technique outdoors is to use the camera's flash as a fill.

flash An external light source that produces an almost instant flash of light in order to illuminate a scene.

flash exposure compensation Adjusting the flash output by +/- 3 stops in 1/3-stop increments. If images are too dark (underexposed), use flash exposure compensation to increase the flash output. If images are too bright (overexposed), you can use flash exposure compensation to reduce the flash output.

flash modes Control the output of the flash by using different parameters.

flash output level The output level of the flash as determined by one of the flash modes used.

front-curtain sync Front-curtain sync causes the flash to fire at the beginning of this period when the shutter is completely open, in the instant that the first curtain of the focal plane shutter finishes its movement across the film or sensor plane. This is the default setting. See also *rear-curtain sync*.

frontlighting The illumination coming from the direction of the camera. See also *backlighting* and *sidelighting*.

f-stop See aperture.

histogram A graphic representation of the range of tones in an image.

hot shoe Slot located on the top of the camera where the flash connects. The hot shoe is considered hot because of its electronic contacts that allow communication between the flash and the camera.

ISO sensitivity The ISO (International Organization for Standardization) setting on the camera indicates the light sensitivity setting. Film cameras need to be set to the film ISO speed being used (such as ISO 100, 200, or 400 film), where a digital camera's ISO setting can be set to any available setting. In digital cameras, lower ISO settings provide better quality images with less image noise; however, the lower the ISO setting, the more exposure time is needed.

JPEG (Joint Photographic Experts Group) This is an image format that compresses the image data from the camera to achieve a smaller file size. The compression algorithm discards some of the detail when closing the image.

Kelvin A unit of measurement color temperature based on a theoretical black body that glows a specific color when heated to a certain temperature. The sun is approximately 5500 K.

lag time Length of time between when the Shutter button is pressed and the shutter is actually released; the lag time on the D300 is so quick it is almost imperceptible. Compact digital cameras are notorious for having long lag times, which can cause you to miss important shots.

LCD (Liquid Crystal Display) This is where the camera's images are displayed.

leading line An element in a composition that leads the viewer's eye toward the subject.

lens flare An effect caused by stray light reflecting off of the many glass elements of a lens. Lens flare is generally avoided by shades on the lens, but sometimes lens flare can be used creatively.

lighting ratio The proportion between the amount of light falling on the subject from the main light and the secondary light. An example would be a 2:1 ratio in which one light is twice as bright as the other.

macro lens A lens that provides the ability to focus at a very close range enabling extreme close-up photographs.

manual exposure Bypassing the camera's internal light meter settings in favor of setting the shutter and aperture manually. Manual exposure is beneficial in difficult lighting situations where the camera's meter does not provide correct results. Switching to manual settings could entail a trial-and-error process until the correct exposure is reviewed on the digital camera's LCD after a series of photos is taken.

Manual mode Manually setting the exposure on the camera.

Matrix metering A light metering system that calculates exposure by measuring the light from different areas of the scene and averaging them out.

metering Measuring the amount of light utilizing the camera's internal light meter.

mirror lock-up A function of the camera that allows the mirror, which reflects the image to the viewfinder, to be retracted without the shutter being released. This is done in order to reduce vibration from the mirror moving or to allow sensor cleaning (when the shutter is open).

NEF (Nikon Electronic File) The name of Nikon's RAW file format.

noise Pixels with randomly distributed color values in a digital image. Noise in digital photographs tends to be more pronounced with low-light conditions and long exposures, particularly when you set your camera to a higher ISO rating.

noise reduction A technology used to decrease the amount of random information in a digital picture, usually caused by long exposures and high ISO settings. Noise reduction typically involves the camera automatically taking a second blank/dark exposure at the same settings that contains only noise, and then using the blank photo's information to cancel the noise in the original picture.

pincushion distortion An aberration in a lens in which the lines at the edges and sides of the image are bowed inward. This distortion is usually found in longer focal-length (telephoto) lenses.

Programmed auto (P) On the camera, the shutter speed and aperture are set automatically when the subject is focused.

RAW An image file format that contains the unprocessed camera data as it was captured. Using this format allows you to change image parameters such as white balance saturation and sharpening after the image is downloaded. Processing RAW files such as Nikon's NEF require special software, such as Adobe Camera Raw (available in Photoshop), Adobe Lightroom, or Nikon's Capture NX.

rear-curtain sync Rear-curtain sync causes the flash to fire at the end of the exposure, an instant before the second or rear curtain of the focal plane shutter begins to move. With slow shutter speeds, this feature can create a blur effect from the ambient light, showing as patterns that follow a moving subject with the subject shown sharply frozen at the end of the blur trail. This setting is usually used in conjunction with longer shutter speeds. See also *front-curtain sync*.

red-eye An effect from flash photography that appears to make a person's eyes glow red, or an animal's yellow or green. It's caused by light bouncing from the retina of the eye and is most noticeable in dimly lit situations (when the irises are wide open), and when the electronic flash is close to the lens and, therefore, prone to reflect the light directly back.

Red-Eye Reduction A flash mode controlled by a camera setting that is used to prevent the subject's eyes from appearing red in color. The Speedlight fires multiple flashes just before the shutter is opened.

S-curve A leading line that is shaped like the letter S. See also *leading line*.

self-timer A mechanism that delays the opening of the shutter for some seconds after the Shutter Release button has been pressed.

short lighting When your main light is illuminating the side of the subject that is facing away from you.

shutter A mechanism that allows light to pass to the sensor for a specified amount of time.

Shutter Priority In this camera mode, you set the desired shutter speed, and the camera automatically sets the aperture for you. Often used when shooting action shots to freeze motion of the subject using fast shutter speeds.

Shutter Release button When this button is pressed the camera takes the picture.

shutter speed The length of time the shutter is open to allow light to fall onto the imaging sensor. The shutter speed is measured in seconds or more commonly, fractions of seconds.

sidelighting Illuminating the subject from the left or right. See also *frontlighting* and *backlighting*.

Single Auto-focus (AF-S) A focus setting that locks the focus on the subject when the Shutter Release button is half-pressed. This allows you to focus on the subject and recompose the image without losing focus as long as the Shutter Release button is half-pressed.

Slow sync Flash mode that allows the camera's shutter to stay open for a longer time to allow the ambient light to be recorded resulting in the background receiving more exposure, which gives the image a more natural appearance.

Speedlight Nikon-specific term for its flashes.

spot meter A metering system in which the exposure is based on a small area of the image; usually the spot is linked to the AF point.

TIFF (Tagged Image File Format) A type of file storage format that has no compression, therefore, no loss of image detail. TIFFs can be very large image files.

TTL Metering system where the light is measured directly though the lens.

tungsten light The light from a standard household light bulb.

vanishing point The point at which parallel lines converge and seem to disappear.

vibration reduction (VR) A function of the camera in which the lens elements are shifted in order to reduce the effects of camera shake.

white balance Used to compensate for the differences in color temperature common in different light sources. For example, a typical tungsten light bulb is very yellow-orange, so the camera adds blue to the image to ensure that the light looks like standard white light.

Index

NUMBERS

1 step spd/aperture, 84 2-leaf barn doors, 153 3D Color Matrix II metering mode, 6, 36–37 3D tracking, focus point switching, 46–47 4-leaf barn doors, 153 5-degree grid, light modifier, 154 8 fps, MD-D10 battery grip, 6 9-point AF area mode, 46 10-pin remote terminal cover, 21–22 12 bit, RAW file recording, 70 14 bit, RAW file recording, 70 21-point AF area mode, 46 51-point AF area mode, 46 51-point AF area mode, 46–47 60-degree grid, light modifier, 154 1005-pixel RGB sensor, 36–37, 46

Α

A (Aperture Priority) mode, 3, 35 a1 - AF-C priority selection, 75 a10 - AF-ON for MB-D10, 75, 77 a2 - AF-S priority selection, 75-76 a3 - Dynamic AF area, 75–76 a4 - Focus tracking with lock-on, 75-76 a5 - AF activation, 75-76 a6 - AF point illumination, 75-76 a7 - Focus point wrap-around, 75-76 a8 - AF point selection, 75-77 a9 - Built-in AF-assist illuminator, 75, 77 abstract photography, 155-158 abstract, landscape photography style, 186 AC adapter input port, side panel connector, 24 accessories 10-pin remote terminal connections, 21-22 barn doors, 153 camera bags/cases, 241-242 diffusion panels, 152-153 extension tubes, 109, 194 fill cards, 215 filters, 109-110 gobos, 154 grids, 153-154 Lensbaby, 166-167 light blockers, 168 light modifiers, 150-154 MB-D10 battery grip, 6, 237-238 parabolic reflectors, 153 radio slaves, 145 reflectors, 128, 154 remote shutter release, 191, 193, 198 reversing rings, 195 snoots, 154

softboxes, 151-152 Speedlights, 140-143 speedrings, 152 studio strobes, 144-147 teleconverters, 108-109 tripods, 239-241 umbrellas, 150-151 WT-4a wireless transmitter, 239 action shots, 3, 8, 35, 44, 134-135 action/sports photography, 158–162 active AF point, viewfinder illumination, 76 Active D-Lighting, Shooting menu, 67, 72 active focus points, viewfinder display, 26 Active folder, Shooting menu, 67-68 Adobe RGB color space, 68, 72 AE Lock (hold), 84 AE lock, 26-27, 84 AE lock only, 84 AE/AF Lock, 84 AE-L/AF-L (Auto-Exposure/Auto-Focus) button, 19-20, 79, 85 AF (autofocus) area modes, 9, 19-20, 46-47 AF (autofocus) modes, 44. See also focus modes AF (autofocus), lens designation, 96–97 AF area mode indicator, LCD control panel, 31 AF area mode selector, 9, 19–20 AF fine tune, Setup menu, 86, 89-90 AF Lock only, 84 AF system, activating/deactivating, 76 AF-assist illuminator, 22-23 AF-D (autofocus-distance), 96-97 AF-I (autofocus-internal), 96-97 AF-ON (Auto-Focus On) button, 19-20, 76-77 AF-S (autofocus-Silent Wave), 96-97 After delete, Playback menu, 64, 65-66 AI/AIS (auto-indexing), lens designation, 96-97 ambient light, ghosting, 133 angles, 185, 205 animal sanctuaries, wildlife photography, 221-225 aperture multi-function, LCD control panel, 29, 31 Aperture Priority (A) mode, semiautomatic, 3, 35 Aperture setting, command dial assignments, 85 aperture/f-stop indicator, viewfinder display, 26 - 27apertures. See also f-stops aperture/f-stop indicator, 26-27 exposure control settings, 79 exposure element, 130 exposure factors, 111, 114 macro photography, 194 numbering system, 114

Sub-command dial, 22-23

258 Index **+** A–C

architectural photography, 162-166 area modes, 19-20, 46-47 art photography, 166-172 Auto Aperture mode, flash exposure mode, 131 Auto image rotation, Setup menu, 86-87 Auto ISO indicator, 26-27, 30-32 Auto ISO mode, ISO settings, 48-49 Auto mode, flash exposure mode, 131 Auto, white balance setting, 51-52 Auto-area AF mode, AF-assist illuminator, 22 auto-bracketing compensation increments, 29, 32 Auto-bracketing function, 41-43 auto-bracketing, 84 auto-exposure bracketing/WB bracketing, 32 Auto-Exposure/Auto-Focus (AE-L/AF-L) button, 19 - 20autofocus, 16, 19-20 autofocus (AF) area modes, 9, 46-47 autofocus (AF) modes, 44. See also focus modes autofocus (AF-S) modes, 76 Auto-Focus/Auto-Exposure (AF-L/AE-L) button, 19-20, 79, 275 Automatic area AF mode, candid shots, 47

B

B&W, custom Picture Control, 56 b1 - ISO sensitivity step value, 75, 77-78 b2 - EV steps for exposure cntrl, 75, 77-78 b3 - Exp comp/fine tune, 75, 77-78 b4 - Easy exposure compensation, 75, 77-78 b5 - Center-weighted area, 75, 77-78 b6 - Fine tune optimal exposure, 75, 77-78 back panel controls, 6-7, 9-11, 18-21 background blurs, 3, 35, 104-106 backgrounds, 123, 185, 206-207, 214-215, 225 backlighting, 136-137, 166, 229-230 backpacks, 242 ball heads, tripods, 239 barn doors, light modifier, 153 barrel distortion, wide-angle lenses, 166 batteries, 25, 27, 80-81, 88, 237-238 battery chamber cover, 25 battery grip indicator, LCD control panel, 30-32 battery indicator, 26-27, 30-31 Battery info, Setup menu, 86, 88 beep indicator, 29, 32 beeps, self-timer, 80 bellows lens, 16-17 bit depth, 60 black-and-white photos, 123, 231 bottom panel controls, 25 bounce flash, 137, 138, 210 bracketing, 41-43, 79, 82 Bracketing burst, 84 bracketing sequence, LCD control panel, 29, 32 bright spots, composition guidelines, 122 Brightness, custom Picture Control, 55 broad lighting, portrait photography, 207-208 buffers, exposures remaining information, 26, 28 buildings, architectural photography, 162-166 built-in Speedlight, 21-22, 81-82, 130, 143-144

Bulb mode, light trail/fireworks photography, 191 butterfly lighting, portrait photography, 208

С

C (Continuous) focus mode, action shots, 8, 44 c1 - Shutter-release button AE-L, 79 c2 - Auto meter-off delay, 79 c3 - Self-timer delay, 79 c4 - Monitor off delay, 79 camera bags, 241-242 camera cases. 241-242 Camera Control Pro 2, USB port connector, 24 camera shake, 5, 107-108 candid shots, Automatic area AF mode, 47 Capture NX, image comments, 87 card readers, downloading images, 11-12 card slot cover latch, 19-20 Center-weighted metering mode, 6, 37-38, 78, 84 CF (CompactFlash) cards. See CompactFlash (CF) cards Ch (Continuous High) mode, 4 Change main/sub, command dial assignments, 85 child photography, 172-175 Chimera, speedrings, 152 Choose non-CPU lens number, 84 chrominance, digital noise element, 49 circle of confusion, depth of field, 115 Cl (Continuous Low) mode, multiple frame capture, 4 Clean image sensor, Setup menu, 86-87 clock indicator, 30-32 clock, time settings, 87 close-up filters, macro photography, 194-195 close-up photography, 5, 106-107, 240 close-up portraits, perspective distortion, 102 clothing, portrait photography, 213 clouds, 52-53, 128 CLS (Creative Lighting System), 139-140 CMOS image sensor, 16–17. See also sensors Color balance, Retouch menu, 232-233 color charts, color balance corrections, 232-233 Color space, Shooting menu, 67, 72 color spaces, 72 color temperatures, 29, 31, 50-51 color tints, filters, 109-110 Color toning, custom Picture Control, 57 colors abstract photography, 155-158 bit depth, 60 flower/plant photography, 180-185 night photography, 200 shooting info display, 80 still-life/product photography, 217 Commander mode, 81 comments, image addition, 87 CompactFlash (CF) cards. See also memory cards card slot cover latch, 19-20 downloading images, 11-12 exposures remaining information display, 26, 28 formatting, 16, 86 K indicator, 26, 28

Index + C-E 259

compositions abstract photography, 155-156 background separation, 123 bright spot, 122 cropping, 122 frame fills, 123 framing grid display, 26-27 horizons, 123 keep it simple, 117-118 leading lines, 121 merger, 122 odd number of multiple subjects, 123 Rule of Thirds, 118-120 S-curves, 121-122 subject framing, 122 unnecessary details, 122 vanishing points, 121 Compressed, RAW file compression setting, 70 compression, 59-60, 69-70, 104 computers, downloading images, 11-12 concert photography, 38, 176-180 contact cover, MB-D10 battery grip attachment, 25 Continuous (C) focus mode, action shots, 8, 44 Continuous AF mode. See Continuous (C) focus mode Continuous autofocus (AF-C) modes, 75 Continuous High (Ch) mode, 4 Continuous Low (Cl) mode, multiple frame capture, 4 Continuous Low shooting mode, frame rates, 80 Continuous shooting mode, image capture settings, 80 Contrast, custom Picture Control, 55 controls back panel, 6-7, 9-11, 18-21 bottom panel, 25 front panel, 8, 20-21 lenses, 16-17 side panel, 11-12, 23-25 top panel, 1-6, 16-18 convertible umbrellas, light modifier, 150-151 copyrights, architectural photography, 164 Creative Lighting System (CLS), 139-140 crop factors, lens selection element, 100-101 cropping, 122, 230-231 cross-processing, art photography, 170 CSM a - Autofocus, 75-77 CSM b - Metering/exposure, 77-78 CSM c - Timers/AE Lock, 79 CSM d - Shooting/display, 79-81 CSM d2, framing grid display, 27 CSM d3, battery indicator, 27 CSM e - Bracketing/flash, 81-82 CSM f - Controls, 82-85 Custom menus, 31-32 Custom Picture Controls, 71 Custom setting bank, 75 custom settings menu bank, 31-32 Custom Settings menu, 75-85 cyanotype, 56, 231-232

D

D (distance information), lens designation, 96 d1 - Beep, 79-80 d10 - MB-D10 battery type, 79-81 d11 - Battery order, 79, 81 d2 - Viewfinder grid display, 79-80 d3 - Viewfinder warning display, 79-80 d4 - CL mode shooting speed, 79–80 d5 - Max. continuous release, 79-80 d6 - File number sequence, 79-80 d7 - Shooting info display, 79-80 d8 - LCD illumination, 79-80 d9 - Exposure delay mode, 79-80 data, image review display, 65 date, settings, 87 Daylight, white balance setting, 52, 53 daylight-saving time, 87 DC in port, side panel connector, 24 deep depth of field, subject sharpness, 116 Delete button, 10-11, 16, 19-20 Delete menu, Custom Picture Control, 71 Delete, Playback menu, 64 demo mode, enabling/disabling, 85 depth of field, 114-116 Depth of field preview button, 22-23, 84-85 destinations, travel photography, 221 details (unnecessary), composition, 122 diffused lighting, still-life/product photography, 215 diffusion panels, light modifier, 152-153 digital noise, 49. See also noise Digital Print Order Format (DPOF), 66-67 diopter adjustment control, 18-20 Display mode, Playback menu, 64-65 distance, exposure element, 130 distance scale, lens control, 16-17 distortion, 101-104, 162-164 D-Lighting, Retouch menu, 229-230 Domke, shoulder bags, 242 DPOF (Digital Print Order Format), 66-67 _DSC (Adobe RGB colorspace) filenames, 68 DSC_ (sRGB colorspace) filenames, 68 Dust off ref photo, Setup menu, 86, 88 DX (APS-C sensor), lens designation, 96 Dyna-lite, studio strobes, 145 Dynamic area AF mode, 22, 46-47, 76, 84

E

F. (EM/FG/FG-20), lens designation, 96 e1 - Flash sync speed, 81 e2 - Flash shutter speed, 81 e3 - Flash cntrl for built-in flash, 81 e4 - Modeling flash, 81–82 c5 - Auto bracketing set, 81–82 e6 - Auto bracketing (Mode M), 81–82 e7 - Bracketing order, 81–82 earplugs, concert photography, 176, 180 ED (extra low dispersion), lens designation, 96 electronic analog exposure, 26–27, 30–32 electronic light meter, reverse indicators, 85

260 Index **+ E**–**F**

emotions/moods, child photography, 173 equipment, travel photography packing, 218, 221 Expodisc, white balance setting, 51 exposure compensation bracketing, 41-43, 45 Easy exposure compensation, 78 Exposure Compensation button, 16-17, 38 exposure compensation indicator, 26, 30-32, 38 FEC indicator. 26-27 histograms, 39-41 increment settings, 78 Exposure Compensation button, 16-17, 38 exposure compensation indicator, 26, 30-32, 38 exposure compensation values, 28, 32 exposure meters, 79, 83 exposure modes, 26-28, 31, 34-36 exposures AE-L/AF-L button, 19-20 apertures, 111, 114 bracketing, 41-43, 45 bracketing order, 82 Exposure Compensation button, 16-17 exposures remaining display, 26, 28 fine tuning, 78 ghosting, 133 ISO sensitivity, 111, 114 K indicator, 26, 28 Long exp. NR, 72 M (Manual) mode, 3, 36 Multiple exposure settings, 73-74 shutter speeds, 111-113 Sunny 16 Rule, 125 exposures remaining multifunction, 31 exposures remaining, viewfinder information, 26, 28 extension tubes, 94, 109 external flash, PC sync terminal, 21-22 external strobes, M (Manual) mode, 3, 36 eyesight, diopter adjustment control, 18, 20

F

f1 - Multi selector center button, 82-83 f2 - Multi selector, 83 f3 - Photo info/playback, 83 f4 - Assign FUNC button, 83-84 f5 - Assign preview button, 83, 85 f6 - Assign AE-L/AF-L button, 83, 85 f7 - Customize command dials, 83, 85 f8 - Release button to use dial, 83, 85 f9 - No memory card?, 83, 85 f10 - Reverse indicators, 83, 85 FEC (Flash Exposure Compensation), 21, 135–136 FEC indicator, 26-27, 30-32 FEC values, 28, 32 file formats, 17, 30-31, 59-60, 69 File naming, Shooting menu, 67-68 files, 68-69, 80 fill cards, still-life/product photography, 215 fill flash, 128, 136-137, 210 fill frames, composition guidelines, 123 Filter Effects, 55–56, 231–232 filters, 109-110, 181-183, 194-195, 231-232

fireworks/light trail photography, 190-193 firmware, version display, 90-91 Firmware version, Setup menu, 86, 90-91 fisheve lenses, non-rectilinear, 101-102 flagging, light blocking, 153 flash. See also Speedlights action/sports photography, 159 bounce flash, 137-138, 210 built-in Speedlight, 21-22, 143-144 CLS (Creative Lighting System), 139-143 concert photography, 177, 180 dragging the shutter, 132 exposure bracketing, 42 exposure elements, 129-130 exposure modes, 130-131 FEC (Flash Exposure Compensation), 21, 135 - 136fill flash, 136-137, 210 flash ready indicator, 26, 28 Front-curtain sync mode, 132-133 GN (Guide Number), 129 GN/Distance = aperture formula, 130 hot shoe attachment point, 17 iTTL system, 129-131 nondedicated hot-shoe flashes, 146 outdoor portraits, 210 Rear-curtain sync mode, 134-135 Red-eye corrections, 230 Red-eve reduction mode, 133 Slow sync mode, 133-134 Speedlights, 140-143 studio strobes, 144-147 sync modes, 132-135 sync speed, 132 white balance setting, 52, 53 wildlife photography, 221 Flash Exposure Compensation (FEC), 21, 135–136 Flash mode button, 21-22 flash modes, 21-22, 30-31 Flash off, 84 Flash pop-up button, 21-22 flash ready indicator, 26, 28 flash shutter speed, Speedlights, 81 flash sync indicator, 26-28, 32 flash sync speed, Speedlights, 81 flash sync terminal cover, 21–22 flash-head, bounce flash angling, 137-138 flexible program, 2, 34-35 flexible program indicator, 28, 31 flower/plant photography, 180-185 fluorescent lights, 147, 149 Fluorescent, white balance setting, 51, 53 Fn button, 23 focal length, 18, 29, 100-101 focal plane mark, 16-17 focal plane shutter, dSLR cameras, 132 focus A (Aperture Priority) mode, 3 AF (autofocus) area modes, 9, 46–47 AF-ON (Auto-Focus On) button, 19-20 Depth of field preview button, 22-23

focus indicator, 26-27 focus modes, 7-8, 44 Shutter Release button activation, 16 focus indicator, viewfinder information, 26-27 Focus Mode selector, 8, 44 focus modes, 7-8, 22, 44. See also AF (autofocus) modes focus points 3D tracking, 46-47 active AF point illumination, 76 active focus point, 26 AF (autofocus) area modes, 9, 47 Dynamic AF area, 76 Dynamic area AF mode, 46-47 focus selector lock switch, 19-20 focus tracking w/lock-on, 76 image review display, 65 Multi-selector button settings, 82-83 selection settings, 76-77 viewfinder information display. 26-27 wrap-around, 76 focus ring, lens control, 16-17 focus selector lock, 19-20 folders, 64, 68, 83 Format memory card, Setup menu, 86 forms, 155-158, 217 frame fills, composition guidelines, 123 frame rates, 80, 158-159m frames, Auto-bracketing, 41-43 framing grid, viewfinder information display, 26-27 freeze frames, S (Shutter Priority) mode, 3, 35 Front mode selector switch, 22-23 front panel controls, 21-23 Front-curtain sync mode, 132-133 f-stops. See also apertures aperture/f-stop indicator, 26-27 exposure factors, 111, 114 numbering system, 114 Sunny 16 Rule, 125 FUNC button, control assignments, 83-84 functions, 23, 41 FV lock, 84 FV lock indicator, 26-27, 30-32

G

G, lens designation, 96 ghosting, ambient light condition, 133 GN (Guide Number), exposure element, 129 GN/DIstance = aperture formula, 130 gobos, light modifier, 154 golden hour, landscape photography, 187 GPS connection indicator, 30–32 GPS devices, 21–22, 86–88 gray cards, white balance setting, 51 Green, custom Picture Control, 56 grids, 26–27, 80, 153–154 group portraits, wide-angle lens, 101–103 Guide Number (GN), exposure element, 129 Guide Number (GN), exposure element, 131

Н

halogen lights, 147-149 hand-held mode, LiveView, 60-61, 73 hard light, texture highlights, 123 HDMI connection, 62, 86-87 HDMI port, side panel connection, 11-12, 24 HDTV, image viewing, 227-228 heads, tripods, 239 heights, tripods, 239 Help/Info/Protect button, 20 Hide image, Playback menu, 64-65 high ISO NR, 49-50, 67, 73 high-contrast lighting, 6, 72 high-key images, histograms, 40 highlights, image review display, 65 high-speed action sequence shots, 4 high-speed/moderate sequence shots, 4 HIM (Hydrargyrum Medium-Arc Iodide) lamps, 148, 149-150 histograms color balance corrections, 232-233 exposure compensation, 39-41 image information display, 10-11 LCD display, 41 Multi-selector button settings 83 RGB. 65 Holga, TtV photography, 168-169 Hollywood glamour lighting, 208 honeycombs, light modifier, 153-154 horizons, composition rules, 123 hot shoe, 17 Hoya R72, IR (infrared) filter, 181 Hue, custom Picture Control, 55 Hydrargyrum Medium-Arc Iodide (HIM) lamps, 148, 149-150

l

IF (internal focus), lens designation, 97 Image Authentication Software, 88 Image authentication, Setup menu, 86, 88 image comment indicator, 30-32 Image comment, Setup menu, 86-87 image editors, 87, 91 Image overlay, Retouch menu, 233-234 image quality, 30-31, 67-69 image reviews, 16, 18, 64-65 image sensors, cleaning, 86-87 image size, 30-31, 59-60, 67, 69 images authentication information embedding, 88 auto image rotation, 87 bracketing, 41-43, 45 color balance corrections, 232-233 color to black-and-white conversion, 231 comment indicator, 30, 32 comments, 87 continuing after deletion, 66 crop factors, 100-101 cyanotype effect, 231-232

continued

images (continued) deleting, 19 deletion prevention, 10-11 disabling/enabling instant review, 65 display mode highlights, 65 downloading, 11-12 DPOF (Digital Print Order Format), 66-67 dust reference photo, 88 erasing, 10-11 exposure reviews, 111-114 focus point display, 65 full-frame display, 20-21 ghosting, 133 hiding/displaying during playback, 65 information display, 10 JPEG compression settings, 69 most recently taken playback, 19 multiple exposures, 73-74 overlays, 233-234 Picture Controls, 70-71 protecting, 20 quality settings, 68-69 RGB histogram display, 65 rotating, 66 scrolling through recently taken, 10-11 selecting/deleting, 64 sepia effect, 231-232 shooting data display, 65 shooting menu bank settings, 68 showing next after deletion, 66 showing previous after deletion, 66 side-by-side comparison, 234 size information display, 30-31 size settings, 69 slide shows, 66 thumbnail display, 20-21 viewing, 227-228 vignetting, 102 zooming in/out, 21 impressionistic, landscape photography style, 186 incandescent lighting, 51-52, 147-149 indoor shots, portrait photography, 209-210 Info/Help/Protect button, 20 infrared (IR) filters, uses, 110, 181 infrared (IR) photography, flowers/plants, 181-183 Input Comment menu, image comments, 87 insects, macro photography, 196-197 International Organization for Standardization (ISO), 47 interval timer indicator, 30-32 interval timer number, 29, 32 Interval timer shooting, Shooting menu, 67, 74 ISO button, 3-4, 16-17 ISO sensitivity Auto ISO indicator, 26-27 Auto ISO mode, 48-49 concert photography, 177 exposure factors, 111, 114 extended settings, 48 GN (Guide Number) factor, 129

High ISO NR, 72

increment adjustments, 113–114 ISO button, 17–18 LCD Control panel display, 29, 32 LCD display, 18 macro photography, 198 noise reduction, 49–50 setting selections, 3–4 Shooting menu, 67, 73 standard settings, 47 step values, 78 viewfinder information display, 26, 28 i-TTL Balanced Fill-Flash (BL) mode, 130 iTTL system, flash exposure modes, 129–131

J

JPEG basic, file format, 69 JPEG compression, Shooting menu, 67, 69 JPEG fine, file format, 69 JPEG format, 17, 59–60, 69 JPEG normal, file format, 69

Κ

K indicator, 26, 28, 31 K, white balance setting, 52 keep it simple, composition rule, 117–118 Kelvin scale, color temperatures, 29, 31, 50–51 kiosks, DPOF (Digital Print Order Format), 66–67 Kodak Duaflex, TtV photography, 167–168

L

landscape photography A (Aperture Priority) mode, 35 guidelines, 186-190 normal lens, 103-104 tripods, 240 wide-angle lens, 101-103 Language, Setup menu, 86–87 Large, image size setting, 69 LCD brightness, Setup menu, 86 LCD control panel, 1-4, 16-18, 28-32, 38, 80 LCD display auto off settings, 79 back panel control, 18, 20 brightness settings, 86 disabling/enabling instant image review, 65 exposure compensation indicator, 38 grid display, 80 histogram reviews, 41 image reviews, 16, 18 LiveView, 18, 60-62 LiveView Tripod mode adjustment, 62 shooting info display, 20, 80 LCD illuminator, 16-17 leading lines, composition rules, 121 lens codes, 96-97 Lens release button, 22 Lensbaby, art photography, 166-167 lenses, 16-17, 22, 89-90, 96-110, 166-167. 194 AF fine tune, 89-90 backwards compatibility, 97

Index + L-M 263

bellows, 16 crop factors, 100-101 distance scale, 16-17 extension tubes, 109 filters, 109-110 fisheye, 101-102 focus ring, 16-17 lens codes, 96-97 Lens release button, 22 Lensbaby, 166-167 macro, 106-107, 194 non-CPU. 89 normal, 103-104 prime, 99-100 rectilinear, 101 teleconverters, 108-109 telephoto, 104-106 VR (Vibration Reduction), 107-108 wide-angle, 101-103 zoom. 98 zoom ring, 16-17 light blockers, 168 light metering, TTL (through-the-lens) system, 125 light meters, 26-27, 30-32 light trail/fireworks photography, 190-193 lighting Active D-Lighting, 72 AF-assist illuminator, 77 barn doors, 153 built-in Speedlight, 143-144 CLS (Creative Lighting System), 139-143 continuous, 147-150 diffusion panels, 152–153 fluorescent, 147, 149 gobos, 154 grids, 153-154 halogen, 147-149 hard light, 123 HMI lamps, 148-150 incandescent, 147-149 ISO settings, 3-4 light metering, 125 light modifiers, 150-154 natural light conditions, 127-128 parabolic reflectors, 153 quality of light, 123-124 reflectors, 154 snoots, 154 soft light, 124 softboxes, 151-152 Speedlights, 140-143 speedrings, 152 still-life/product photography, 214-215, 217 studio portraits, 206-207 studio strobes, 144-147 Sunny 16 Rule, 125 umbrellas, 150-151 lighting patterns, portrait photography, 207–209 lines, abstract photography, 155-158 liquid crystal display. See LCD display; LCD control panel

LiveView, 18, 60–62, 67, 73 LiveView (Lv) mode, shot previews, 5 Load/Save menu, Custom Picture Control, 71 Lock mirror up for cleaning, Setup menu, 86–87 Lomo, TtV photography, 168–169 Long exp. NR, Shooting menu, 67, 72 long exposure NR, 49–50 loop lighting, portrait photography, 208 Lossless compressed, 70 low light conditions, LCD illuminator, 16 Lowepro, shoulder bags, 242 low-key images, histograms, 40 low-light conditions, 22, 77, 101–104, 240 luminance, digital noise element, 49 Lv (LiveView) mode, shot previews, 5

Μ

M (Manual) mode. See Manual (M) mode macro lenses, 106-107 macro photography, 5, 16, 194-198 Main Command dial back panel control, 19-20 decreasing/increasing exposure setting, 16 file quality settings, 17 flexible programs, 34-35 FUNC button assignments, 84 function assignments, 85 image quality settings, 69 ISO sensitivity settings, 18 ISO settings, 3-4 shooting mode selections, 1-2 Trim aspect ratios, 230 white balance adjustments, 18 Manage Picture Control, Shooting menu, 67, 71 Manual (M) mode, 3, 7, 35-36, 44, 81-82, 131, 182 Mass Storage (MSC), computer connections, 88 Matrix metering, 84. See 3D Color Matrix II maximum aperture, 29, 31 MB-D10 battery grip, 6, 25, 30, 32, 77, 80-81, 237-238 MC (Monochrome), Picture Control, 55, 71 MC-35 GPS adapter, GPS device connection, 88 Media Transfer Protocol/Picture Transfer Protocol, 88 Medium, image size setting, 69 memory card slot cover, 25 memory cards. See also CF (CompactFlash) cards card slot cover latch, 19-20 downloading images, 11-12 exposures remaining information display, 26, 28 formatting, 86 image deletion prevention, 10-11 K indicator, 26, 28 saving/loading settings, 88 selecting/deleting images, 64 travel photography, 221 memory, 26, 28. See also RAM Menu button, 19-20 menus command dial assignments, 85 Custom Settings, 74-85

264 Index + M–Q

menus (continued) Help button information display, 20 item selections, 21 LCD display, 18 My Menu, 91 Playback, 63-67 Retouch, 91 Setup, 86-90 Shooting, 67-74 mergers, composition guidelines, 122 messenger bags, 242 metering indicator, viewfinder display, 26-27 Metering Mode dial. 6-7, 19-20 metering modes, 6, 16-19, 36-38, 78 Micro, lens designation, 96 Mirror up (Mup) mode, close-up shots, 5 mirror, locking up for cleaning, 87 Mode button, 1-2, 16-17 moderate/high-speed sequence shots, 4 modifiers, natural light conditions, 128 Monochrome (MC), Picture Control, 55, 71 Monochrome, Retouch menu, 231 mono-lights, studio strobes, 144-147 moods/emotions, child photography, 173 motion blurs, 3, 35, 159 MSC (Mass Storage), 88 MTP/PTP (M/P), 88 Multi-CAM 3500DX module, AF area modes, 46-47 multiple exposure indicator, 30-32 Multiple exposure, Shooting menu, 67, 73-74 Multi-selector button, 9-11, 19-20, 82-83 Mup (Mirror up) mode, close-up shots, 5 My menu, saving custom settings, 91

Ν

NaneuPro bags, 242 ND (neutral density) filters, 110 NEF (RAW), 69-70 NEF (RAW) recording, Shooting menu, 67, 70 NEF (RAW) + JPEG, file formats, 68-69 neon lights, night photography, 200 Neutral (NL), Picture Control, 54, 70 neutral density (ND) filters, 110 night photography, 199-202 night shots, Slow sync mode, 133-134 Nikon Capture NX, Picture Controls, 70-71 Nikon View, Picture Controls, 70-71 Nikon's Capture NX, image comments, 87 NL (Neutral), Picture Control, 54, 70 noise, 3-4, 49-50, 72. See also digital noise non-CLS flash, M (Manual) mode, 3 Non-CPU lens data, Setup menu, 86, 89 non-CPU lenses, 29, 35-36, 89 nonobjective abstract art, 156 normal lenses, 103-104. See also prime lenses NSTS video mode, 87

0

objective abstract art, object recognition, 156 OK button, 10–11, 20–21 On/Off switch/LCD illuminator, 16–17 Optimal quality, JPEG compression, 69 Orange filter, custom Picture Control, 56 orientation, auto image rotation, 87 outdoor photography, fill flash, 136–137 outdoor shots, 125, 210–211 overexposures, 3, 36, 40

P

P (Programmed Auto) mode, 2, 28, 31, 34-35 painting with light, night photography, 200 PAL video mode, 87 pan/tilt head, tripods, 239 panning, 107-108, 159 parabolic reflectors, light modifier, 153 Paramount lighting, portrait photography, 208 PC cords, flash sync terminal, 21-22 PC mode indicator, 29, 31 PC sync, PC cord connection, 21-22 Pelican cases, 242 permissions, architectural photography, 164 perspective distortion, 102, 104, 162-164, 166 perspectives, abstract photography, 156 pet photography, 203-205 photo kiosk, DPOF, 66-67 Pict-Bridge-compatible printers, DPOF, 66-67 Picture Controls, 54-59, 70-71 plates, tripods, 239-240 Play button, 10-11 Playback button, 19-20 Playback folder, Playback menu, 64 Playback menu, 64-67 Playback mode, 10-11, 20-21, 83, 85 Pocket Wizard, radio slaves, 145 portrait orientation, rotating images, 66 portrait photography, 206-213 portraits A (Aperture Priority) mode, 35 Center-weighted metering mode, 6, 37-38 hard light, 123 normal lens 103-104 Red-eye reduction mode, 133 S (Single) focus mode, 4, 7, 44 soft light, 124 telephoto lenses, 104-106 poses, portrait photography, 213 power in port, side panel connection, 11-12 PRE, white balance setting, 51 prime lenses, 99-100. See also normal lenses Print Set (DPOF), Playback menu, 64, 66-67 printing, DPOF, 64, 66-67 Pro-foto, studio strobes, 145 Programmed Auto (P) mode, 2, 28, 31, 34-35 props, 175, 206 Protect button, image deletion prevention, 10-11 Protect/Info/Help button, 20 pulse modulation, CLS system communications, 139

Q

QUAL button, image quality settings, 69 Quality button, 16–17 quality of light, 187 quality, image information display, 30–31 Quick adjust, custom Picture Control, 55 quick release plates, tripods, 239–240 Quick Tour, 1–12

R

R1/R1C1 Speedlight, ring lights, 142-143 radio slaves, wireless studio strobe firing, 145 RAM (random access memory), 26, 28, See also memory RAW format, 60, 70, 233-234 Rear sync mode, night photography, 199 Rear-curtain sync mode, moving subjects, 134-135 rectilinear, wide-angle lenses, 101 Red filter, custom Picture Control, 56 Red-eye correction, Retouch menu, 230 Red-eye reduction mode, 133, 205 reflectors, 128, 134 Release mode dial/lock, 4-6, 17 release modes, 4-5, 17 Rembrandt lighting, 209 remote shutter release, 62, 191, 193, 198 remote shutter release cord, 21-22 Rename menu, Custom Picture Control, 71 Repeating flash mode, 81, 131 representational, landscape photography style, 186 Reset custom settings, 75 Reset shooting menu, Shooting menu, 67-68 resolutions, 69, 87 Retouch menu, 91, 229-234 Reverse rotation, 85 reversing rings, macro photography, 195 RGB histograms, image review display, 65 Rotate tall, Playback menu, 64, 66 rotation, image orientation, 87 Rule of Thirds, subject/image placement, 118-120

S

S (Shutter Priority) mode, semiautomatic, 3, 35 S (Single shot) mode, single frame capture, 4 S (Single) focus mode, portraits, 7, 44 Saturation, custom Picture Control, 55 Save/Edit menu, Custom Picture Control, 71 Save/load settings, Setup menu, 86, 88 SB-400 Speedlight, entry-level Speedlight, 141 SB-600 Speedlight, 82, 141 SB-800 Speedlight, 82, 131, 140 SBR-200 Speedlight, ring lights, 142-143 Scene Recognition System, 46 S-curves, composition rules, 121-122 SD (Standard), Picture Control, 54, 70 self-portraits, Self-timer mode, 5 Self-timer mode, time delay shots, 5 self-timers, 79-80, 198, 202 sensors. See also CMOS image sensor 1005-pixel RGB, 36-37, 46 cleaning, 86-87 crop factors, 100-101 dust reference photo, 88 sepia, 56, 231-232 Set Picture Control, Shooting menu, 67, 70-71

Setup menu, 86-91 shade, 52, 54, 128 shadowless lighting, portrait photography, 207-208 shadows, 228-230 shallow depth of field, subject sharpness, 115 Sharpness, custom Picture Control, 55 shooting data, image review display, 65 Shooting menu, 30, 32, 48-50, 57-59, 67-74 shooting menu bank, 30-32, 67-68 shooting modes, 1-3, 20, 82-83 shoot-through umbrellas, light modifier, 150-151 short lighting, portrait photography, 208 shots per interval number, 29, 31 shoulder bags, 242 Shutter Priority (S) mode, semiautomatic, 3, 35 Shutter Release button, 1-2, 16-17, 80 shutter release, No memory card? setting, 85 shutter speed indicator, 26-27 shutter speed multi-function, 28-29, 31 shutter speeds, 26-27, 79, 111-113, 132 shutters, 4-6, 80 side panel controls, 11-12, 24-25 Side-by-side comparison, Retouch menu, 234 Single (S) focus mode, portraits, 7, 44 Single AF mode. See Single (S) focus mode Single area AF mode, 22, 46 Single focus mode, 19, 22 Single point AF area mode, focus points, 9 Single Shot (S) mode, single frame capture, 4 Size Priority, JPEG compression, 69 Skylight filter, Retouch menu, 231 skylines, night photography, 199-202 sleep mode, Shutter Release button activation, 16 Slide show, Playback menu, 64, 66 Slow sync mode, 133-134, 199, 202 Small, image size setting, 69 Smith Victor RTK4, radio slave, 145 snapshots, 2, 21-22, 34-35, 133, 137-138 snoots, light modifier, 154 soft light, subject flattering, 124 softboxes, light modifier, 151-152 specifications, Nikon D300, 243-247 Speedlights. See also flash Auto Aperture mode, 131 Auto mode, 131 built-in, 21-22, 143-144 CLS (Creative Lighting System), 139-143 concert photography, 180 control settings, 81-82 fill flash, 136-137 GN (Guide Number), 129 GN/Distance = aperture formula, 130 Guide Number distance priority mode, 131 indoor portrait lighting, 210 i-TTL system, 129 Manual mode, 131 painting with light, 200 R1/R1C1, 142 SB-400, 141

Speedlights (continued) SB-600, 141 SB-800, 140 SBR-200, 142-143 SU-800. 141-142 Speedotron, studio strobes, 145 speedring, softbox connection, 152 split lighting, 209 sporting events, 158-162 sports shots, telephoto lenses, 104-106 sports/action photography, 158-162 Spot metering mode, 6, 38, 84 sRGB color space, 68, 72 Standard (SD), Picture Control, 54, 70 Standard i-TTL flash, 130 standard packs, studio strobes, 144-147 standard umbrellas, light modifier, 150-151 Standard video output, side panel connector, 24 still-life photography, 4, 7, 44, 46, 214-217 studio flash, M (Manual) mode, 36 studio strobes, 21-22, 144-147 studios, portrait photography, 206-207 SU-800 Speedlight, wireless, 141-142 Sub-command dial, 22-23, 84-85 subject framing, 122 sunlight, 123, 125, 127-128 Sunny 16 Rule, outdoor exposures, 125 sync speeds, 26-28, 32, 132

Т

Tamrac, shoulder bags, 242 teleconverters, lens accessory, 108-109 telephoto lenses, 104-106, 225 televisions, image viewing, 227-228 terms. 251-256 textures, 155-158, 180-185 through the viewfinder (TtV), art, 167-168 through the lens (TTL) light metering, 125 Thumbnail/Zoom out button, 10-11, 20-21 thumbnails, 10, 20-21, 83 TIFF (RGB), file format, 69 TIFF format, 60, 69 time delays, Self-timer mode, 5 time zones, setting, 87 time-lapse photography, interval times, 29, 32, 74 timers, settings, 79 tonal ranges, histogram display, 39-41 tonality, 3, 36, 206 Toning, custom Picture Controls, 56-57 top panel controls, 1-6, 15-17 travel photography, 218-221 Trim, Retouch menu, 230-231 Tripod mode, LiveView, 61-62, 73 tripod socket, bottom panel component, 25 tripods ball heads, 239 exposure delay mode, 80 height considerations, 239 landscape photography, 190 light trail/fireworks photography, 191 Mup (Mirror up) mode, 5

night photography, 199–202 pan/tilt heads, 239 plates, 239–240 portrait photography, 213 purchasing guidelines, 240–241 quick release plates, 239–240 Self-timer mode, 5 use guidelines, 240 TTL (through the lens) light metering, 125 TTL mode, built-in flash, 81 TtV (through the viewfinder), art, 167–168 tungsten lights, 147–149

U

ultrasonic vibration, sensor cleaning, 86–87 ultraviolet (UV) filters, 109–110 umbrellas, light modifier, 150–151 Uncompressed, RAW file compression setting, 70 underexposures, 3, 36, 40, 229–230 updates, firmware, 91 USB cable, downloading images, 11–12 USB port, 11–12, 24, 86–87 UV (ultraviolet) filters, 109–110

V

vanishing points, leading lines, 121 venues, concert photography, 180 VI (Vivid), Picture Control, 54–55, 71 Vibration Reduction (VR) lenses, 107–108 Video mode, Setup menu, 86–87 video out ports side panel connection, 11–12, 24 View NX, image comments, 87 viewfinder, 3–4, 10, 18, 20, 26–28, 76, 80 vignetting, wide-angle lenses, 102 vistas, landscape photography, 186–190 Vivid (VI), Picture Control, 54–55, 71 VR (Vibration Reduction) lenses, 96, 107–108

W

Warm filter, Retouch menu, 232 WB bracketing, setup, 42 WB fine-tuning, 29, 31 WB indicator, 31 WB preset number, 29, 31 Web sites Chimera, 152 Communication Arts, 250 Digital Photo Pro, 250 Digital Photographer, 250 Flickr.com, 250 informational, 249 Nikon, 91 Nikonions.org, 249 Nikonusa.com, 249 Outdoor Photographer, 250 Photo District News, 250 photo sharing/critiquing, 250 Photo.net, 249 photography magazines, 250 Photoworkshop.com, 250

Popular Photography & Imaging, 250 Russ Morris, 168 ShotAddict.com, 250 Strobist techniques, 146 white balance, 42, 50–54, 67, 70 White balance button, 16–17 wide-angle lenses, 101–103, 166 wildlife photography, 104–106, 221–225 window lighting, 210 windows, natural light conditions, 128 Wireless transmitter, Setup menu, 86, 88 World time, Setup menu, 86–87 WT-4a Wireless transmitter, 88, 239

Х

X-pro, art photography, 170

Y

Yellow filter, custom Picture Control, 56

Z

Zoom In button, image views, 10–11, 20–11 zoom lenses, 98 Zoom out/Thumbnail button, 20–21 zoom ring, 16–18 zooms, 21, 83 zoos, wildlife photography, 221–225

Guides to go.

Colorful, portable Digital Field Guides are packed with essential tips and techniques about your camera equipment, iPod, or notebook. They go where you go; more than books—they're gear. Each \$19.99.

978-0-470-12051-4

Full Color Throughout! 978-0-470-11007-2

978-0-7645-9679-7

Also available

Canon EOS 30D Digital Field Guide • 978-0-470-05340-9 Digital Travel Photography Digital Field Guide • 978-0-471-79834-7 Nikon D200 Digital Field Guide • 978-0-470-03748-5 Nikon D50 Digital Field Guide • 978-0-471-78746-4 PowerBook and iBook Digital Field Guide • 978-0-7645-9680-3

Available wherever books are sold

WILEY Now you know.

Wiley and the Wiley logo are registered trademarks of John Wiley & Sons, Inc. and/or its affiliates. All other trademarks are the property of their respective owners.